THE WORLD'S GREAT NEWS PHOTOS 1840~1980

THE WORLD'S GREAT NEWS PHOTOS 1840~1980

Selected and Edited by

Craig T. Norback and Melvin Gray

Crown Publishers, Inc. New York

Inquiries should be addressed to Crown Publishers, Inc.,

One Park Avenue, New York, New York 10016

Printed in the United States of America

Published simultaneously in Canada

by General Publishing Company Limited

Library of Congress Cataloging in Publication Data

Main entry under title:

The world's great news photos, 1840–1980.

1. Photography, Journalistic. 2. Journalism,

Pictorial. I. Norback, Craig T. II. Gray, Melvin.

TR820.W7 779'.99098 80–15600

ISBN: 0–517–539489

Design by Camilla Filancia

10 9 8 7 6 5 4 3 2 1

First Edition

CONTENTS

Preface ix
Photograph Credits xi

The First Daguerreotype: A Boulevard in Paris, ca.
 1839 1
Samuel F. B. Morse, 1840 2
Mexican-American War, ca. 1847 3
Sutter's Mill, 1848 4
The Swedish Nightingale, 1850 5
First Sewing Machine, 1851 5
Surgery Without Pain, 1853 6
The Pony Express, ca. 1860 7
Civil War Balloon, 1861 8
Lincoln at Antietam, October 4, 1862 9
Tom Thumb's Wedding, 1863 10
Mathew Brady and the Civil War, 1863 11
The Building of the Capitol, ca. 1863 12
Execution of Conspirators, July 7, 1865 13
Drake's Well, ca. 1866 14
Sherman–Indian Treaty, 1868 15
Meeting of the Railroads, May 10, 1869 16–17
The Great Chicago Fire, October 8, 1871 18
Buffalo Bill, ca. 1872 19
The Remington Typewriter, 1872 20
Susan B. Anthony, ca. 1875 20
First Five-and-Ten, June 21, 1879 21
Edison and His Light Bulb, October 19, 1879 21
Sitting Bull, 1885 22
Lillie Langtry, 1888 23
Dixon Crossing Niagara, 1890 24

Alexander Graham Bell's Telephone, 1892 25
The Duryea Auto, 1893 25
The Royal Family, ca. 1893 26
Geronimo, ca. 1893 27
Oklahoma Land Rush, September 16, 1893 28
Henry Ford, 1896 28
The Klondike Gold Rush, 1897–1898 29
Discovery of the X Ray, 1898 30
Madame Curie, 1898 30
Sinking of the Maine, 1898 31
Brooklyn Bridge, 1898 32
Mark Twain, ca. 1900 33
John L. Sullivan, ca. 1900 34
Carry Nation, ca. 1900 34
Homestead Strike, 1901 35
The Flatiron Building Under Construction,
 1901 36
Barney Oldfield, ca. 1903 37
Kitty Hawk, December 17, 1903 38
New York Subway, October 27, 1904 38
General William Gorgas, 1904 39
Ellis Island, 1905 40
Alice Roosevelt's Wedding, February 17, 1906 41
Teddy Roosevelt at the Panama Canal, 1906 42
San Francisco Earthquake, April 18, 1906 43
Child Labor, 1908 44
Robert Peary, 1909 45
Mata Hari, ca. 1910 46
Attempted Assassination of Mayor Gaynor, August
 9, 1910 47

v

Horse-Drawn Fire Engine, *1910* 48

New York's Triangle Shirtwaist Factory Fire, *March 25, 1911* 49

First Indy 500, *1911* 50

Eddie Rickenbacker, *ca. 1912* 50

Pancho Villa and General Pershing, *August 26, 1914* 51

The Assembly Line, *1914* 52

Jess Willard–Jack Johnson Fight, *April 5, 1915* 53

Rasputin, *ca. 1915* 54

Irish Rebellion, *1916* 55

Margaret Sanger, *June 4, 1917* 56

The Draft, World War I, *1917* 57

World War I, *1917* 58

First Airmail Service in U.S., *May 15, 1918* 59

The Paris Peace Conference, *June 28, 1919* 60

Edison and His Friends, *1919* 61

Prohibition, *January 16, 1920* 62

Women's Suffrage, *1920* 63

Dawn of the Radio, *November 2, 1920* 64

Prohibition Agents, *1921* 65

Sigmund Freud, *1922* 66

John D. Rockefeller at Eighty-Three Years Old, *1922* 66

King Tut's Tomb, *1922* 67

The Leopold-Loeb Trial, *September 12, 1924* 68

The Scopes Trial, *July 1925* 69

The Tramp, *ca. 1925* 70

Aimee Semple McPherson, *1925* 71

Albert Einstein, *ca. 1926* 72

Gertrude Ederle, *August 6, 1926* 73

The Lone Eagle, *May 20–21, 1927* 74

Dempsey–Tunney Fight, *September 22, 1927* 75

The Jazz Singer, *October 6, 1927* 76

Billy Sunday, *1928* 77

St. Valentine's Day Massacre, *February 14, 1929* 78

Black Tuesday, *October 29, 1929* 79

Al Capone's Soup Kitchen, *November 1930* 80

Amelia Earhart, *ca. 1930* 81

The Great Depression, *Early 1930s* 82

Dance Marathon, *1930s* 82

The Dust Bowl, *Early 1930s* 83

The Scottsboro Case, *1932* 84

Hitler and Hindenburg, *March 21, 1933* 85

J. P. Morgan and the Midget, *June 1, 1933* 86

Bruno Richard Hauptmann, *February 14, 1935* 86

Dionne Quints, *1935* 87

Robert Goddard, *1935* 88

First Portable Television Broadcasting Outfit, *ca. 1935* 88

The Abdication of King Edward VIII, *1936* 89

Shanghai Railroad Station, *August 28, 1937* 90

Nazis in Nuremberg Stadium, *Late 1930s* 91

Hitler and Volkswagen, *May 26, 1938* 92

Joe Louis vs. Max Schmeling, *June 22, 1938* 93

Goldfish Swallowing, *1939* 94

FDR in Car, *1939* 95

Gandhi, *ca. 1940* 96

Wendell Wilkie, *August 17, 1940* 97

W. C. Fields, *1940* 98

Hitler's Jig, *1940* 99

Winston Churchill, *ca. 1940* 100

First Peacetime Draft, *October 1940* 101

J. Edgar Hoover, *ca. 1940* 102

John Wayne, *1941* 103

Marseilles, France, *February 1941* 104

FDR's Fireside Chats, *May 27, 1941* 105

Pearl Harbor, *December 7, 1941* 106–107

A Declaration of War, *December 8, 1941* 108

Oveta Culp Hobby, *May 16, 1942* 108

World War II Bombing of Singapore, *1942* 109

Coming Home, *July 15, 1943* 110

Teheran, *November 28–December 1, 1943* 111

Ulm, Germany, *1944* 112

Sewell Avery, *April 27, 1944* 113

D-Day, *June 6, 1944* 113

The Liberation of Paris, *August 25, 1944* 114

Leyte Gulf, *October 23–26, 1944* 115

Arabs Intercepted at the Israeli Border, *1945* 116

Yalta, *February 4–11, 1945* 117

Iwo Jima, *February 23, 1945* 118

Mussolini, *April 29, 1945* 119

The Holocaust, *1933–1945* 120

V-E Day, *May 8, 1945* 121

Potsdam, *July 25, 1945* 122

Hiroshima, *August 6, 1945* 123

Hiroshima, *August 6, 1945* 124

Japanese Surrender, World War II, *August 1945* 125

Nuremberg Trials, *November 1945–October 1946* 126

Child's Play, *June 23, 1947* 127

UFO Sighting, *July 8, 1947* 128

The Birth of Israel, *May 14, 1948* 129

Babe Ruth, *June 13, 1948* 130

The Berlin Airlift, *June 1948–September 1949* 131

Harry Truman, *November 4, 1948* 132

Axis Sally, *March 10, 1949* 133

Marilyn Monroe, *1949* 134

The Brinks Robbery, *January 17, 1950* 135

Julius and Ethel Rosenberg, *March 21, 1951* 136

Dwight D. Eisenhower, *April 11, 1951* 137

Adlai Stevenson, *1952* 137

Three Queens in Mourning, *February 11, 1952* 138

Selman Waksman, *1952* 139

Joseph Stalin, *March 5, 1953* 140

Truman, Eisenhower, Nixon, and Hoover, *January 20, 1953* 141

Pit River Bridge Rescue, *May 3, 1953* 142

The Conquest of Everest, *May 29, 1953* 143

Queen Elizabeth's Coronation, *June 2, 1953* 144

Charlie Chaplin and Chou En-Lai, *1954* 145

The Polio Vaccine, *March 10, 1954* 146

A Family's Tragedy, *April 2, 1954* 147

Roger Bannister, *May 6, 1954* 148

Joe McCarthy, *November 4, 1954* 149

Elvis Presley, *1956* 150

Plane Crash in Long Island, *November 2, 1955* 151

Andrea Doria, *July 25, 1956* 152

Sputnik I, *October 8, 1957* 153

Hula Hoops, *September 25, 1958* 154

Telephone Booth Cramming, *April 6, 1959* 154

The Mercury Astronauts, *April 1959* 155

Mickey and the Master, *ca. 1959* 156

The Kitchen Debate, *July 24, 1959* 157

Castro and Khrushchev Meet, *September 20, 1960* 158

The Great Debates, *Fall 1960* 159

A Strong Denial, *October 12, 1960* 159

Ku Klux Klan, *1960* 160

Segregation, *1960* 161

A Japanese Political Assassination, *October 12, 1960* 162

JFK Inaugural Address, *January 20, 1961* 162

Kennedy and Eisenhower at Camp David, *April 22, 1961* 163

First American in Space, *May 5, 1961* 164

The Berlin Wall, *August 18, 1961* 165

Maurice Wilkins and DNA, *October 18, 1962* 166

Buddhist Monk, *June 11, 1963* 167

I Have a Dream, *August 28, 1963* 168

Assassination of John F. Kennedy, *November 22, 1963* 169

Lyndon B. Johnson, *November 22, 1963* 170

Assassination of Lee Harvey Oswald, *November 24, 1963* 171

The Beatles, *February 1964* 172

Vietnam, *January 1, 1965* 173

Ed White's Spacewalk, *June 3, 1965* 174

The Great Blackout, *November 9, 1965* 175

Shooting of James Meredith, *June 6, 1966* 176

Detroit's Long Hot Summer, *July 23, 1967* 176

A Colleague's Revival, *July 17, 1967* 177

Dr. Christiaan Barnard, *1967* 178

First Heart Transplant Patient, *December 12, 1967* 179

Loan Shooting, *February 1, 1968* 180

The King Funeral, *April 9, 1968* 181

The Assassination of Robert Kennedy, *June 5, 1968* 182

Joe Namath, *January 12, 1969* 183

Cornell Campus Takeover, *April 20, 1969* 184

Man Walks on the Moon, *July 20, 1969* 185

Woodstock, *August 15–17, 1969* 186

Attica Prison, *September 11, 1971* 187

East Pakistan, *December 18, 1971* 188

East Meets West, *February 1972* 189

The Birth of Jacki Lynn Coburn, *March 16, 1972* 189

Vietnam Bombing, *June 8, 1972* 190

Olympic Games, Munich, *September 5, 1972* 191

Coming Home, *March 17, 1973* 192

Richard Leakey, *November 9, 1972* 193

John Dean's Testimony, *June 25, 1973* 194

Spiro Agnew's Resignation, *October 10, 1973* 194

Nixon's Resignation, *August 9, 1974* 195

Nixon's Farewell, *August 9, 1974* 196

Number 715, *April 8, 1974* 197

Patty Hearst, *April 1974* 198

Apollo-Soyuz Flight, *July 1975* 199

Carter's Inaugural Walk, *January 20, 1977* 200

First Test-Tube Baby, *July 25, 1978* 201

Israeli-Egyptian Peace Treaty, *September 17, 1978* 202

Pope John Paul II, *October 17, 1978* 203

Guyana—The People's Temple, *November 1978* 204

Ayatollah Khomeini, *February 1, 1979* 205

The Planet Venus, *February 19, 1979* 206

Three Mile Island, *March 1979* 207

New York Marathon, *October 22, 1979* 208–209

Balls of Fire, *April 22, 1980* 210

PREFACE

The World's Great News Photos: 1840–1980 brings together not just those photographs that have won prizes for their photographic technique or historical significance; it also includes pictures millions of people will recognize as capturing an event that is rare and important in American and world history.

This is a book for everyone—not just the photographic buff. Many photographers, however, amateur and professional, will recognize most of the best photographs ever taken. We have all lived through many of the experiences depicted in this book, and for those we have only read about, the pictures included here will give new meaning to each incident.

The book spans 140 years of American and world history and captures over 225 different significant occurrences. We have included the first photograph ever taken by man—the daguerreotype. Our goal was to include a picture for as many major events or important and meaningful occurrences as the size and number of pages in this book would allow. *The World's Great News Photos: 1840–1980* is

the most comprehensive book of its kind, in that we did succeed in including more memorable photographs than any other such book to date and we think you will agree you will relive history as you turn each page.

We have not delved into the type of camera that was used, the type of shot that was taken, or any of the technical aspects of photography. Rather, we detail the historical significance of each photograph— and it is our belief that a great photograph is one recognized by most people as *the* photograph of a particular occurrence. This book includes over 225 of the photographs that depict history in the most exacting way—in real life photography.

The World's Great News Photos: 1840–1980 is a book of pictures you can read and enjoy like no other book of its kind. This is a history book, a photographic chronicle, and a fascinating study in real-life incidents. Open the pages and discover, in a new and fresh way, the most spectacular incidents of the past 140 years.

PHOTOGRAPH CREDITS

THE WORLD'S GREAT NEWS PHOTOS 1840~1980

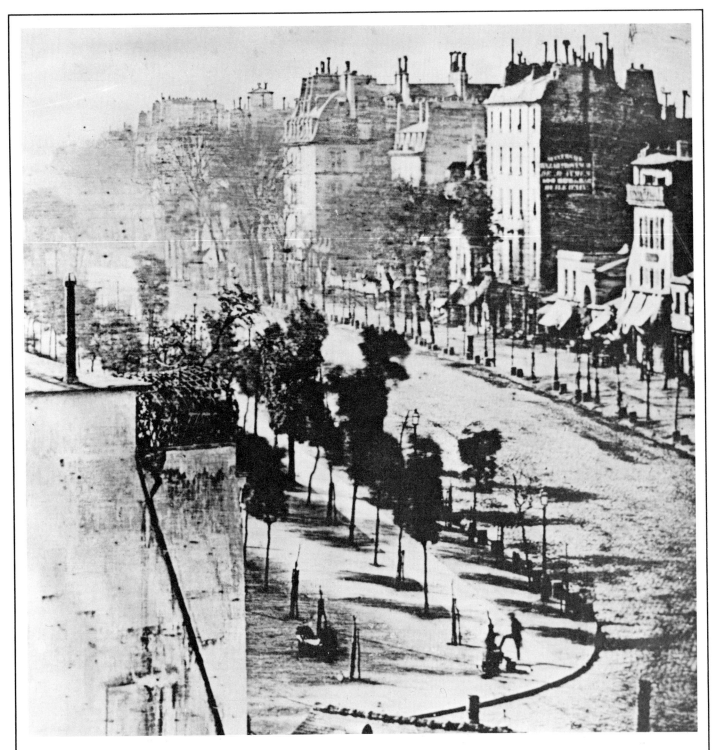

THE FIRST DAGUERREOTYPE: A BOULEVARD IN PARIS

ca. 1839

"We have much pleasure," wrote a French journal in January 1839, "in announcing an important discovery made by M. Daguerre, the celebrated painter of the Diorama. This discovery seems like a prodigy. It disconcerts all the theories of science in light and optics, and if borne out, promises to make a revolution in the arts of design."

This "revolution" was the invention of the daguerreotype—a photograph produced on a silver-coated copper plate treated with iodine vapor. Daguerreotypes became extremely popular and remained so until the late 1850s. It is probable that over 30 million daguerreotype photographs were taken in this country alone during this time period.

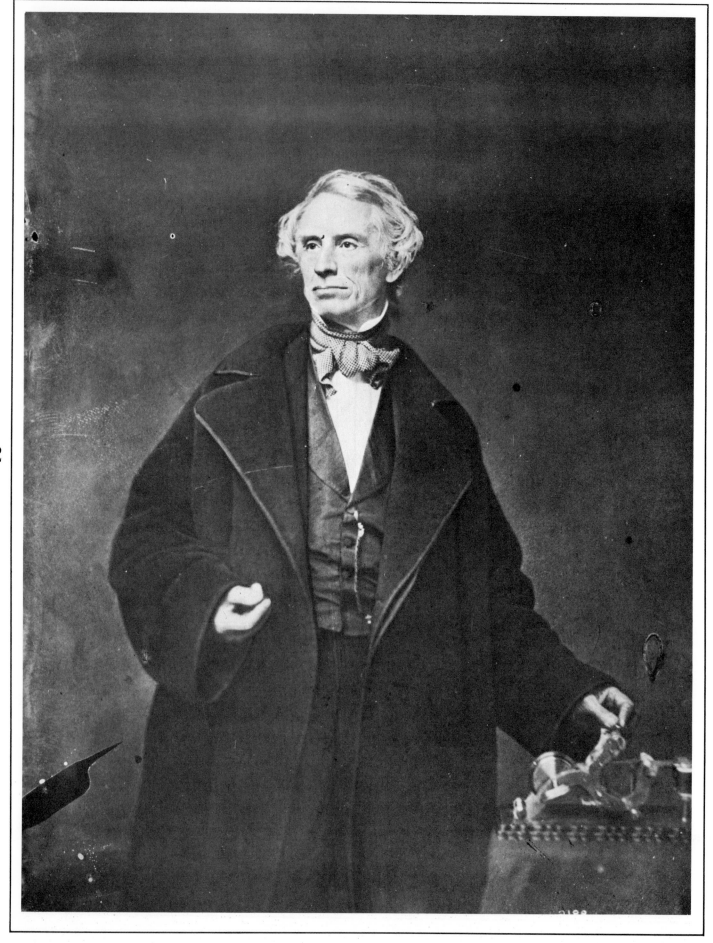

SAMUEL F. B. MORSE
1840

A simple phrase, "What hath God wrought," was dotted and dashed over the wire from Washington to Baltimore in 1844, and Samuel Finley Breese Morse won the attention of the world with his telegraph. Suddenly the slow and tortuous wait to get a letter was over; it was now possible to transmit a message across miles almost immediately.

The mails, of course, continued to serve for routine or lengthy communications, but Morse's telegraph changed the face of communication.

The originality of his invention has always been disputed; in Great Britain, Germany, and France, other men claimed similar inventions and Morse was forced to go to court to defend the telegraph. Even his "Morse code" was similar to other codes. Nevertheless, Morse, who had begun professional life as a painter and had founded the National Academy of Design, is considered by most to be the father of the telegraph.

MEXICAN-AMERICAN WAR
ca. 1847

In one of the earliest daguerreotypes ever taken of a war scene, American General John E. Wool and his staff posed at Saltillo, a spot northwest of Mexico City, where minor skirmishes occurred.

3

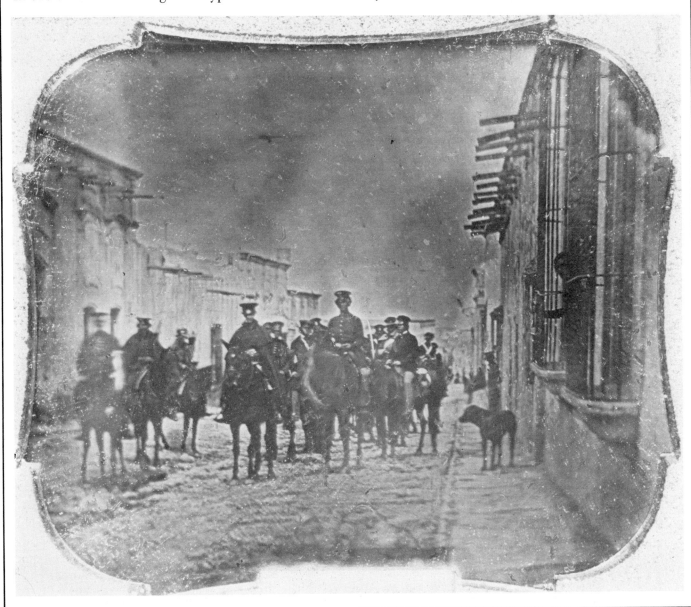

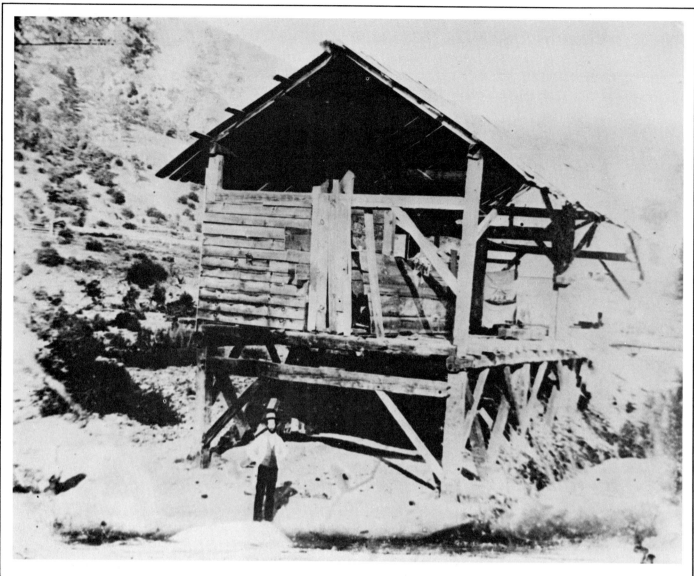

SUTTER'S MILL
1848

It was gold that settled California. On January 24, 1848, James Wilson Marshall discovered some small pieces of gold while he was building a sawmill for John Sutter in the Sacramento Valley. The word spread across the nation quickly, and thousands rushed to California. Within a year's time, San Francisco had grown from a small town to a city of 25,000.

Prices for necessities jumped sky-high, as miners searched for food and lodging. A shack rented for $100 a week, it was reported.

Despite the vast wealth that was all around him, James Marshall never prospered from it—the first prospectors who came to the site paid a small fee, but in the crush of people, late arrivals flatly refused to pay, and the claims of Marshall and Sutter were ignored.

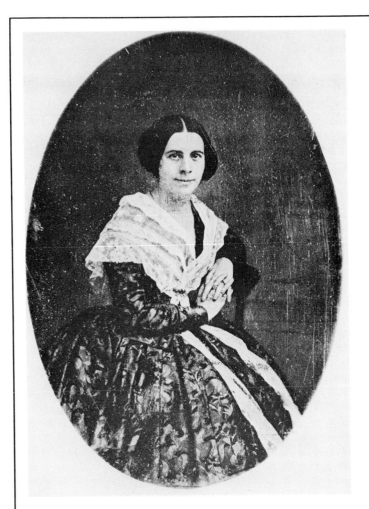

THE SWEDISH NIGHTINGALE
1850

Jenny Lind, of the crystal-clear coloratura voice, is shown here in an original daguerreotype made by Mathew Brady at the Fulton Street Gallery. She was just beginning her spectacular U.S. tour, which was managed and organized by P. T. Barnum.

FIRST SEWING MACHINE
1851

For all the years that have passed since Isaac Singer introduced the first practical sewing machine, few of the basics have ever changed. It was Singer who introduced the presser foot and the continuous feed that are still staples of any machine today. Elias Howe is credited with the introduction of the lock stitch and the eye-pointed needle (which Singer used and was forced to pay for in an infringement suit Howe brought against Singer in 1854), but this event did not prevent Singer from becoming not only the first, but the largest, sewing machine manufacturer.

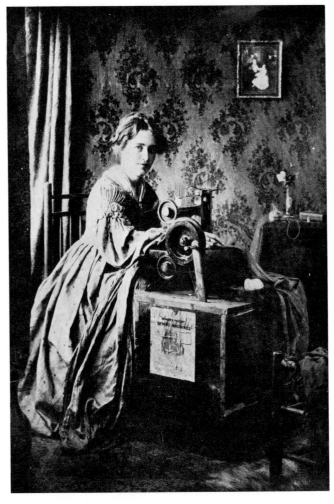

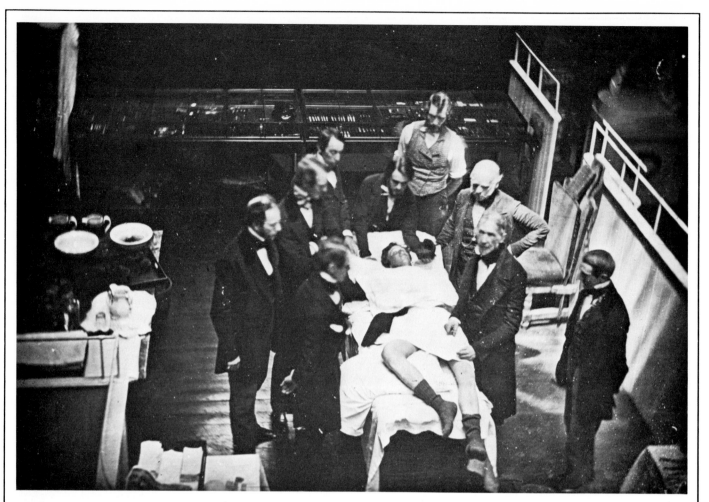

6

SURGERY WITHOUT PAIN

1853

This rare daguerreotype documents possibly the greatest advance in surgery's history—the discovery and application of anesthetics. The daguerreotype, however, shows a reenactment of the actual scene at Boston General Hospital. The real operation took place on October 16, 1846. Surgeon John C. War-ren, shown here with his hands on the patient's thigh, operated on a neck tumor, while Dr. William Morton applied ether as an anesthetic. Morton, not present for the reenactment, was replaced by Freeman Bumpstead, who holds the ether cloth here. A stand-in was also used for the patient, Gilbert Abbott, on whom the operation was originally performed.

THE PONY EXPRESS

ca. 1860

The "Help Wanted" signs for Pony Express riders stated that single men were preferred for the Pony Express team. The assignment, carrying the mail through the roughest land in America at breakneck speeds, was extremely dangerous and the company was not interested in leaving a string of widows and fatherless children.

The route from St. Joseph, Missouri, to Sacra-mento, California, was about 2,000 miles long, and the express riders covered it in about nine days, hopping onto a fresh horse every fifteen miles or so. It cost five dollars a half-ounce to send mail via Pony Express, but later that charge was reduced to one dollar a half-ounce.

Ultimately, it was not the Indians or the bandits or the route that stopped the Pony Express—it was the completion of the coast-to-coast telegraph on October 24, 1861.

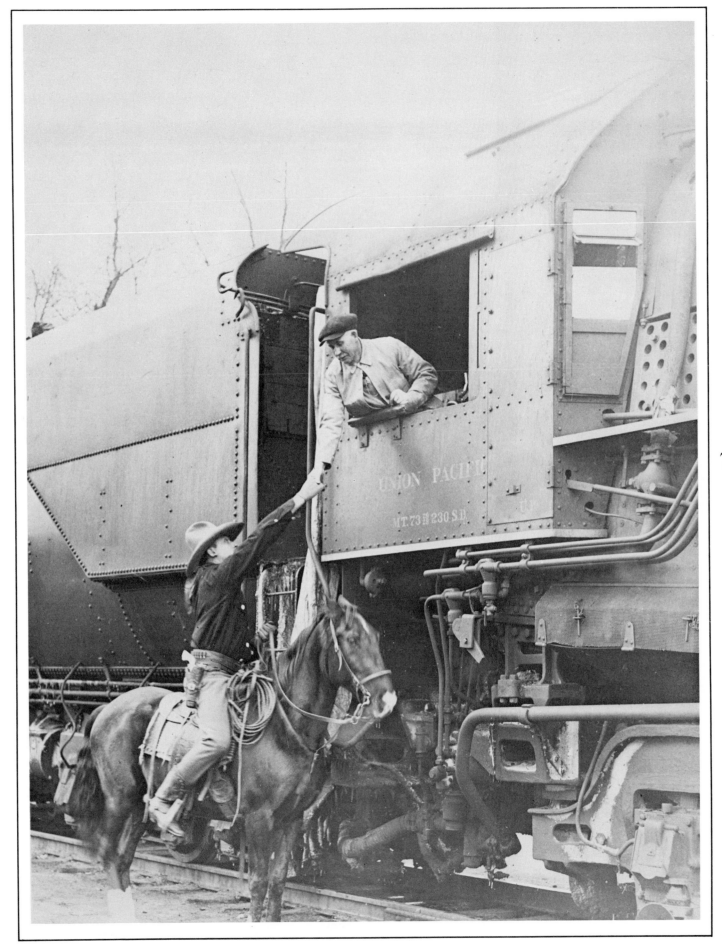

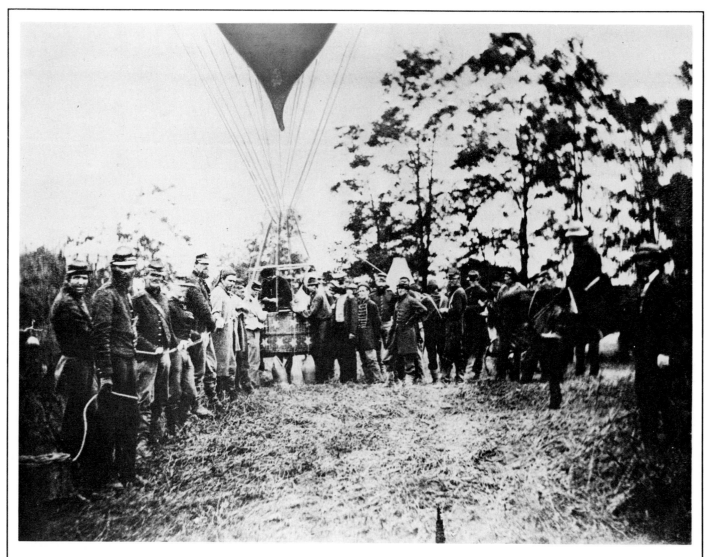

8

CIVIL WAR BALLOON
1861

T. S. C. Lowe so impressed Abe Lincoln with his
900-mile trip in his homemade balloon in 1861 that
Lincoln appointed him chief of the corps of aeronau-
tics of the U.S. Army. Lowe built up a small fleet of
balloons used for scouting missions, the most fam-
ous of which was the *Intrepid.* Here, Lowe sends a
report from a balloon during an 1861 campaign.

LINCOLN AT ANTIETAM
October 4, 1862

One of a select group of photographers who record-
ed the Civil War for history, Alexander Gardner
took this photograph of Abraham Lincoln, at Antie-
tam, visiting his generals. To the left is Alan Pinker-
ton, who was later to form a famous guard company,
and to the right of Lincoln is Major General George
McClellan.

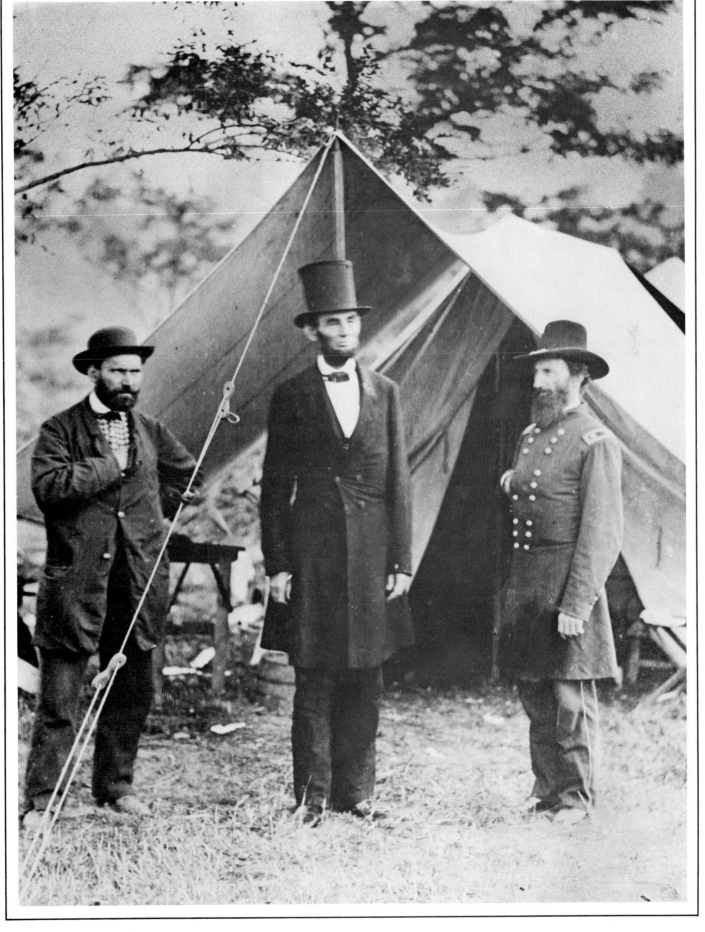

9

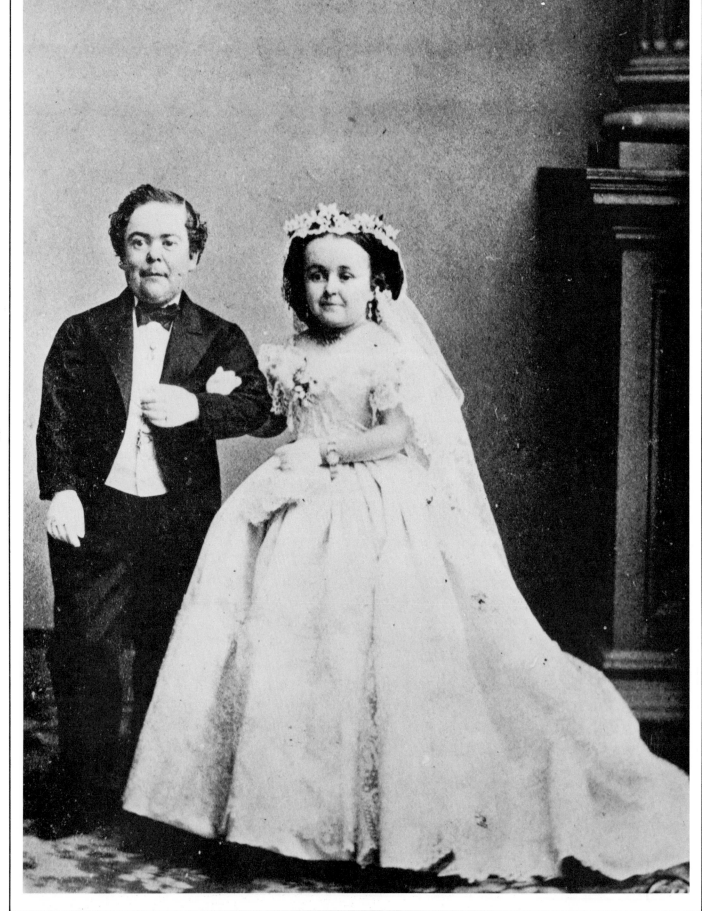

10

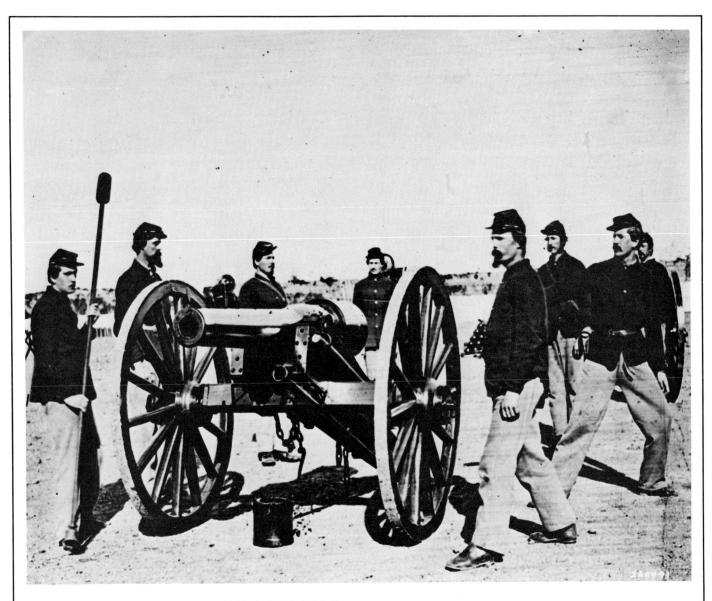

MATHEW BRADY AND THE CIVIL WAR
1863

Mathew Brady is credited with preserving much of the history of the Civil War for future generations. He learned his craft from Samuel Morse fifteen years before he went off with the armies, then snapped everything that happened during the years the country was torn by civil war. Brady is credited with leaving the most complete visual record of the war. Here, he records a Union gun squad on a drill in Virginia.

TOM THUMB'S WEDDING
1863

Charles Sherwood Stratton, dubbed "General Tom Thumb" by his employer, P. T. Barnum, and the former Lavinia Warren pose here on their wedding day. The two tiny adults, Thumb measuring just over two feet and Warren also slightly over two feet (twenty-five inches), met and fell in love while both were attractions at Barnum's exhibition. The wedding ceremony was the social event of the season, with 2,000 guests attending the reception held at the Metropolitan Hotel.

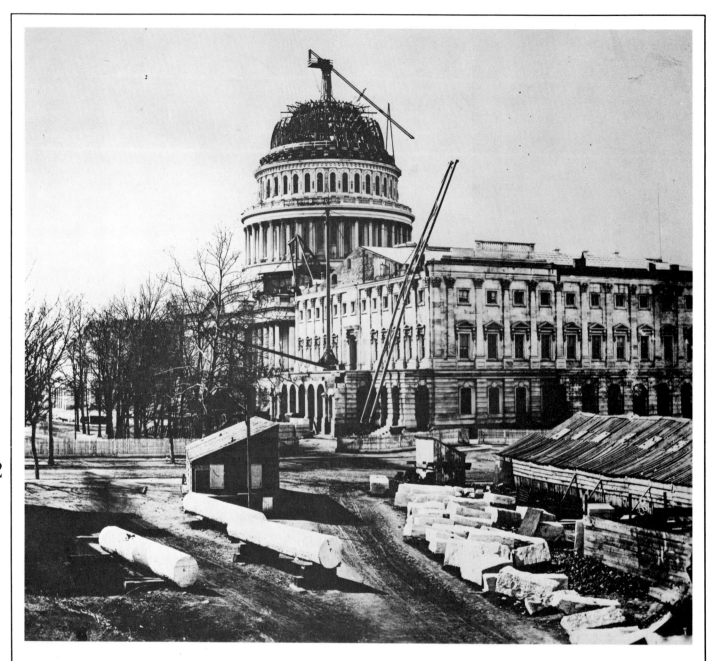

12

THE BUILDING OF THE CAPITOL

ca. 1863

The original Capitol building, which sat on the rise in Washington once known as Jenkins Hill, had gone up in flames, ignited by the British during the War of 1812. Construction on the new building, designed by Thomas Ustick Walter and greatly en-

larged to accommodate the ever-growing Congress, was begun in 1851. Work on the building proceeded unhampered through the Civil War. While battles were being fought not far from Washington, sections of the dome of the Capitol were lifted into place. The building was crowned with the placement of the bronze sculpture "Freedom" on December 2, 1863.

EXECUTION OF CONSPIRATORS
July 7, 1865

John Wilkes Booth, the unstable actor who shot Abraham Lincoln, outlived Lincoln by only eleven days. Booth died after being shot—either by himself or by a soldier who was tracking him. But four of Booth's co-conspirators were tried, found guilty, and sentenced to death.

Three men, David Herold, Lewis Paine, George Atzerodt, and one woman, Mary Surratt, were hanged on July 7, 1865. Herold had directed Paine in his attack on Secretary of State William Seward, an attack that wounded the cabinet officer, his two sons, and two other men. Atzerodt, an uneducated immigrant originally directed to kill Vice-President Andrew Johnson, had spent the fateful night drinking and roaming the city. Surratt, the owner of the boardinghouse in Washington where the plan was concocted, was convicted for her silence about the conspiracy, of which she knew.

13

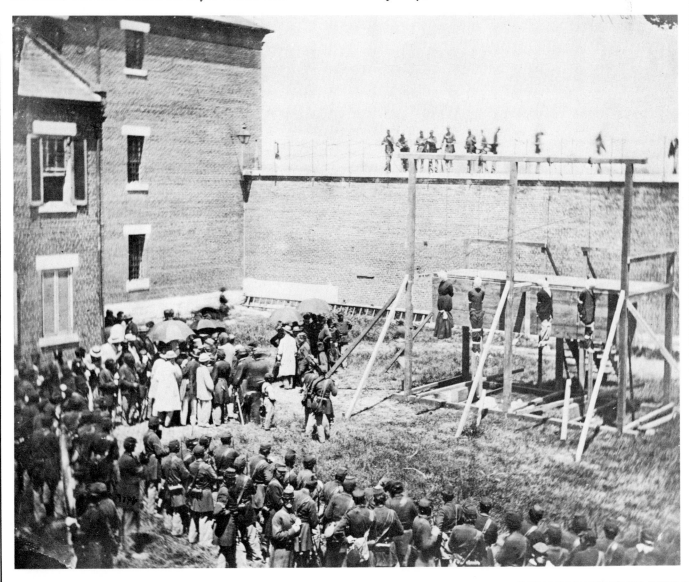

14

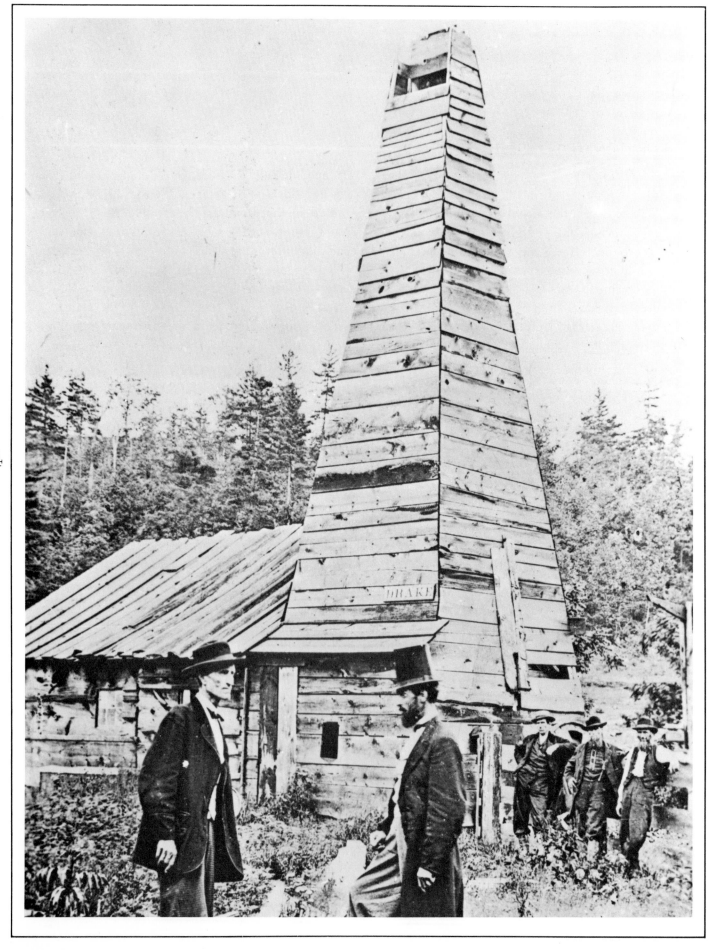

DRAKE'S WELL

ca. 1866

It was known that the land near Titusville, Pennsylvania, was full of quality oil, but little was being done to extract it from underground. Edwin Drake, a former hotel clerk, steamboat employee, and railroad conductor, arrived in Titusville in 1857 after studying the salt well drilling projects in Pittsburgh and Syracuse. Drake formed the Seneca Oil Company and began drilling the first well in June 1859.

Popular reaction ranged from ridicule to skepticism, but in late August of that year Drake's well began spewing twenty-five barrels of oil daily. Unfortunately, in the stereotypical legend of a rags-to-riches-to-rags story, Drake lost the considerable fortune he had made, in a stock deal, and eventually died in poverty.

Here, Drake stands to the right, and an associate, Peter Wilson, stands to the left.

SHERMAN—INDIAN TREATY

1868

No one knew better than William Sherman that, as he put it, "War is hell." After years of fighting in the Civil War, Sherman was anxious to see the West again. He got his opportunity, and also the opportunity to talk and think of peace rather than war. Here, Sherman (to the left of the white-bearded man) is shown at a treaty signing with the Sioux Indians at Fort Laramie, Wyoming.

15

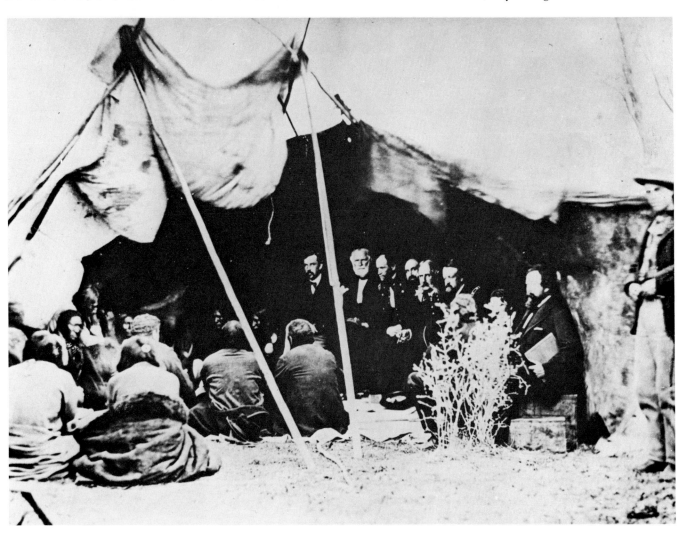

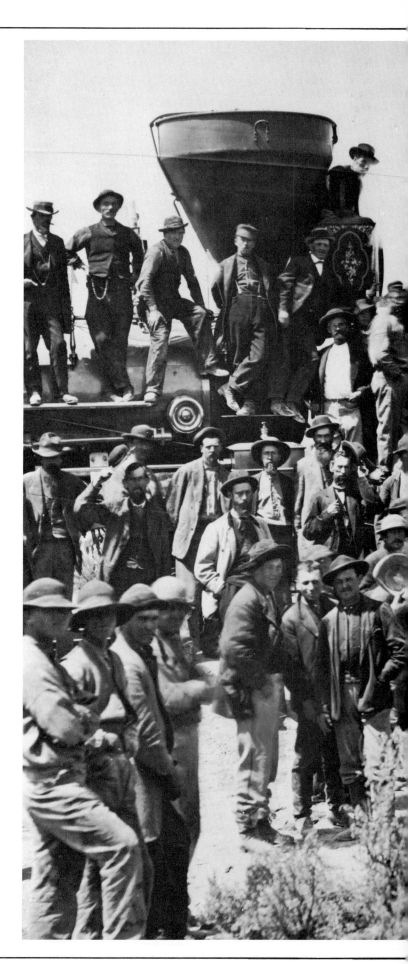

16

MEETING OF THE RAILROADS
May 10, 1869

For six years, the two railroad companies had been
tediously laying tracks. The Central Pacific was
working east from Sacramento, California, and the
Union Pacific was working west from Omaha, Ne-
braska. Immigrants from several countries did the
work on the railroad: Chinese, Irish, Scots, Ger-
mans, and Scandinavians. They reached each other
on May 10, at Promontory, Utah. Between the en-
gines of two hulking locomotives, the last spikes,
one of gold and the other of silver, were driven into
the ground to commemorate the completion of the
transcontinental line.

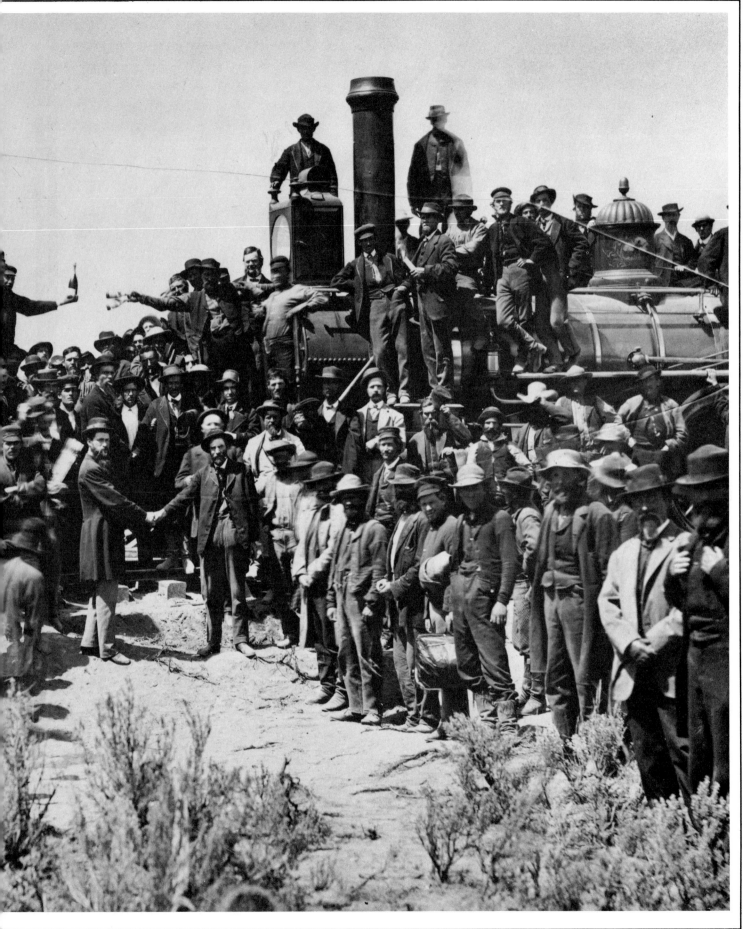

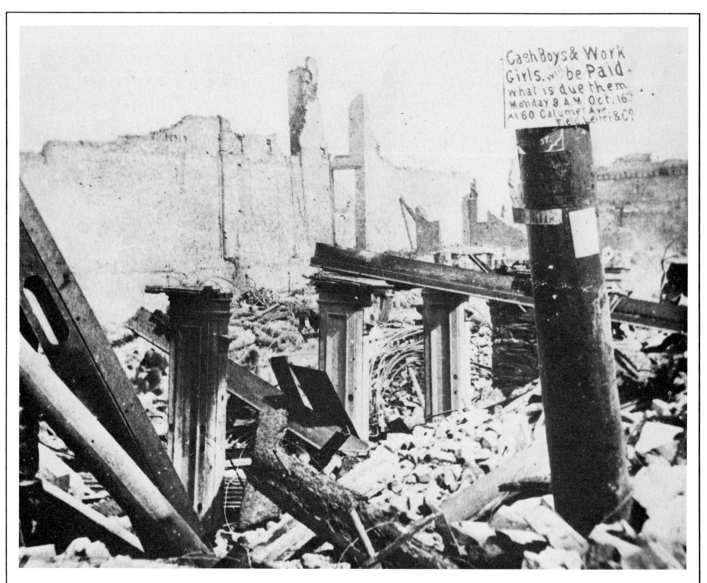

Cash Boys & Work
Girls. will be Paid.
what is due them
Monday 9 A.M. Oct. 16
at 60 Calumet Ave
Field Leiter & Co.

ST.

THE GREAT CHICAGO FIRE
October 8, 1871

It is doubtful that Mrs. O'Leary's cow was really to blame for the great fire of Chicago. What is known is that it began on a Sunday night in the O'Learys' barn and within an hour the whole block was in flames. Chicago in 1870 was built almost entirely of wood, so the city was primed for a disastrous blaze. There had been little rain throughout the preceding summer, and in the week before the big fire there had been twenty-four fires in the city. The Chicago fire, which began on a Sunday evening, lasted until Tuesday morning, turning the city into ashes and rubble, taking 300 lives, and leaving $400 million in damage.

BUFFALO BILL
ca. 1872

If anyone could claim the credit for romanticizing the American West, it had to be William Cody, alias "Buffalo Bill." He was a rider for the Pony Express, served in the Civil War, was a buffalo hunter (he hunted to feed workers on the Kansas Pacific Railroad, which explains his nickname), and a scout during the Indian fighting. All of these skills came in handy when he embarked upon his most famous career—running Buffalo Bill's Wild West Show. The show was a traveling exposition that remained an attraction for thirty years. At different times, Cody counted Annie Oakley and the Indian chief Sitting Bull among his attractions.

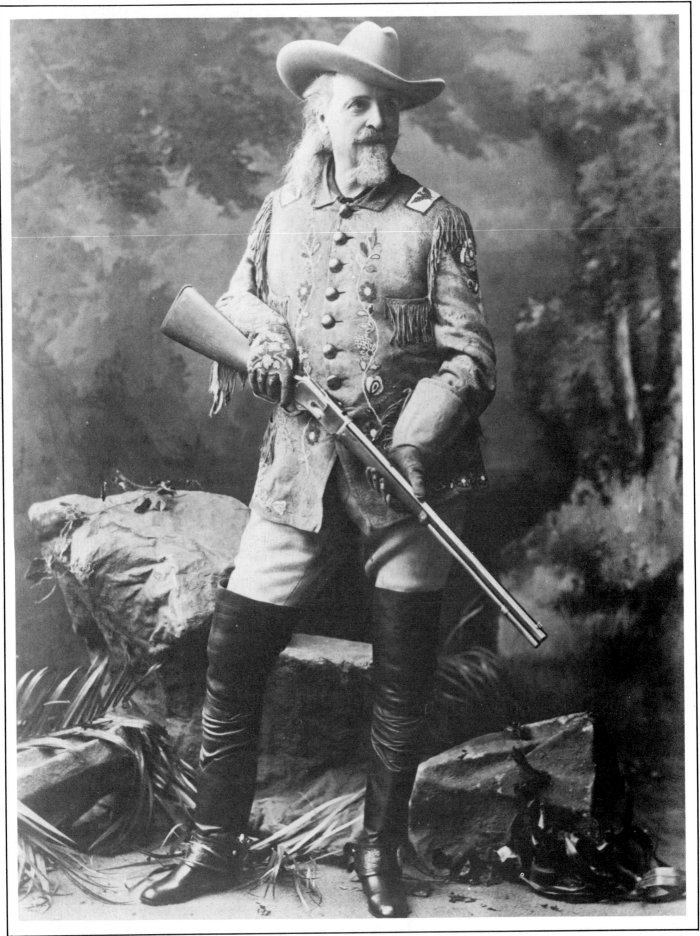

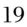
19

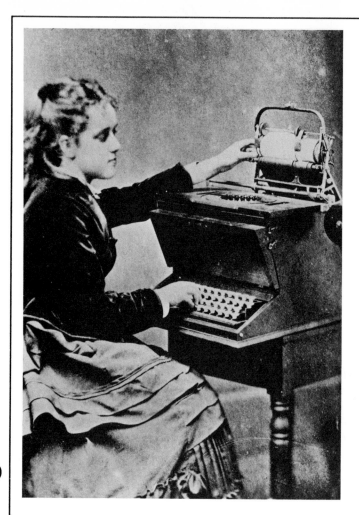

THE REMINGTON TYPEWRITER
1872

The company was known primarily for its gun manufacturing, but in 1873, E. Remington and Sons began to market a new invention. The three inventors from Milwaukee, Christopher Latham Sholes, Carlos Glidden, and S. W. Soule, had received a patent for their typing machine in 1868.

The model that Remington marketed over one hundred years ago doesn't differ much from today's typewriters. The biggest difference is in the placement of the platen—in the original typewriters the type was positioned so that the typist could not see what had been produced.

SUSAN B. ANTHONY
ca. 1875

On election day in 1872, a remarkable thing happened. Susan B. Anthony led fifteen women into a polling station in Rochester, New York, and they all voted. She was arrested for her crime shortly thereafter—she had "knowingly, wrongfully, and unlawfully voted."

A strict Victorian, she had championed such causes as temperance, the abolition of slavery, and dress reform (she was one of the first women to wear bloomers), but she eventually abandoned her other causes to concentrate on women's suffrage.

She died in 1906, fourteen years before the Nineteenth Amendment assured women of the right to vote.

FIRST FIVE-AND-TEN
June 21, 1879

Once a clerk in assorted stores, Frank Woolworth opened the first five-and-ten in Lancaster, Pennsylvania, on June 21, 1879. Earlier that year he had tried unsuccessfully to open the same type of store in Utica, New York. Woolworth's idea of selling a large variety of goods at a fixed price was a golden one; when he died forty years later, there were over 1,000 Woolworth's stores operating and Frank Woolworth was worth millions.

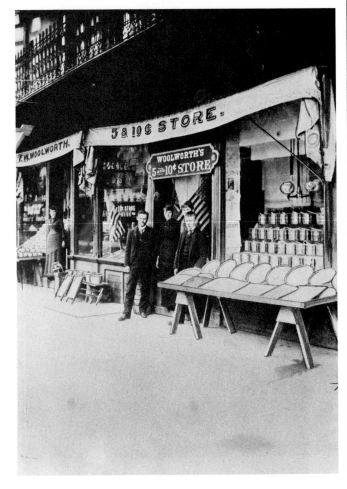

21

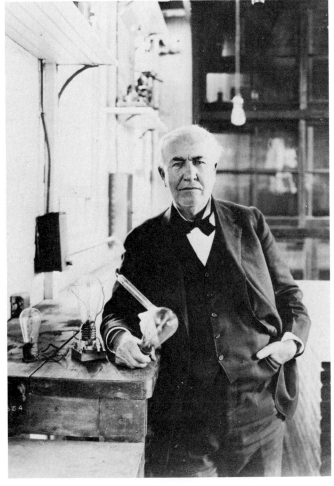

EDISON AND HIS LIGHT BULB
October 19, 1879

"The Wizard of Menlo Park," Thomas Alva Edison, stands holding his most famous invention—the light bulb. He had previously invented the phonograph and had improved the motion picture, the telephone, and the electric generator.

The incandescent light bulb, as it was first called, was for many months stalled by Edison's search for the perfect filament. He had even sent envoys into the jungles of the Amazon and into the forests of Japan for exotic materials, but on October 19, 1879, when he turned on the lamp (or bulb), the filament in it was a piece of ordinary sewing thread.

22

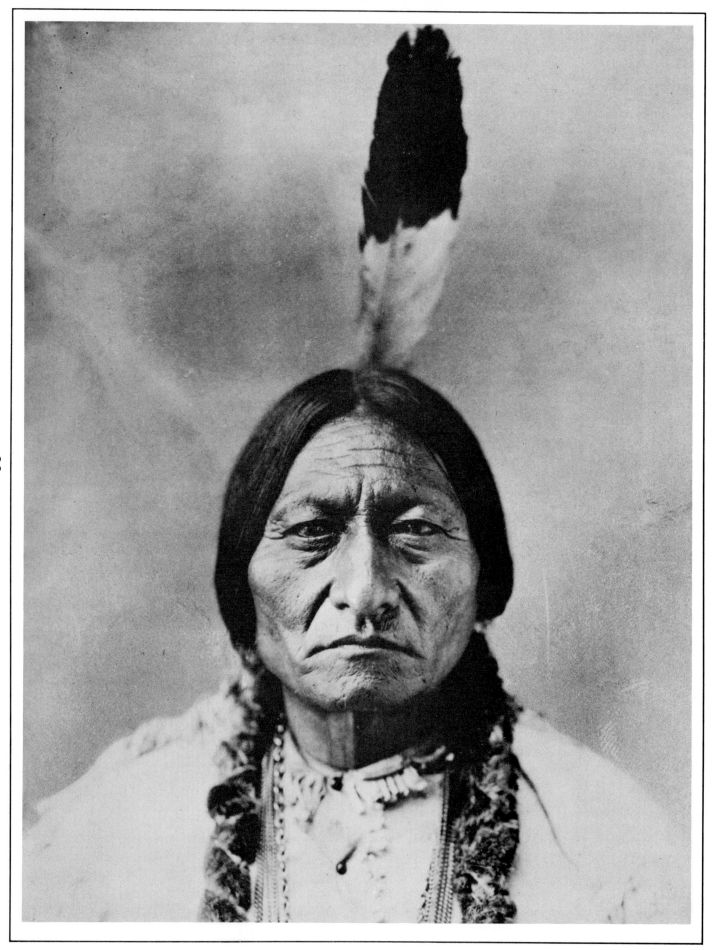

SITTING BULL

1885

The proud Sioux chief led some of the greatest Indian battles—most notably Little Big Horn, where General Custer was killed. Sitting Bull refused to move to a reservation, later fled to Canada, and when he returned, continued to champion the cause of his people. Even while appearing in Buffalo Bill's Wild West Show, he exhorted Indians to refuse to sell their lands. Sitting Bull died in 1890, during a scuffle with Indian police.

LILLIE LANGTRY

1888

The celebrated English actress, nicknamed "the Jersey Lily" (she was born on the isle of Jersey), is shown here at age thirty-five. She jolted English society by becoming the first society woman to appear on stage. Though she was never considered a great actress, she opened her own theater in London. Langtry was celebrated for her great beauty and attracted many admirers, the most famous being the Prince of Wales, later to become King Edward VII. Oscar Wilde wrote *Lady Windermere's Fan* for her. In 1899 she married Sir Hugo Gerald deBathe.

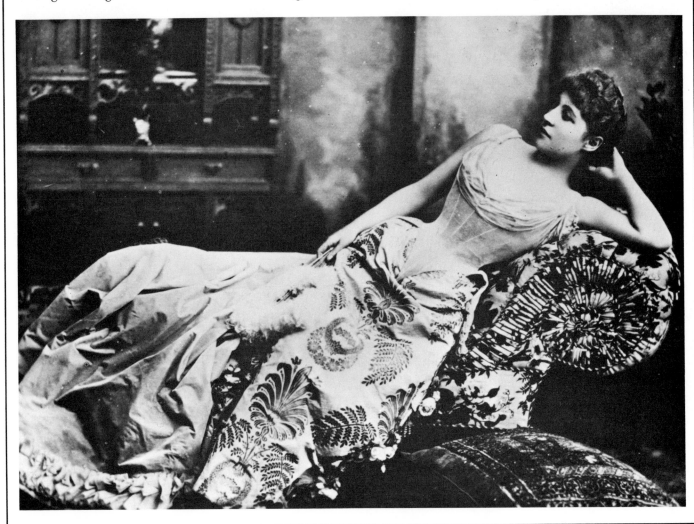

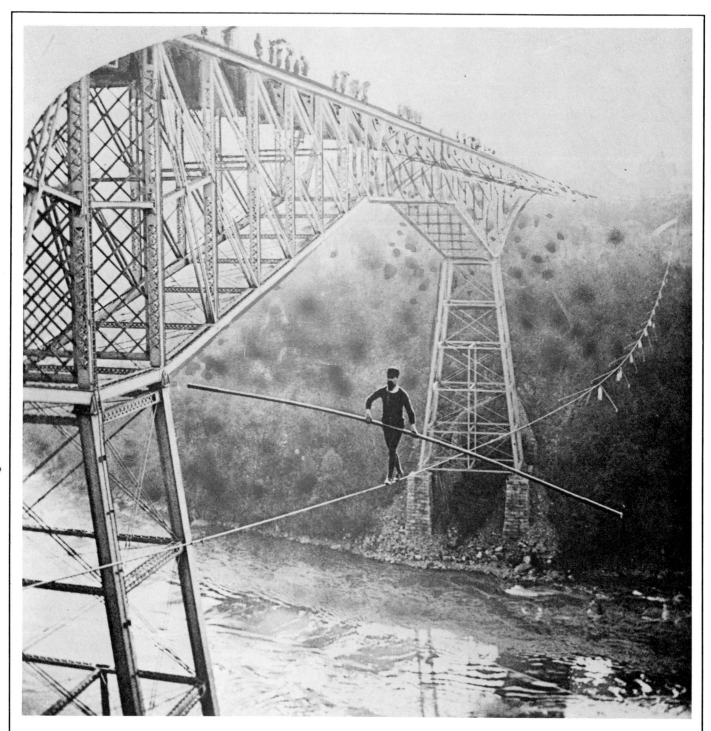

24

DIXON CROSSING NIAGARA

1890

Niagara Falls was in its heyday near the turn of the century—and honeymooners weren't the only visitors to the resort area. Southerners, escaping the heat, came, New York City high society shifted its social life to the Falls, and stuntmen came with the crowds and attracted more crowds.

Crossing the Niagara River just above the Falls

became a favorite stunt, and of the ten or so to cross, only Samuel John Dixon of Toronto made it across twice. He is shown here crossing on a ¾-inch cable, which had been laid by another crosser, Steve Peere, for a fatal nighttime-crossing attempt. The cable was smaller in diameter than many used and was hard and slippery. Aided by a balance pole that was about 30 feet long, Dixon inched his way across the 1,300-foot span.

ALEXANDER GRAHAM BELL'S TELEPHONE
1892

The Scottish-born Alexander Graham Bell made the first New York to Chicago telephone call in October 1892, surrounded by writers, editors, and telephone company executives. Bell's invention, originally introduced in 1876, was looked upon with doubt at first. Western Union refused to buy the machine, a decision they would later deeply regret. Bell went on to other inventions—the iron lung, the audiometer, airplane controls—but none equaled his talking machine in significance.

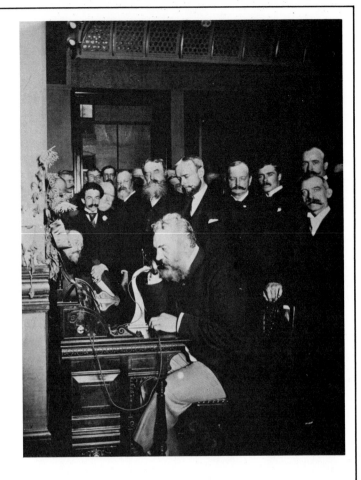

25

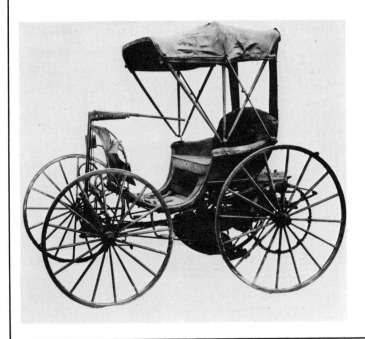

THE DURYEA AUTO
1893

Two brothers, Charles Edgar and J. Frank Duryea, built and operated the first gasoline-powered automobile in the United States, in Springfield, Massachusetts. That early car led to the development of the spray carburetor, the perfection of internal combustion autos in the U.S., and a first-place finish in the first auto race held in this country—Chicago, 1895.

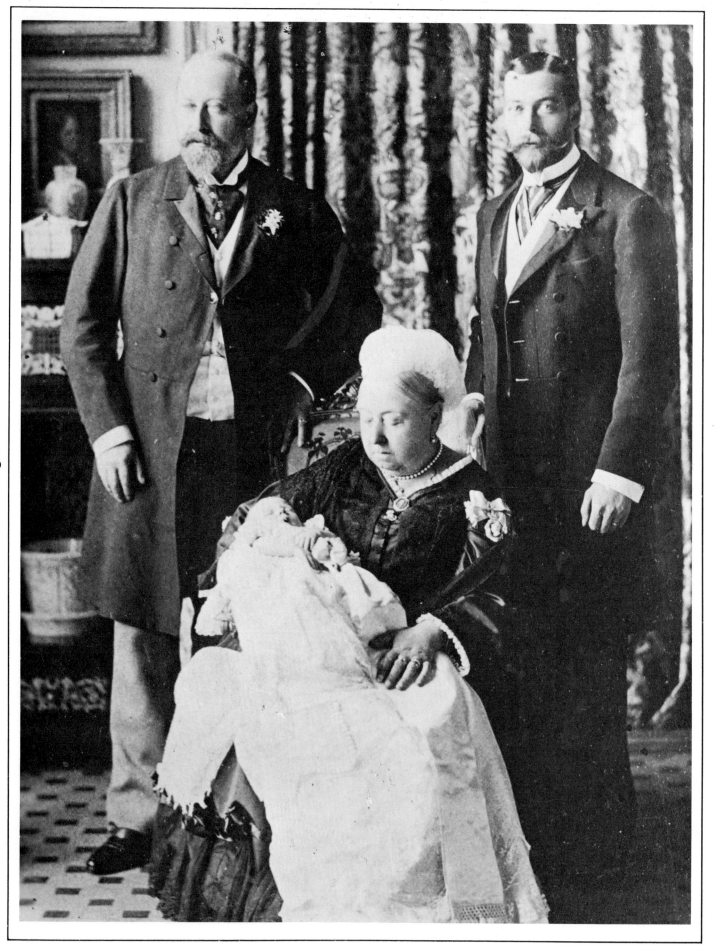

26

THE ROYAL FAMILY

ca. 1893

A rare glimpse of British history is afforded in this portrait of one hundred years of royal succession. The dour Queen Victoria, who came to the throne in 1837, cradles her great-grandson, who reigned briefly as King Edward VIII in 1936 before he abdicated to marry Mrs. Wallis Simpson. Victoria's oldest son, "Bertie," who reigned as King Edward VII after her death in 1901 until his own death in 1910, stands to her right. His son, who reigned as King George V from 1910 until 1936, stands to Victoria's left.

GERONIMO

ca. 1893

After leading one of the last big Indian uprisings, the legendary Apache Indian leader Geronimo was captured several times, only to escape or be returned to the reservation. Finally, after serving time in prisons in Florida and Alabama, Geronimo was permitted to settle in Fort Sill, Oklahoma, where he turned to farming.

He soon adopted Christianity and became a national celebrity when he appeared at the St. Louis World's Fair and at Teddy Roosevelt's inauguration. His original name was Goyathlay, "one who yawns," but the Mexicans gave him the name Geronimo, Spanish for Jerome.

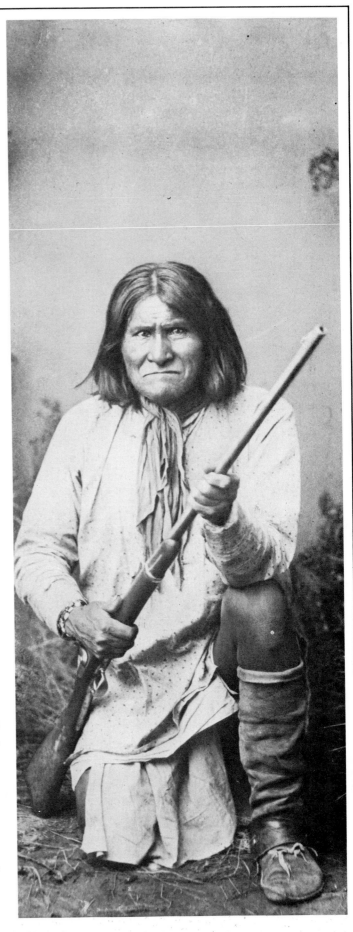

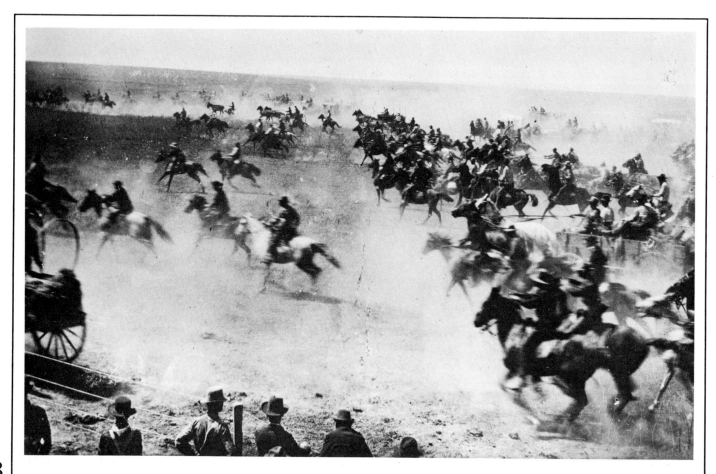

OKLAHOMA LAND RUSH
September 16, 1893

Most land rushes in the 1880s were land-grabs by white settlers of the choicest of Indian lands. On September 16, 1893, there was a land rush of a different kind, when the Cherokee Outlet and the Pawnee and Tonkawa reservations were opened for settlement and ownership by individual Indians rather than, as was the usual custom, by entire tribes. It was first come, first served, and more than 50 thousand red men dashed from the starting line to stake a claim in the seven-million-acre tract.

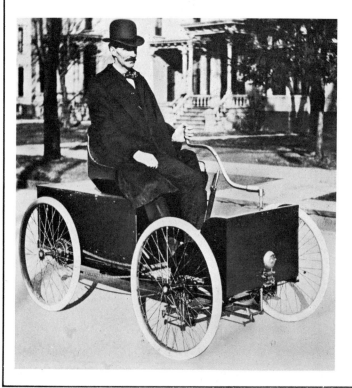

HENRY FORD
1896

Henry Ford shows off his first automobile on Grand Boulevard in Detroit in September 1896. A crude prototype of his Model T, this car had bicycle wheels, a steering tiller, and a wooden box for a body. The auto, which is now on exhibit in Dearborn, Michigan, still runs.

THE KLONDIKE GOLD RUSH

1897–1898

Again, gold had been discovered in an unsettled area of North America—the Klondike region of the Yukon, next door to the territory of Alaska. Thousands traveled to the gold fields, this time by ship to Alaska, then overland to the Klondike.

As the stories of great fortunes spread, the number of prospectors increased. But many never reached the Klondike, stopping instead to develop mining claims in Alaska. Gold was soon discovered at Nome and Fairbanks, but Alaska was no California. Although the gold brought many settlers, many others found they couldn't eke out a living in the wild, hostile land. Some perished from disease; others just packed up and went home.

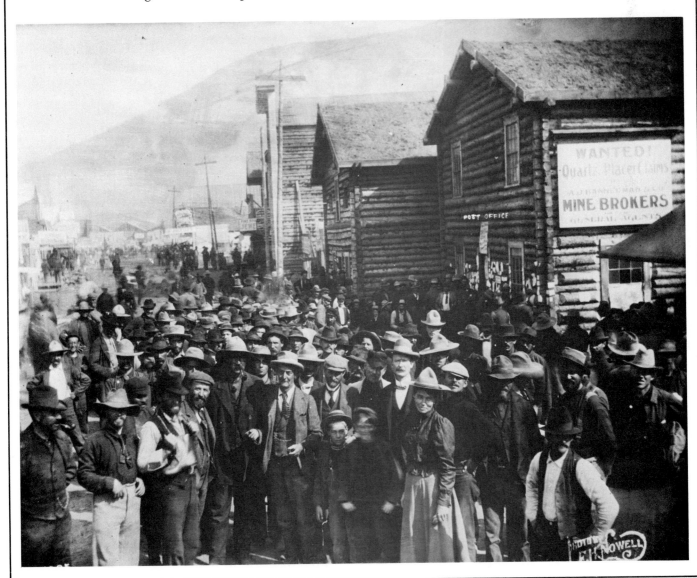

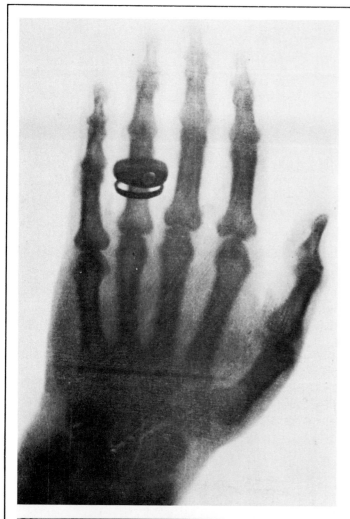

DISCOVERY OF THE X RAY
1898

The shadowy, skeleton-like figure in this photograph is Wilhelm Roentgen, the German physics professor who discovered the X ray.

Roentgen was doing routine experiments with a cathode-ray tube when he noticed that it glowed strangely when an electric current was passed through it. Roentgen also noticed that the tube, even when encased in a black box, made a nearby flourescent screen glow, and that when he placed objects between the box and the screen, some objects produced shadows, like the bones in his hand; other substances were passed through by the mysterious rays, like the flesh and tissue in his hand. The "X" (for unknown) ray immediately captured and held the imagination of the scientific community as well as the rest of the world.

MADAME CURIE
1898

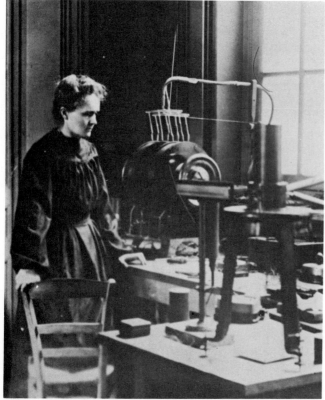

Marie Curie, shown here in her laboratory, was the recipient of two Nobel prizes for her work with radioactivity—one shared with her husband, Pierre, in 1903, and another in 1911 for her work alone.

She was a Polish woman who had come to Paris to study in 1891. She met her husband there, and the two began their lifetime of work together. The Curies are credited with having discovered and isolated radium and polonium, two highly radioactive substances. Madame Curie died in 1934 of leukemia, which may have been caused by excessive exposure to radiation.

SINKING OF THE *MAINE*
1898

The battle cry of the Spanish-American War, "Remember the *Maine*," could hardly be forgotten, thanks to the newspapers of the era. At a time when cutthroat newspaper competition and yellow journalism flourished, the U.S. battleship *Maine* exploded (killing 260 men) and was destroyed, under somewhat mysterious circumstances. One navy report

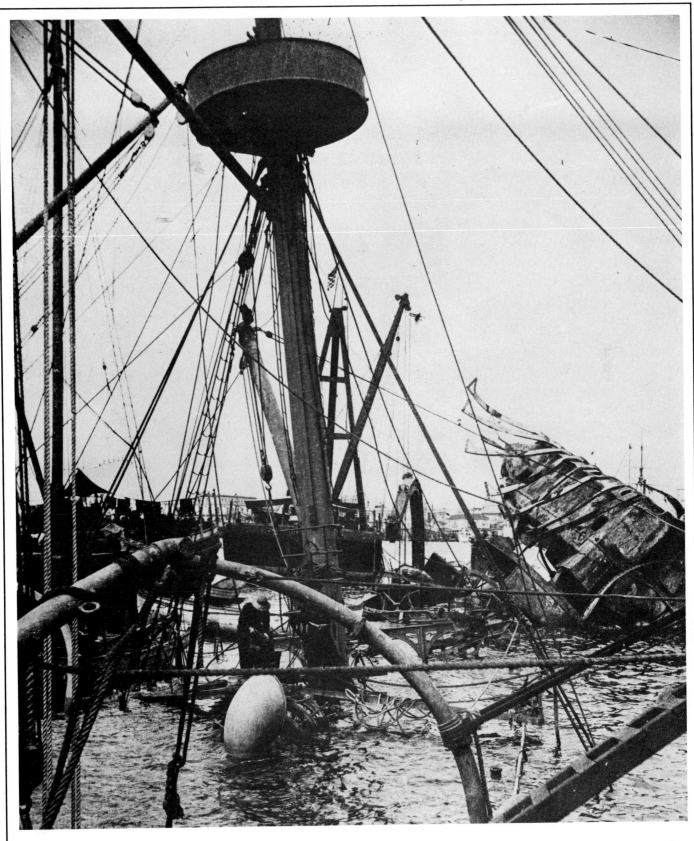

concluded that the ship was sunk by an enemy submarine mine, but the Spanish naval inquiry decided that the accident resulted from an explosion in the forward magazine. Whichever version was true had little effect on the actual outcome—the nation took it belligerently and responded.

Here, the wreckage sits in Havana harbor after the February 15, 1898, event.

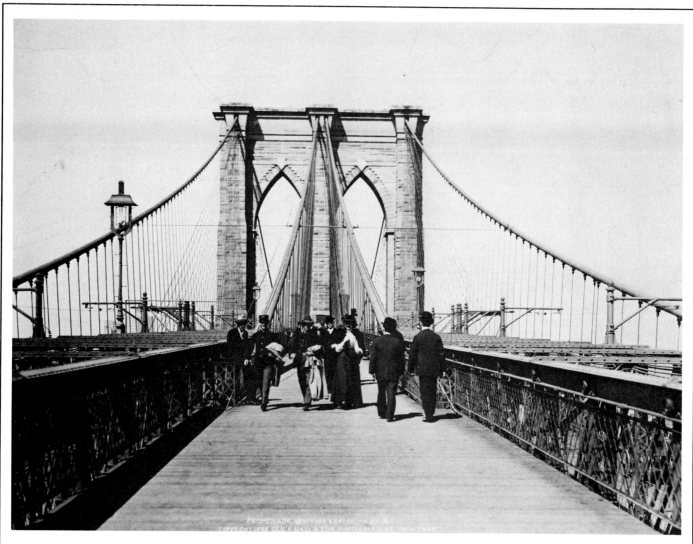

BROOKLYN BRIDGE

1898

The first steel wire suspension bridge in the world was also the world's longest suspension bridge. The Brooklyn Bridge, spanning New York's East River between lower Manhattan and Brooklyn, was begun in 1869 and finished in 1883. In that span of time, the bridge was to claim the life of one of its builders, John Roebling, and the health of another, Roebling's son, Washington. When a properly appreciative New York gathered to celebrate its opening in 1883, one speaker commented, "Peace hath its victories, and it has its victims and its martyrs too."

MARK TWAIN

ca. 1900

The wry and wise Samuel Clemens was known to most of the world's children as Mark Twain, creator of Huck Finn and Tom Sawyer. His irreverent wit ("I believe our heavenly Father invented me because he was disappointed in the monkey," and "Familiarity breeds contempt—and children") won the admiration of future generations, and he is regarded as one of the first truly American writers—in spirit, language, and subject matter.

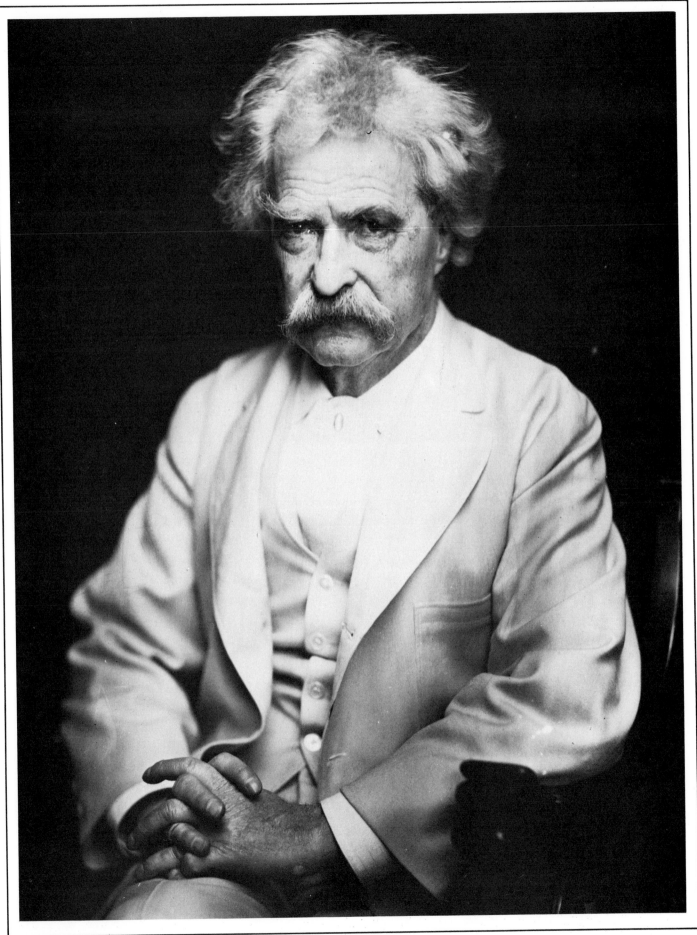

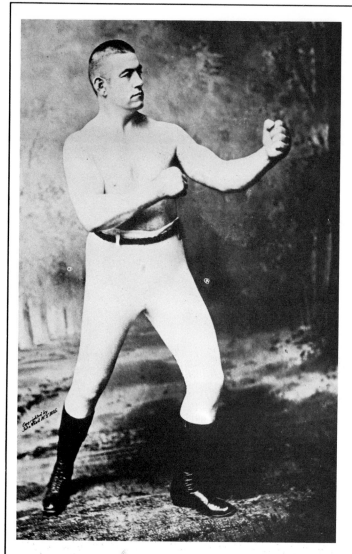

JOHN L. SULLIVAN
ca. 1900

The last of the bare-knuckled boxers first won his title in 1882 from another Irishman, Paddy Ryan, in a nine-round contest in Mississippi. But John L. Sullivan's most famous fight was the one with Jake Kilrain. In the last bare-knuckled professional fight ever, on July 8, 1889, Sullivan knocked out Kilrain in the 75th round—after 2 hours, 16 minutes.

After he retired from the ring, Sullivan joined a theatrical troupe and fought (with gloves) as part of the show. Later he traveled around the country fighting anyone who would take him on—first offering $100, and later in his tours $500, to anyone who could last four rounds with him. Those bouts are credited with having made boxing popular, and it was legalized in many states that had previously banned the sport.

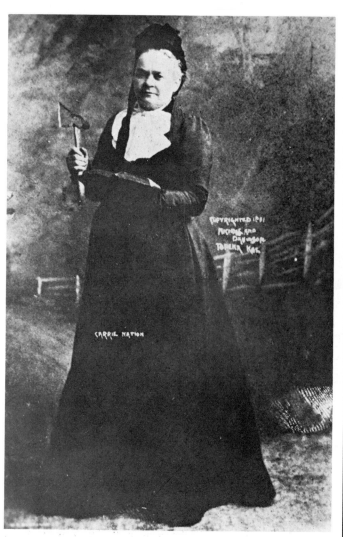

34

CARRY NATION
ca. 1900

With a Bible in one hand and a hatchet in the other, Carry Nation (1846–1911) set forth to dry out America and enforce the scriptures. Almost six feet tall, she cut a powerful figure, speaking before crowds and destroying saloons in the Kansas cities where she concentrated her temperance campaign.

Nation had learned of the evils of alcohol first-hand; her first husband became a hopeless alcoholic and died after they had been married barely two years. She became convinced that it was God's will for her to destroy all saloons.

She was arrested thirty times and was attacked and beaten more often than that. However, her campaign did focus public attention on the Prohibition issue, which culminated in 1920 with the Eighteenth Amendment.

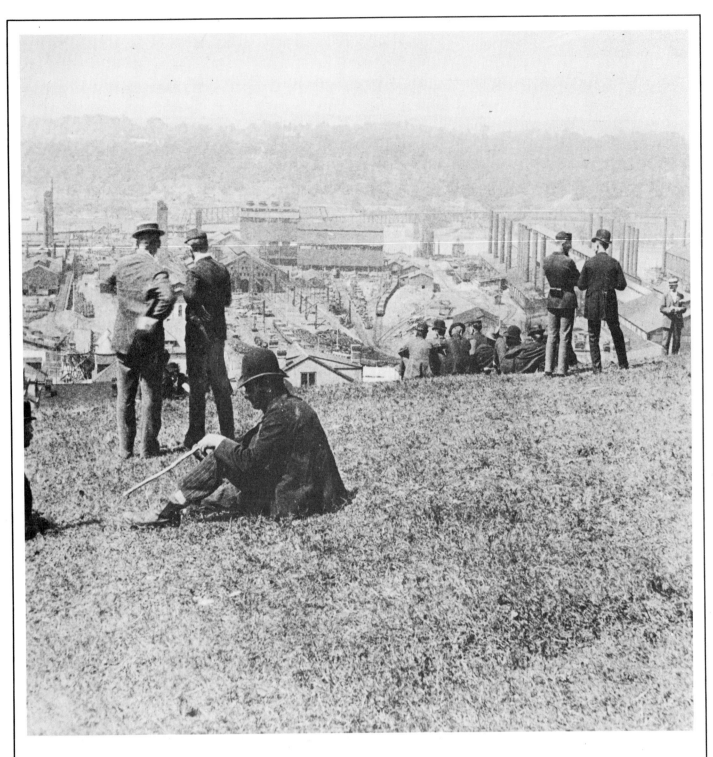

HOMESTEAD STRIKE

1901

It was a black mark in labor history. On June 29, 1892, union workers at the Carnegie Steel Company in Homestead, Pennsylvania, went on strike to protest a proposed wage cut. The company's general manager, Henry Frick, hired Pinkerton guards to protect the facilities and the strikebreakers he brought in. On July 6, several men were wounded and killed during a battle that broke out. The governor of the state called out the militia; the plant stayed open and the strike was broken, as was the union.

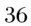

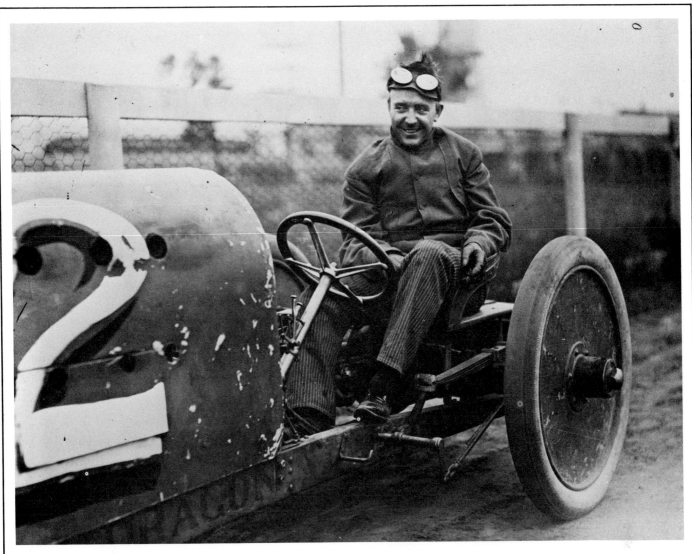

THE FLATIRON BUILDING UNDER CONSTRUCTION

1901

The site was a triangular, pie-shaped slice of land. Therefore the architects and contractors built the building to fit the land, and in the process fashioned an extraordinary building. From the beginning, the office building was seldom known by its proper name—the Fuller Building. Instead, it took its name from the item it most resembled—a flatiron. The building attracted much attention, as noted in the *New York Tribune Illustrated Supplement:* "Since the removal last week of the scaffolding . . . there is scarcely an hour when a staring wayfarer doesn't by his example collect a big crowd of other staring people. . . . No wonder people stare! A building 307 feet high presenting an edge as sharp as the bow of a ship . . . is well worth looking at."

BARNEY OLDFIELD

ca. 1903

The great Barney Oldfield, probably the best-known American automobile racer of the early part of the century, first won the national crown in 1903. But when the Indianapolis 500 was instituted in 1911, Oldfield was forced to sit the race out. He was enduring his fourth "lifetime" suspension from the American Automobile Association, levied for racing on outlaw tracks, and "against horses, other animals, and airplanes." Luckily, Oldfield was back in the running in 1914, where he came from last place (the spot he drew for a starting position the night before the race) to a very respectable fifth-place finish.

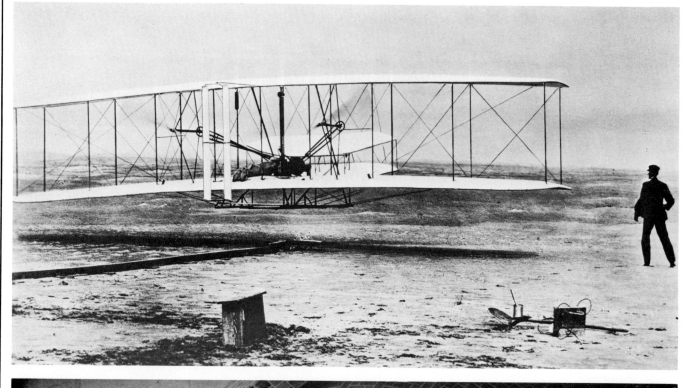

38

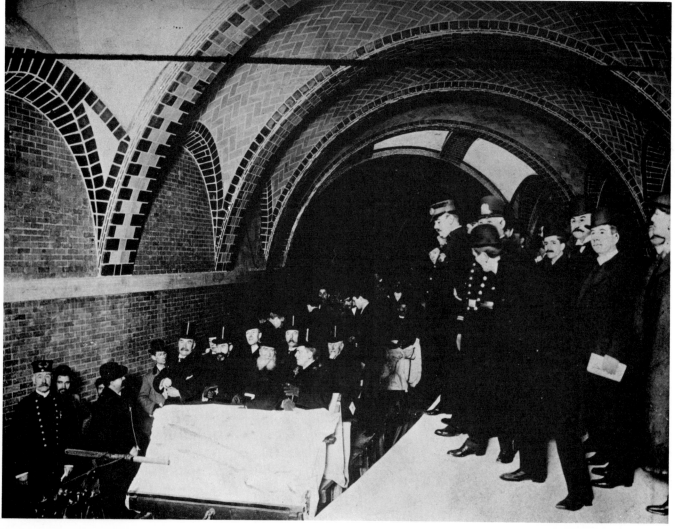

KITTY HAWK
December 17, 1903

The dream of the ages was realized in a coastal North Carolina town. Orville and Wilbur Wright, assisted by five men on a cold and blustery winter day, launched the *Flyer*, their heavier-than-air flying contraption.

Four historic flights were made that day—here, Orville is strapped to the harness that was the pilot's only seat. Wilbur, running alongside the *Flyer*, has just released the wing, after holding it steady. The Wrights, in anticipation of the historic event, had asked one of their assistants, John Daniels, a lifeguard at the nearby Kill Devil Hill Life Saving Station, to stand by and snap a picture if their machine should fly. Daniels, positioned at the end of the runway, did just that as the *Flyer* raised off the ground for its maiden flight, a journey of 120 feet that lasted for about twelve seconds.

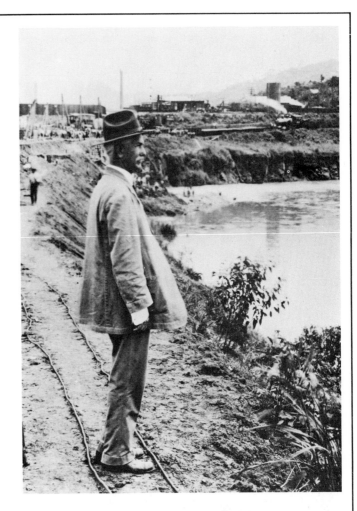

NEW YORK SUBWAY
October 27, 1904

As early as the turn of the century, space in Manhattan was at a premium. The obvious solution was to go underground, and so, in 1904, the first city subway opened. It was a crude version of its descendant—a twenty-five-foot wide rectangular tunnel that ran from near the Brooklyn Bridge, through Grand Central Station and Times Square, and up to 145th Street. Here, at the opening ceremonies, financier August Belmont, Mayor George McClellan (son of the Civil War general), and two other gentlemen share the front row. McClellan, to the surprise of all officials at the opening ceremonies, took his role very seriously. Belmont presented him with an ornamented silver controller as McClellan declared the subway open in the name of the people. McClellan then took the controller and began operating the train. He pulled it out of the station, and ignoring suggestions that perhaps a railway official should take over, ran it all the way to 103rd Street, where he generously yielded the controller.

GENERAL WILLIAM GORGAS
1904

The ambitious Panama Canal project had no more formidable foe than disease. Malaria and yellow fever debilitated many workers, and in 1904 William Gorgas, an American Army doctor who had been stricken with yellow fever and had become immune, permanently rid Havana of yellow fever. He was then sent to Panama. Practicing extensive mosquito control, Gorgas eliminated yellow fever from the Canal Zone by 1906 and the incidences of malaria were brought under control. Ten years after his assignment to Panama, he was awarded the rank of surgeon general and later rose to the rank of major general.

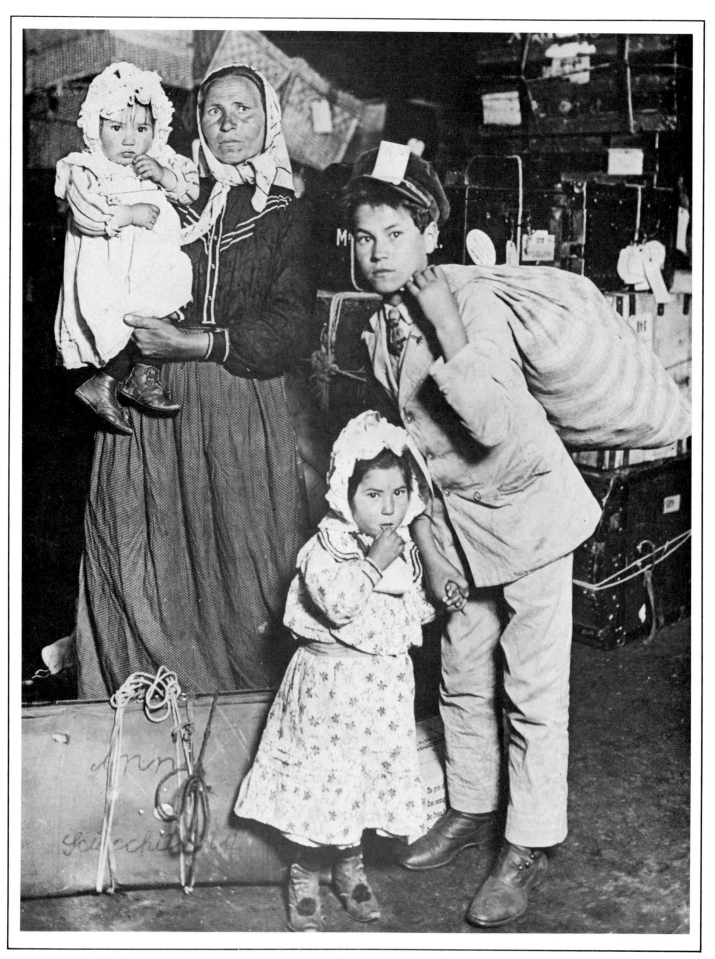

ELLIS ISLAND
1905

This Lewis Hine photograph, one of a series record-ing the influx of immigrants into America in the first decade of this century, reveals the odd batch of emotions welled up in those waiting to be processed at Ellis Island. Etched into the faces was fear (Would they be refused entry?), tension, hope, fa-tigue, and dignity. Here, an Italian mother and her three children look for luggage that has been lost on the long trip.

ALICE ROOSEVELT'S WEDDING
February 17, 1906

Her father Teddy, used to remark that he could ei-ther run the country or control his headstrong daughter Alice, but he couldn't be expected to do both. It was, then, with obvious pride and probably a little relief, that he gave Alice away in a glittering White House wedding to Congressman Nicholas Longworth of Ohio, who later became Speaker of the House of Representatives.

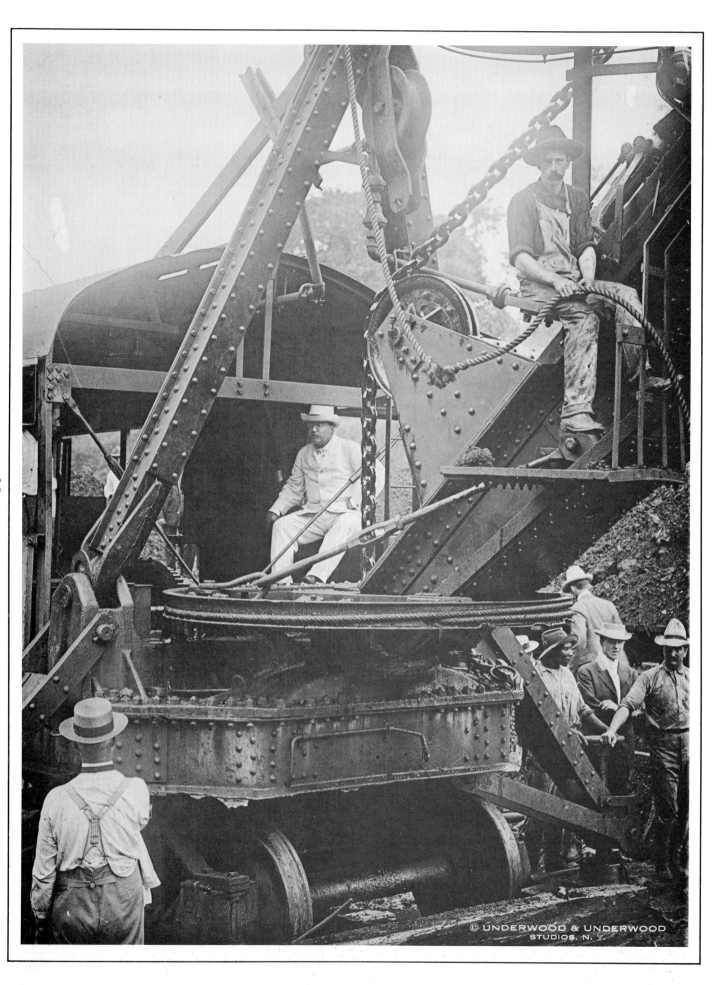

42

TEDDY ROOSEVELT
AT THE PANAMA CANAL

1906

The President went to inspect the job they were doing on the Panama Canal. "They were eating steadily into the mountain, cutting it down and down," he reported after surveying the site. Roosevelt later said he was more proud of the Panama Canal than of anything else he did during his administration.

His visit to the canal, where he is shown here cradled in the arm of a steam shovel, also marked the first time an American president visited a foreign country while in office.

SAN FRANCISCO EARTHQUAKE

April 18, 1906

San Francisco was a thriving city at the turn of the century. Aided by the gold rush and by its perfect location, the city had grown to almost 350,000 citizens. But on April 18, 1906, the city stopped. The earth shook, buildings were toppled, and the city's vital services were severed. The first shock, at 5:13 A.M., destroyed the water system, so that fires burned uncontrolled. There were more shocks that first day, and after two days, soldiers and firemen used dynamite to destroy blocks of the city to create firebreaks.

When the quake and fires were over, 497 blocks of buildings (4½ square miles) were destroyed and 700 people were dead.

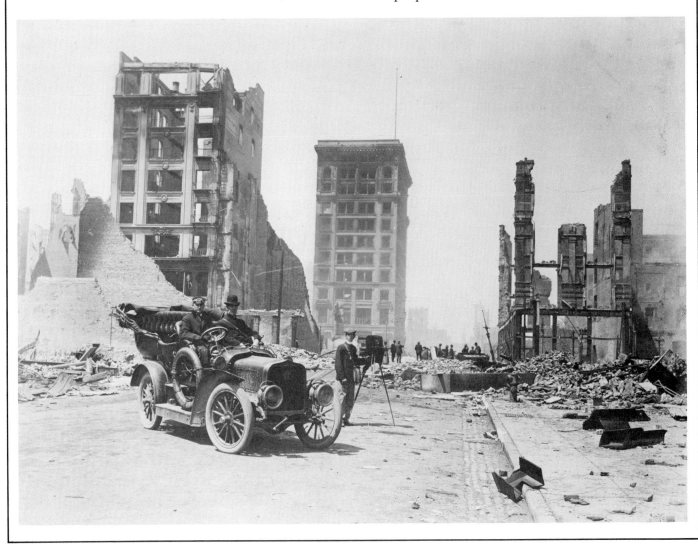

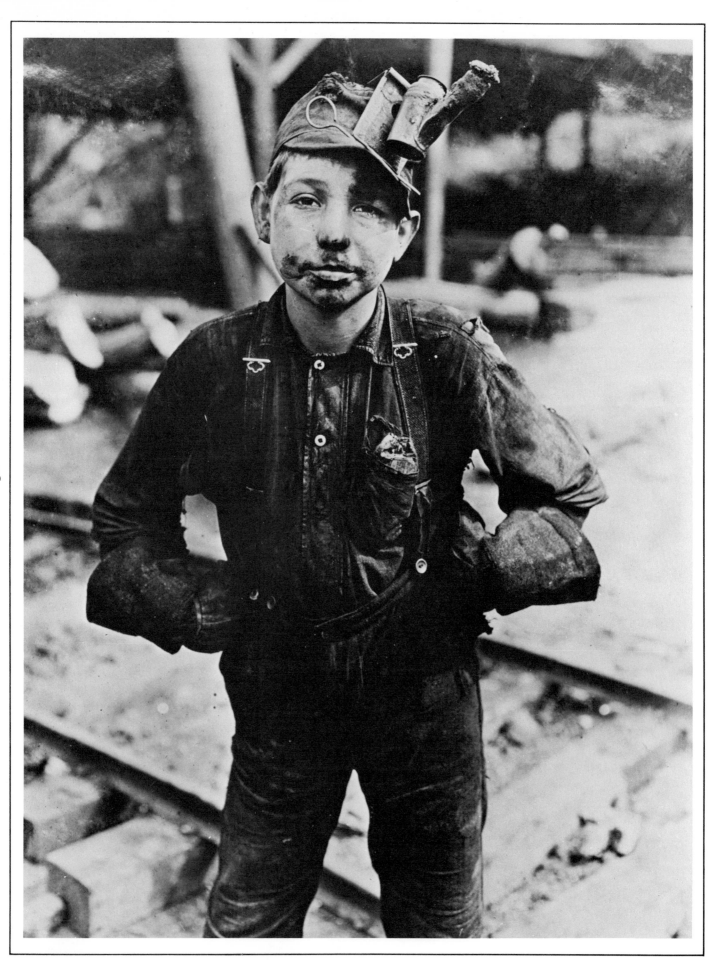

CHILD LABOR
1908

Some insist that the greatest masterpieces of Lewis Hine are his photos depicting child labor. Hine himself described what he did in a child labor bulletin, later reprinted in *America and Lewis Hine:* "For many years I have followed the procession of child workers winding through a thousand industrial communities from the canneries of Maine to the fields of Texas. I have heard their tragic stories, watched their cramped lives, and seen their fruitless struggles in the industrial game where the odds are all against them."

The impact of the images—factory settings surrounding unbelievably young faces—was powerful. Hine's photos were some of the most potent ammunition in the fight for the passage of child labor legislation.

ROBERT PEARY
1909

After two unsuccessful attempts, Robert Edwin Peary reached the North Pole, accompanied by a servant and four Eskimos, on April 6, 1909. Here Peary is shown after his return.

Although there was some dispute caused by a prior claim submitted by Dr. Frederick Cook, a man who had been the ship's surgeon on one of Peary's earlier explorations, Congress recognized Peary as discoverer in 1911.

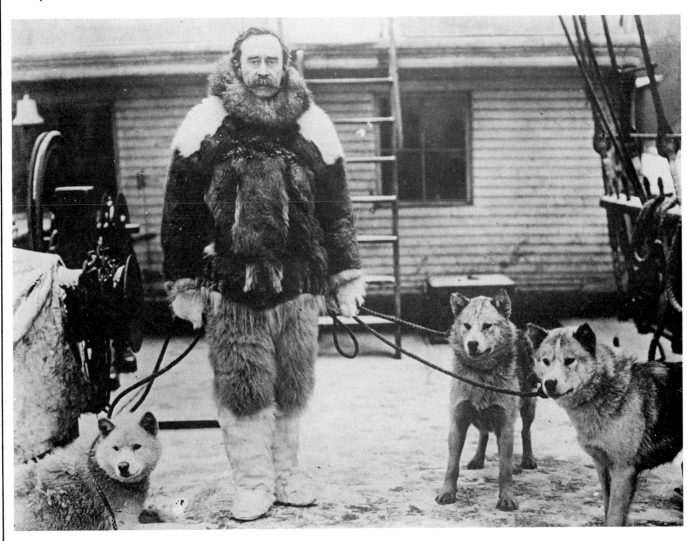

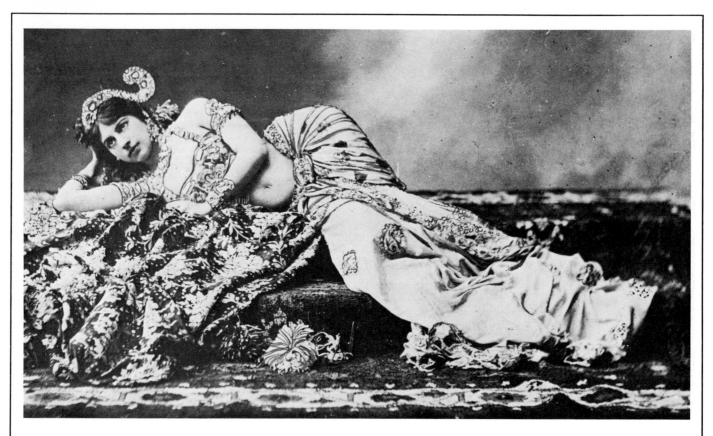

MATA HARI

ca. 1910

The sensuous Dutch woman who pretended to be a Javanese temple dancer was executed in 1917 for a different sort of pretending—Mata Hari was also a spy for the German secret service. Ultimately she was found out by the French, convicted of espionage, and killed by a firing squad on October 15, 1917. She was forty-one.

ATTEMPTED ASSASSINATION OF MAYOR GAYNOR

August 9, 1910

He was a relatively obscure mayor, but the photographs taken of the attempted assassination of New York Mayor William J. Gaynor have sealed his place in history. Gaynor was leaving on a European vacation, having just boarded the S.S. *Kaiser Wilhelm der Grosse,* and was chatting with reporters when a man approached him unnoticed. The would-be assassin, J. J. Gallagher, drew a pistol and fired it twice toward the mayor's head. It didn't go off the first time, but the second time the gun went off and a bullet struck Gaynor. William Warnecke, *New York World Telegram* photographer, took this photograph as Robert Marsh caught Gaynor and tried to steady him. The gunman, Gallagher, was overpowered by policemen and city officials.

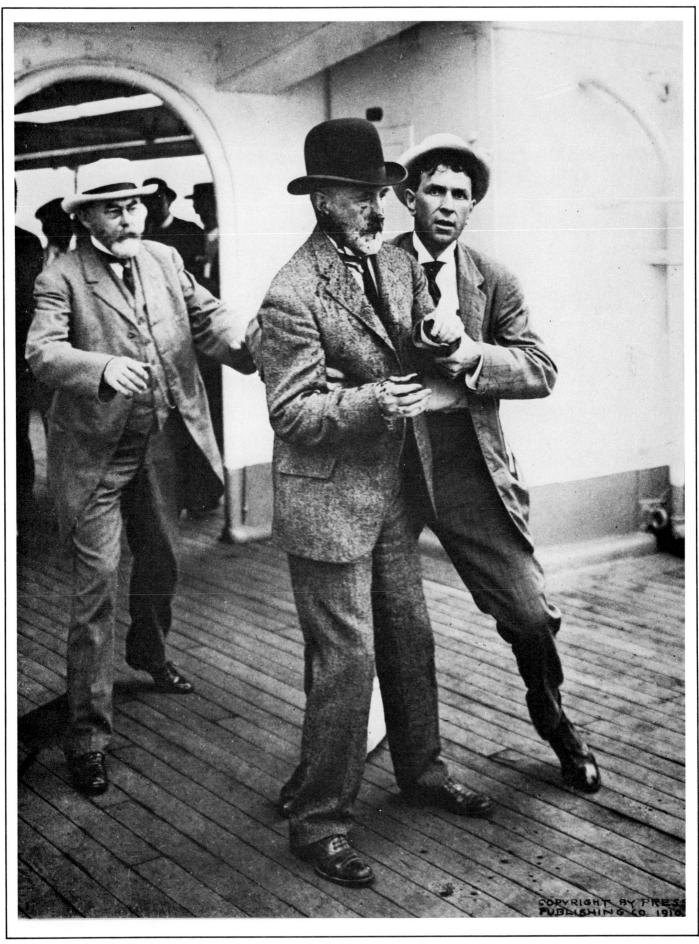

47

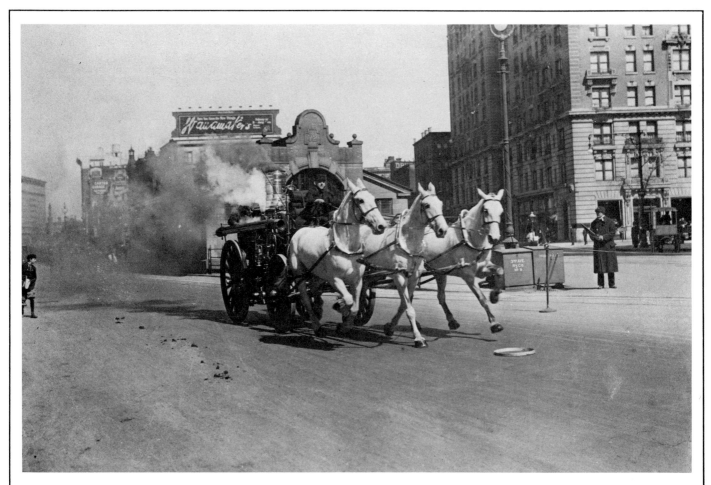

HORSE-DRAWN FIRE ENGINE
1910

The old, hand-pulled fire engines, which originated at a time when a community had to unite to fight a fire, were gradually replaced by horse-drawn engines that carried professional firemen. Here, responding to a New York City alarm, a fire-fighter and his three-horsepower engine race to a blaze past Broadway and 72nd Street.

NEW YORK'S TRIANGLE SHIRTWAIST FACTORY FIRE
March 25, 1911

Most of the damage was done in a mere twenty minutes or so, late one Saturday afternoon, just around quitting time. The Triangle Shirtwaist Factory in New York City, employing hundreds of young women who labored at sewing machines, was a lethal firetrap, with the factory's fabric fueling the fire. It began in a bin of waste fabric that had burst into flames. The screams of nearby workers alerted everyone of the fire and panic set in.

The few escape routes—an elevator that held less than twenty people, and stairways less than a yard wide—were quickly clogged as young women rushed to get out. More than sixty terrified workers jumped to their death in an attempt to escape the fire. A few people, including the owners of the factory, escaped up to the roof, but 145 lives were lost. The resultant investigation did not pinpoint blame, but public outcry led to stronger safety regulations and the growth of the International Ladies Garment Workers Union, soon to become an influential force in the garment business.

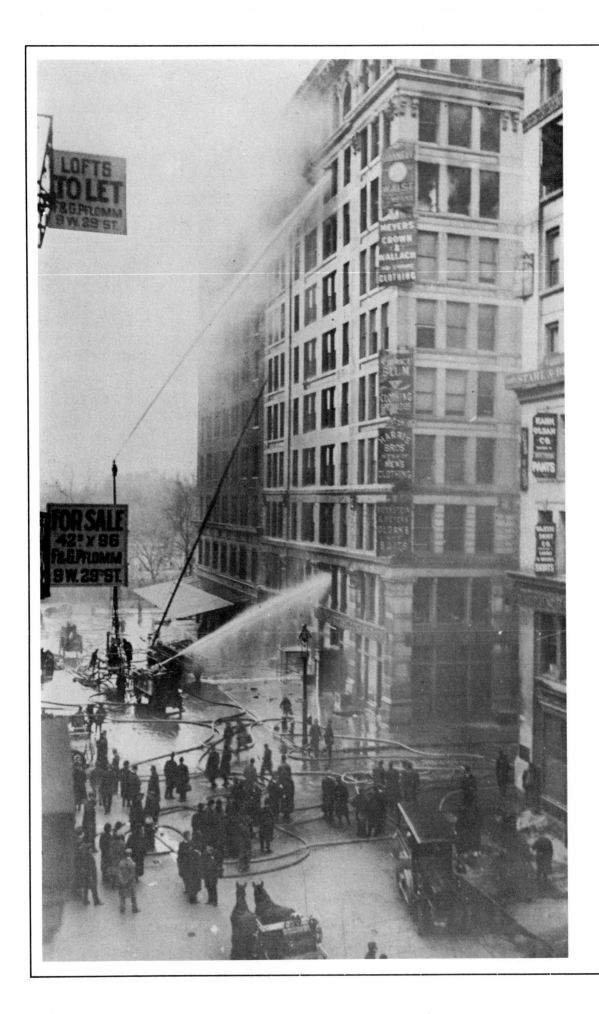

FIRST INDY 500

1911

The most famous of all American auto races had a humble beginning in Indianapolis in 1909, when a group of automobile manufacturers built a dirt track on which to test their cars. The testing course was converted into a speedway for racing within two years, and in 1911, on Memorial Day, the first Indianapolis 500 was held. The winner, Ray Harroun, drove a Marmon Wasp at an average speed of 74.59 miles per hour.

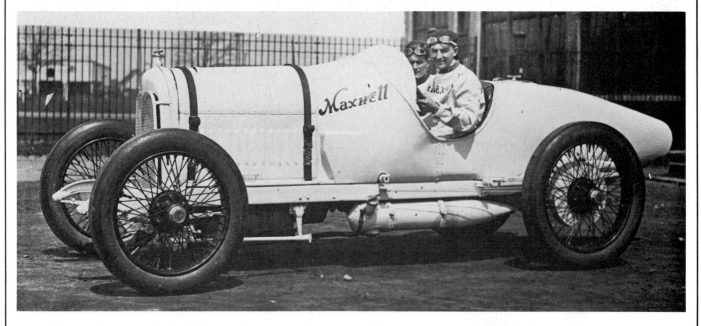

EDDIE RICKENBACKER

ca. 1912

Although Eddie Rickenbacker is best remembered as America's most famous flying ace in World War I, he was also a smashing success as a racecar driver.

After the war, Rickenbacker combined his two interests: he owned the Indianapolis Speedway for eighteen years and was active in automobile racing; he then became the president of Eastern Airlines in 1938, a position he held for twenty-one years.

PANCHO VILLA AND GENERAL PERSHING

August 26, 1914

Mexican generals Alvaro Obregon (left) and Pancho Villa (middle) posed with American general John Pershing at the "border talks" to which Pershing had invited them. Pershing, trying his hand at diplomacy, was also trying to impress upon the Mexicans the ability and willingness of the United States to protect American people and property south of the border. Obregon, Pershing thought, was a "sincere and able patriot," but he had a different impression altogether of Pancho Villa. "He was taciturn and restless, his eyes were shifty, his attitude one of suspicion," Pershing said later.

Their paths would come close to crossing again. In 1916, Pershing was sent out to hunt for Villa, after Villa had led a grisly attack on a town in New Mexico. Pershing led 4,000 men on the "punitive expedition," which was highly publicized but completely unsuccessful. Pershing went on to greater glory in World War I, while Villa was assassinated in 1923.

51

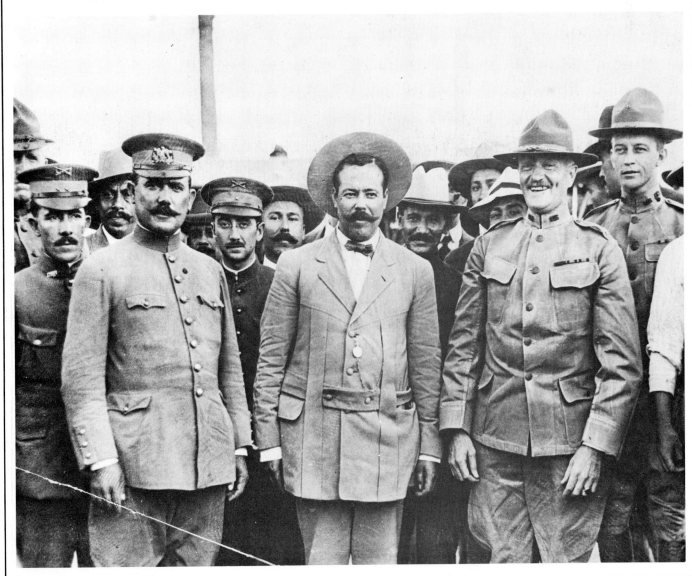

THE ASSEMBLY LINE
1914

Henry Ford believed that anyone, not just the fabulously wealthy, should be able to own a car—a belief that was both radical for the times and extremely shrewd. The assembly line was his means of holding down the price of his Model T. This photo shows one of the first Model Ts rolling off the line in Highland Park, Michigan.

52

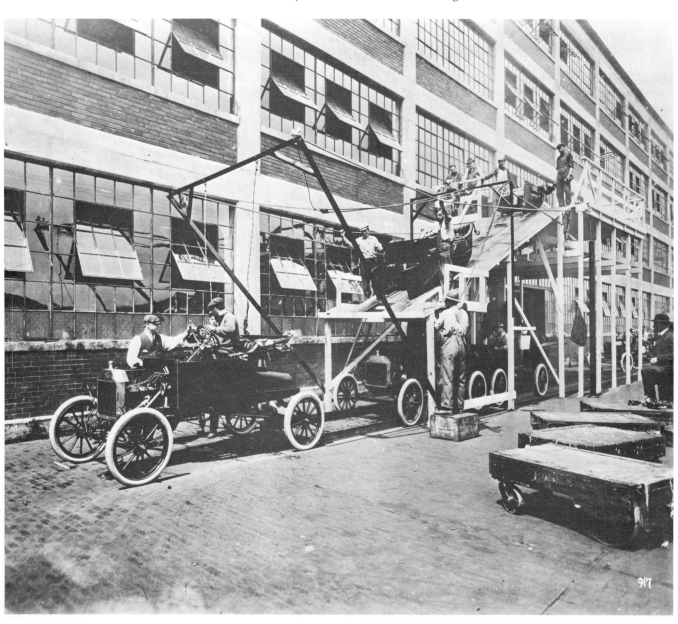

917

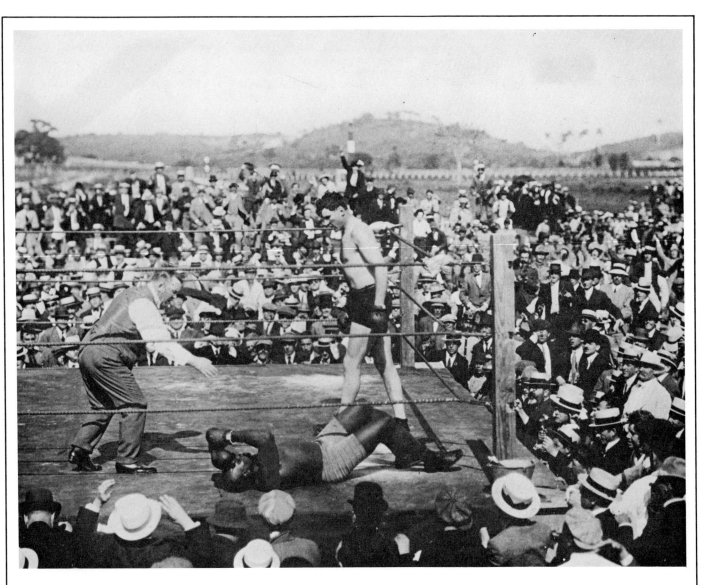

JESS WILLARD–
JACK JOHNSON FIGHT

April 5, 1915

After seven years as the reigning heavyweight champion, Jack Johnson met a new challenger in the ring—Jess Willard.

The challenger, weighing in at 230 pounds, pushed Johnson (slightly lighter at 205 pounds) through 26 rounds until finally, with a sharp jab, Johnson was knocked out before the Havana, Cuba, crowd.

Here, referee Jack Welch begins the count that will proclaim Willard the new champion.

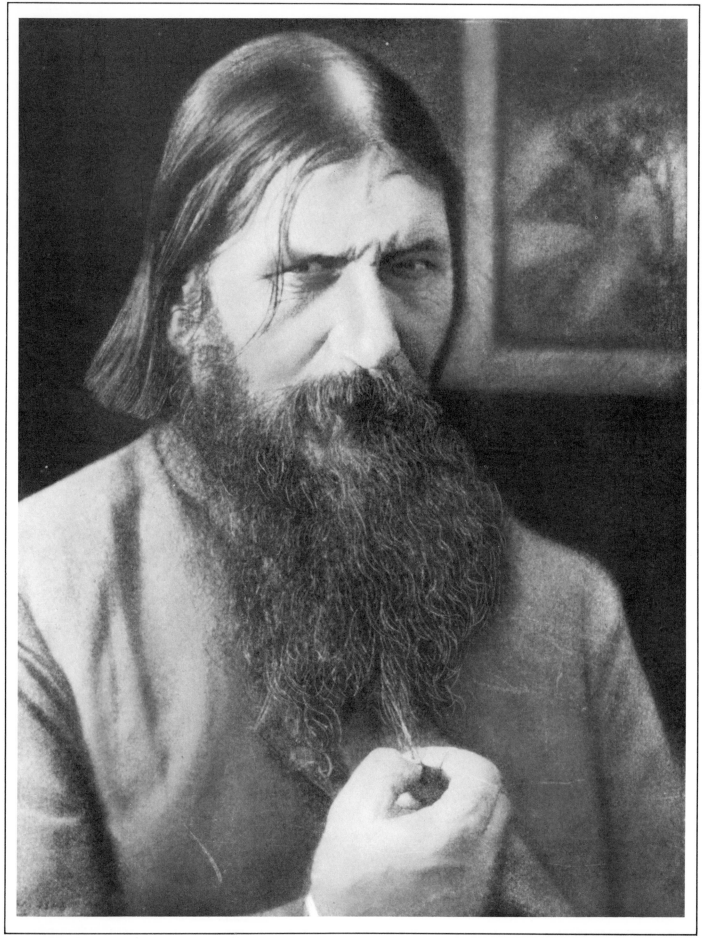

54

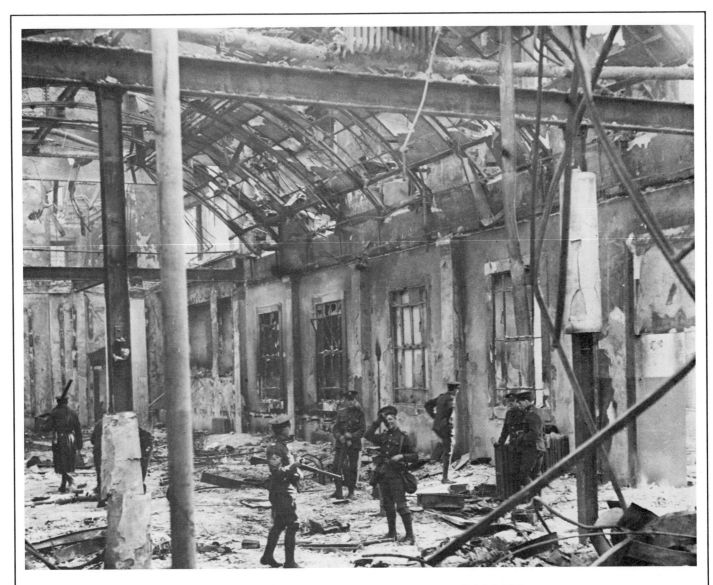

RASPUTIN
ca. 1915

Czarina Alexandra was convinced he was a holy man who had the power to heal and alleviate the pain of her son's hemophilia. Czar Nicholas believed him to be a "good, religious, simpleminded Russian." But most of the Russian people considered Grigori Efimovich Rasputin a mad monk who, by dubious means, had seized control of some of the most important posts in the Russian court. In 1916, a small group of petty aristocrats, including a distant cousin of the ruling Romanoffs, conspired to murder Rasputin. But he proved difficult to kill. Despite a massive dose of poison and two gunshot wounds, when his body was fished out of the Neva River it was found that he had died by drowning.

IRISH REBELLION
1916

An early chapter in the continuing battle between the British and the Irish in northern Ireland is shown here. The insurrection planned on Easter Sunday, 1916, by nationalist groups called the Irish Volunteers and the Citizen Army held out for six days against British troops. The aid that the Irish nationalists had been expecting from the Germans was intercepted, however, when the British stopped a German ship from delivering a shipment of arms to Ireland and captured one of the movement's leaders. Before they were forced to surrender, the revolutionaries still proclaimed a separate, independent Irish republic. Here, members of the English army are shown policing the interior of the bombed-out general post office in Dublin.

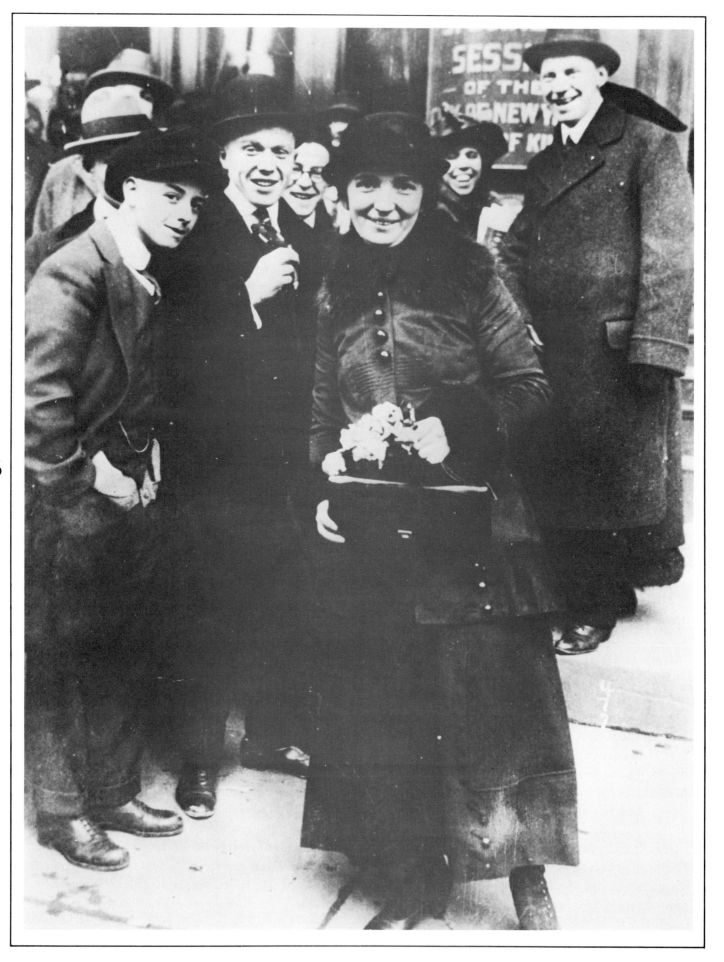

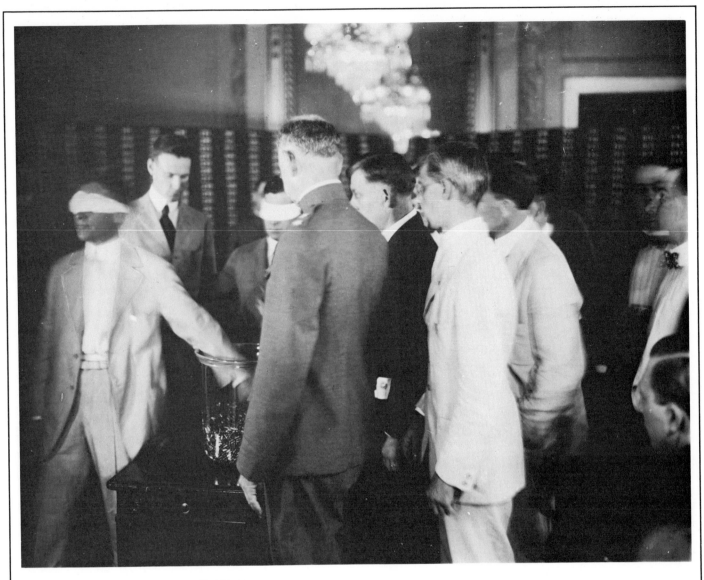

THE DRAFT, WORLD WAR I

1917

On May 19, 1917, the United States passed a selective service law to help raise an army. In a solemn ceremony, Secretary of War Newton Baker stood by as the first young men drew numbers from the goldfish bowl. Through the act, over 24 million men were registered for the draft; ultimately, almost 3 million were inducted.

MARGARET SANGER

June 4, 1917

Impressed as a young public health nurse with the burden a large family bore and the strain it put on women, Margaret Sanger became an early and ardent advocate of birth control. She is shown here just after her acquittal in 1916 for allegedly misusing the mails by sending out birth-control information.

She was arrested again later for operating a birth-control clinic in Brooklyn. Gradually, however, she began to win public approval for her programs. Sanger founded a clinic in New York City in 1923 that still operates today, lectured extensively, and visited many foreign countries to help them set up birth-control clinics.

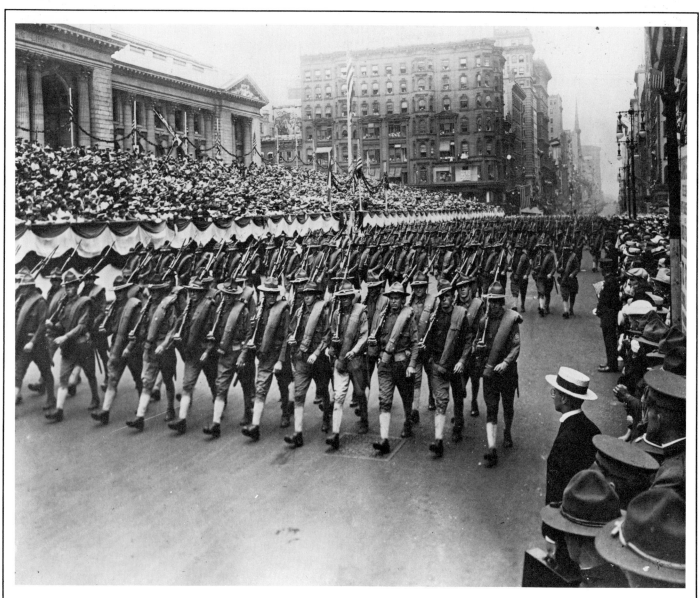

WORLD WAR I

1917

After the declaration of war on April 2, 1917, the nation saw its doughboys off to Europe to make the world safe for democracy. Here, troops march down Fifth Avenue in New York City, passing before the New York Public Library.

Despite the nation's marked unpreparedness for war (the army had only about 200,000 men and, until mid-1918, had to purchase most of its weapons and ammunition from the British and French), Americans threw themselves wholeheartedly into war bond drives, raising an army, and gearing up industry for war.

58

FIRST AIRMAIL SERVICE IN U.S.

May 15, 1918

It was, to be sure, an embarrassing way to begin regularly scheduled airmail service. On the first flight—a Washington, D.C., to Philadelphia to New York route—the plane started to take off only to come to a halt: someone had forgotten to fill the gas tank. Even after the pilot took off, there were problems—he got lost, was forced to make an emergency landing in Maryland, and never did make it to his destination.

Happily, the mail service got better, but the early flights were dangerous ones for the pilots. They didn't have radios, they had no reliable weather forecasts, and many of the navigational instruments that today are standard were nonexistent.

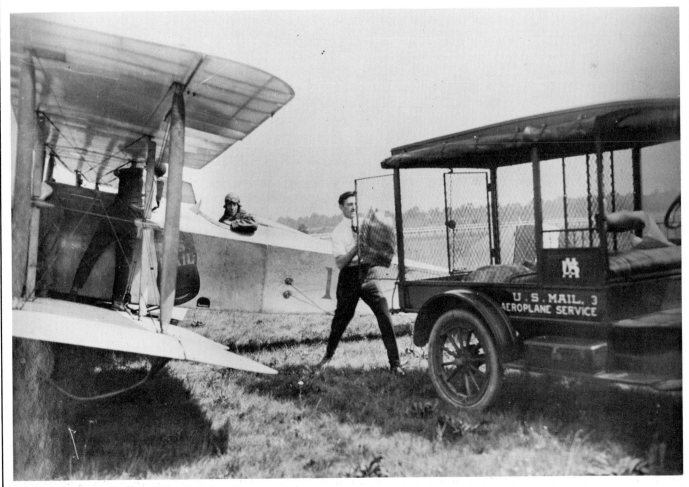

THE PARIS PEACE CONFERENCE
June 28, 1919

At the conference that took place as the War to End All Wars ended, Lloyd George represented England, Orlando came from Italy, Clemenceau from France, and Woodrow Wilson from the United States. They hammered out the Treaty of Versailles, in which France was awarded part of Alsace-Lorraine, reparation payments were demanded from Germany, and

Wilson was promised a League of Nations. But the treaty was destined for failure. The U.S. Senate, in an isolationist mood, refused to ratify it. Germany ignored the treaty after a few years, and in 1935 Hitler, disregarding the section of the treaty forbidding Germany to build up its arms, effectively annuled the whole treaty.

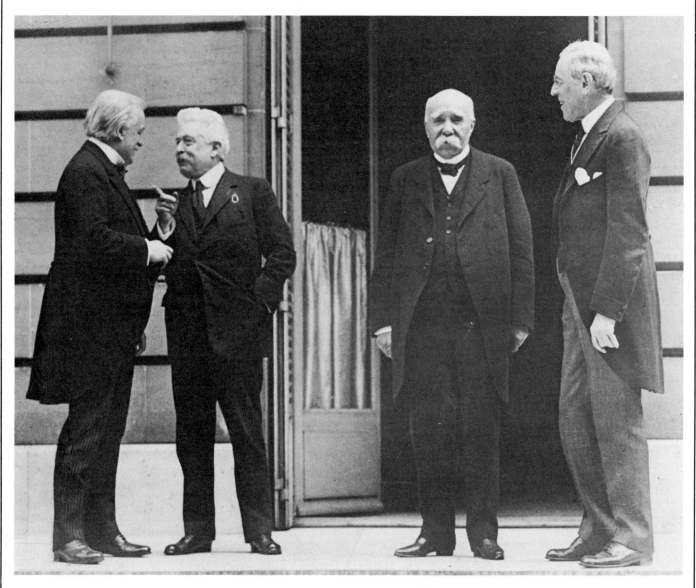

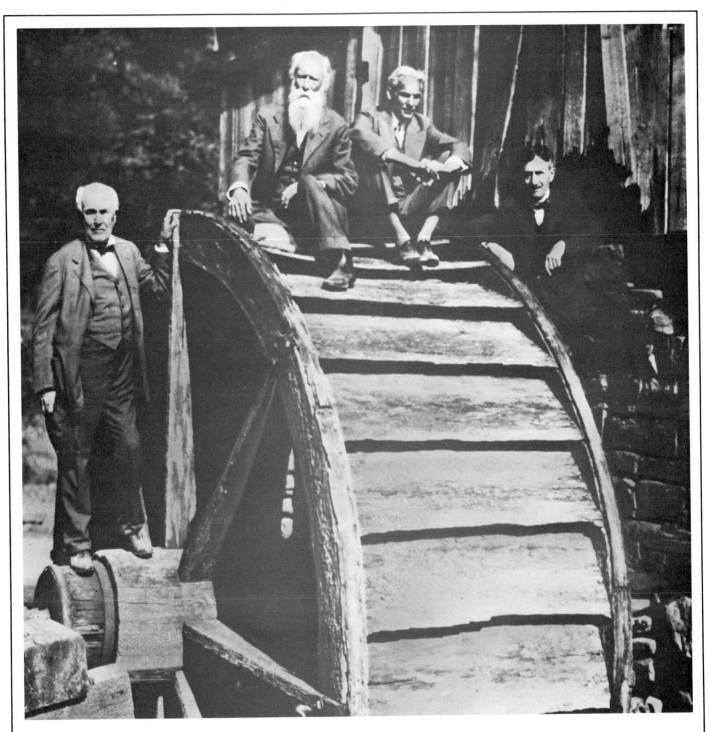

EDISON AND HIS FRIENDS
1919

Four famous friends—inventor Thomas Edison, Henry Ford, naturalist John Burroughs, and Harvey Firestone—pose here for an informal portrait. For years, the four went on elaborate camping trips together, roughing it in the woods of the eastern seaboard, accompanied (on one representative trip) only by a cook and five servants. A heavy truck carrying camping equipment, a refrigerator, and food were all part of their equipment. Together they would wander through small villages (Edison was a markedly poor navigator, famous for getting lost). They delighted in not being recognized, in new scenery, and in the great outdoors (not necessarily in that order). But with the freshly chilled food, the always available servants, and the carrying vans for camping supplies, the four brought a whole new dimension to the concept of camping.

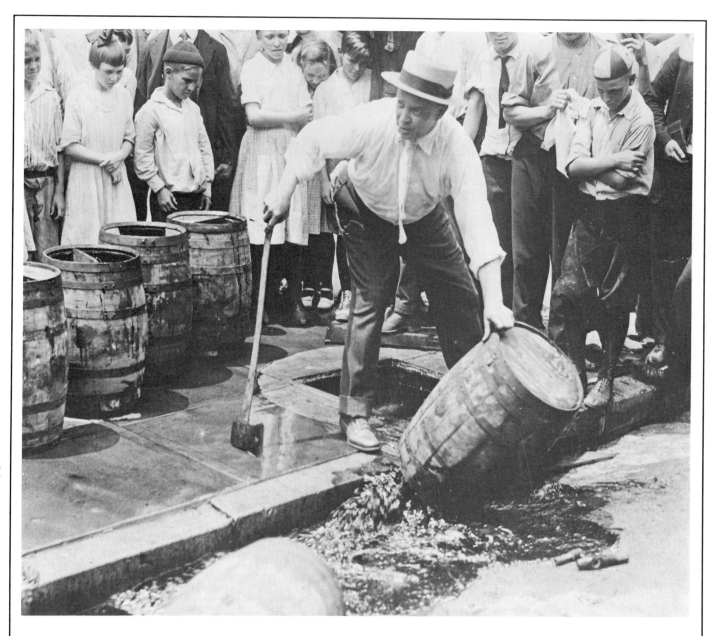

PROHIBITION
January 16, 1920

The Eighteenth Amendment was passed, and suddenly it was illegal to "manufacture, sell, barter, transport, import, export, deliver, furnish, or possess any intoxicating liquor except as authorized." Even though scenes such as this—federal agents dumping liquor—were not uncommon, consumption of alcohol actually increased during Prohibition. Never in the history of America has any law been so flagrantly violated, and in February 1933, Congress passed a repeal measure.

WOMEN'S SUFFRAGE
1920

In a photograph that has become a famous symbol of the women's movement, an unnamed suffragette marches tall and proud down Fifth Avenue in New York City. After a long battle, the suffragettes earned the right to vote in 1920.

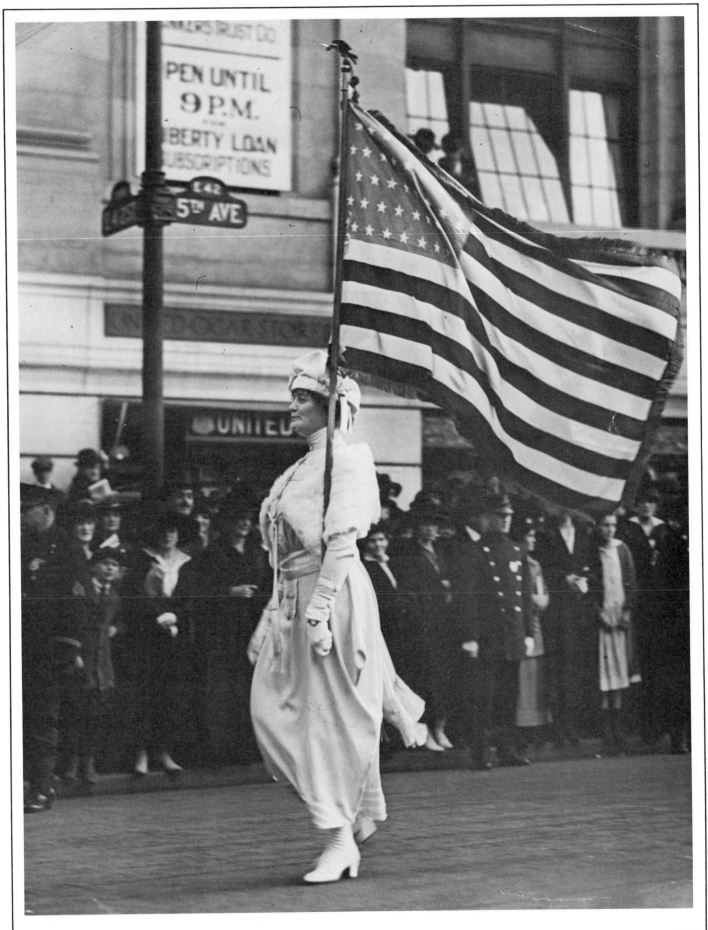

DAWN OF THE RADIO
November 2, 1920

Because several stations claim to be the first to broadcast, the beginning date of radio broadcasting is unclear. Generally accepted as the first radio broadcast, however, is the November 2, 1920, KDKA broadcast from Pittsburgh, Pennsylvania. The broadcast was timed to coincide with that year's presidential election as there were sure to be listeners interested in hearing election returns. The Harding-Cox returns were interspersed with live banjo music and musical recordings. The regular station audience grew quickly as there were few other signals crowding the air, and the station could be picked up from as far away as Canada. On November 7, 1921, KDKA became the first commercially licensed standard broadcast station.

PROHIBITION AGENTS
1921

Federal Prohibition agents like James Coppinger and Edward Kelly, pictured here with and without their disguises, were charged with the near-impossible task of enforcing the Prohibition laws. Besides disguising themselves in order to gain entrance to speakeasies, they were responsible for covering the coastline and outwitting smugglers, keeping a close eye on all of the industries that legally used alcohol in the production of certain goods, searching out home stills, and putting a stop to bootleggers. Added to these difficulties was the problem that the laws they were trying to enforce were highly unpopular with most people, and their task, to put it mildly, was herculean.

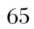

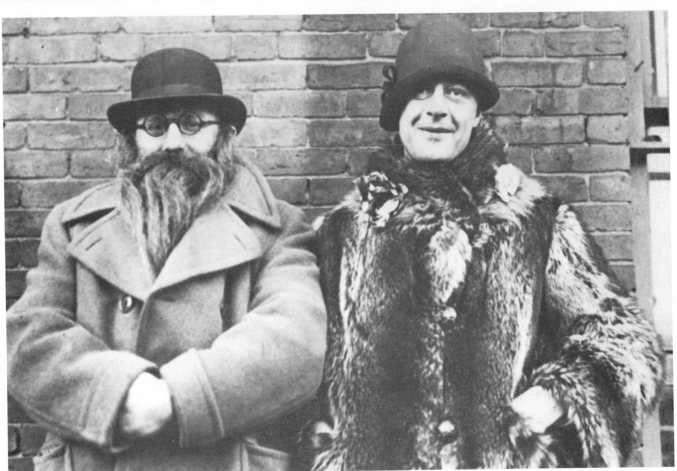

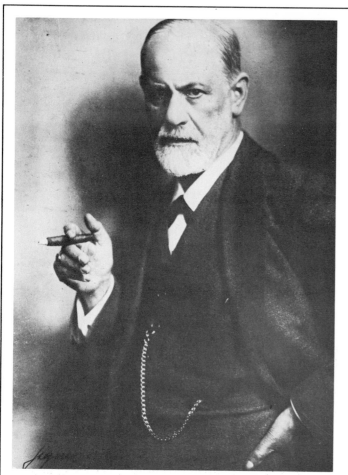

SIGMUND FREUD
1922

His intellectual journey was a trip through the human mind—as revealed in a patient's "rambling" free association, secret dreams, and recollections under hypnosis. Later, it led to the development of psychoanalysis and Freud's controversial ideas about sexual drive. Shown here in 1922, Freud has already made his name and theories world famous—and faced dissension from key disciples.

JOHN D. ROCKEFELLER
AT EIGHTY-THREE YEARS OLD
1922

From all accounts, the man who became one of the world's richest men lived to enjoy his wealth in his retirement years. He usually rose early and liked to walk barefoot in the grass. Then, according to a schedule from which he rarely deviated, he would breakfast, read the morning paper, and go through the mail with his secretary. At about ten he would set out to play nine or twelve holes of golf. His game was "remarkably steady," according to one biographer, and if a shot went badly he sometimes refused to count it and took another. To save his strength in later years, he bicycled between holes, and when he was yet older, he had the bicycle pushed by a caddy. Halfway through the course, malted milk was served. He is shown here at age eighty-three at his Ormond Beach, Florida, house, "The Casements." Rockefeller lived to be ninety-eight years old.

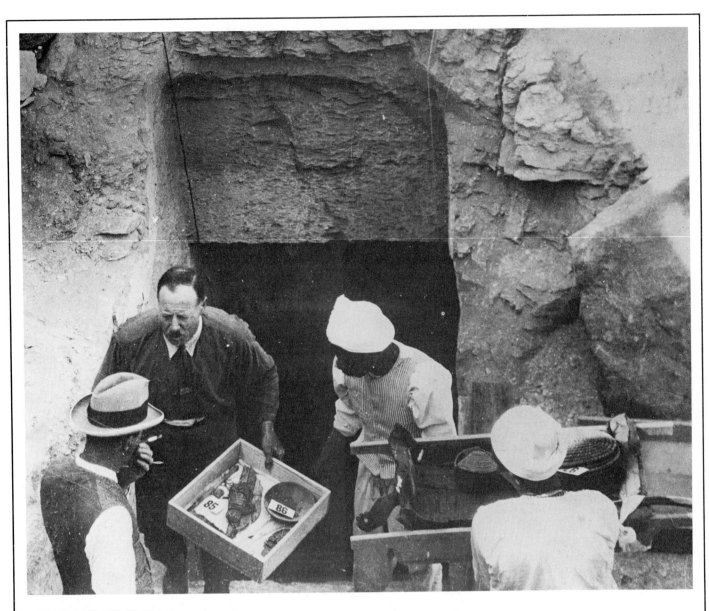

KING TUT'S TOMB

1922

British archaeologist Howard Carter was an expert in excavating Egyptian tombs, but none of his prior digs prepared him and Lord Carnarvon for the splendor and glory they saw in 1922, when they discovered the previously unopened tomb of the boy-king Tutankhamen. Carter is pictured here at the entrance to the tomb.

The king's death mask and inner coffin were of solid gold. There were several rooms filled with furniture and artifacts of incredible beauty. The discovery was hailed as one of the greatest archaeological finds of all time.

Tutankhamen, who died about 1357 B.C., became king when he was a child of eight or nine and reigned only about ten years. He is remembered chiefly for the treasure with which he was buried.

THE LEOPOLD-LOEB TRIAL
September 12, 1924

Nathan Leopold, Jr., and Richard Loeb, two nineteen-year-old college students, await their sentencing from Judge Caverly in Chicago. The two were accused (and convicted) of the brutal murder of fourteen-year-old Bobby Franks.

Their famed attorney, Clarence Darrow, never denied their guilt. Instead he etched out a new territory of legal defense based on the controversial theories of Sigmund Freud. Darrow argued that Leopold and Loeb were mentally disturbed and that society could not hold them responsible for their actions.

The court found them guilty on September 12, 1924. But instead of receiving the death sentence, Leopold and Loeb were sentenced to life imprisonment.

THE SCOPES TRIAL
July 1925

The famous "Monkey Trial" matched the two greatest attorneys of the day, Clarence Darrow and William Jennings Bryan, in an improbable case. John T. Scopes, a biology teacher in Dayton, Tennessee, had taught his students the scientific theory of evolution, rather than the state-approved biblical version of creation. The law had been violated—no one disputed that. But when Darrow called Bryan, a religious fundamentalist, to the stand to testify, he turned up many inconsistencies in the Bible, seeking to prove that it cannot be taken literally. Although Scopes lost and was fined $100, that decision was later overturned on a technicality. Bryan, who was publicly humiliated by the proceedings, died five days after the trial's conclusion.

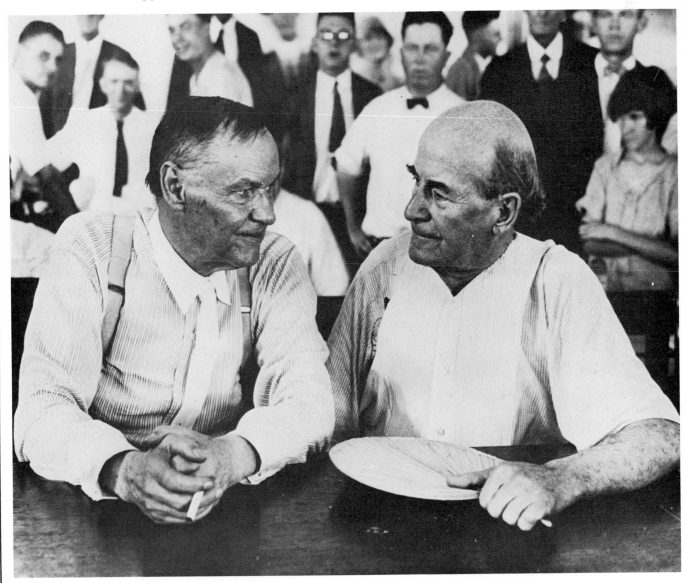

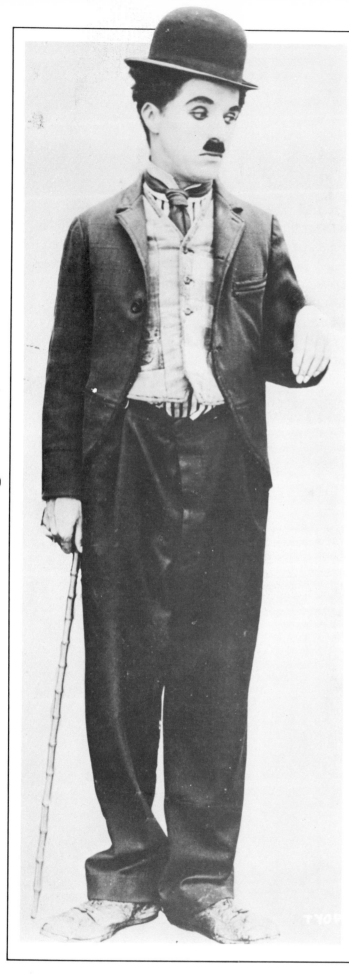

70

THE TRAMP

ca. 1925

Charlie Chaplin, as "The Tramp," came as close to being all things to all people as any man ever has. He was both shabby and elegant. The Tramp was achingly poor and felt life's hardest moments, but he beamed with a simple gladness. He showed moments of both childlike madness and very adult hardheadedness, and all the world loved him.

British-born Chaplin, who started his career as a music hall entertainer in London, created the character of The Tramp while working as an actor in America for Mack Sennett's Keystone Company. Sennett's silent comedy shorts were often filmed in an improvisational fashion, and one day in 1913 Chaplin was told to find himself a costume. In the dressing room he put on baggy pants, tight coat, too-small derby hat, and too-large shoes, added a mustache and an awkward little walk—and Chaplin's trademark character was born.

Chaplin went on to become an extraordinarily popular star and an independent producer of such great Chaplin classics as *The Kid* (1920), *The Gold Rush* (1925), *City Lights* (1931), *Modern Times* (1936), *The Great Dictator* (1940), and *Limelight* (1952).

Later in his career, Chaplin was increasingly criticized for his political views, and settled in Switzerland in 1952. In 1975 he was knighted by Queen Elizabeth II.

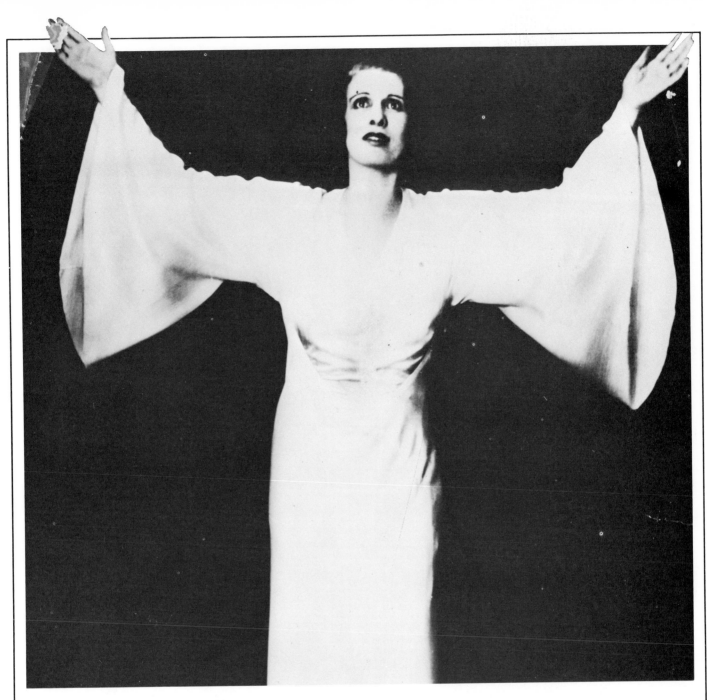

AIMEE SEMPLE McPHERSON
1925

Aimee Semple McPherson, the flamboyant evange-list of the twenties, endured both adoration and con-demnation during her career. At the height of her popularity, in mid-May of 1926, she disappeared one day on the beach. For a month, searches were mounted for McPherson or her body. It was guessed that she had gone for a swim, suffered a mishap, and drowned. But after a month's search, a ransom note was received. The day after the note was re-ceived, she appeared in a Mexican border town, say-ing she had been kidnapped, had escaped, and had found her way to the town. Her story seemed weak—she showed no signs of having been held captive or of crossing a desert, and further investiga-tion ensued. It was discovered that she had spent the month with a married man, Kenneth Ormiston, being seen in several hotels and at a beach house. The facts were made public and for many McPher-son's image was tainted. A small band of faithful fol-lowers continued to attend her dramatic services in Angelus Temple, Los Angeles, until her death in 1944.

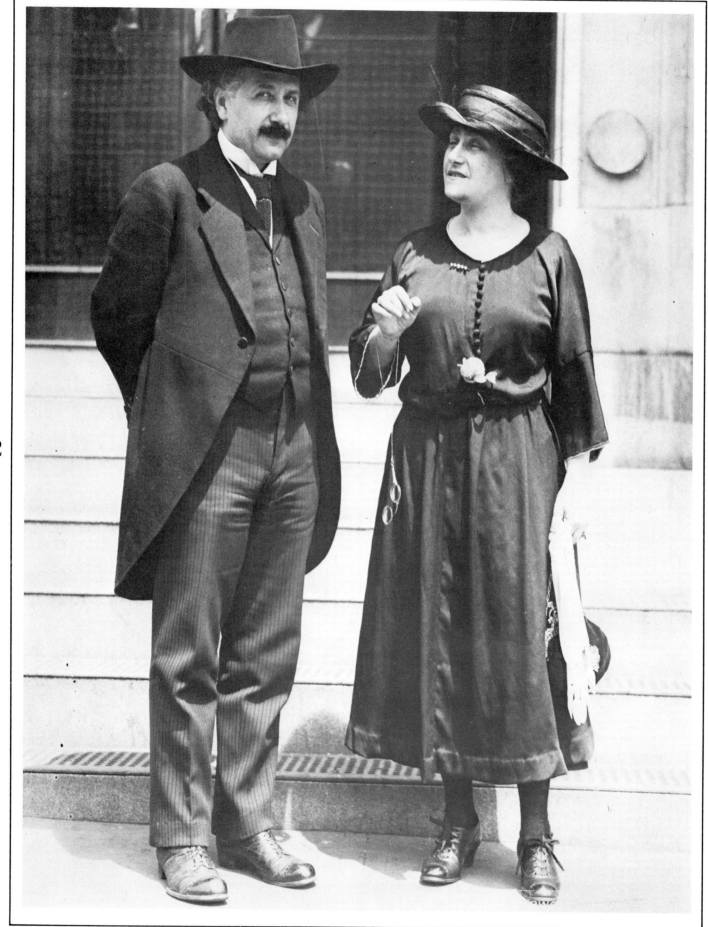

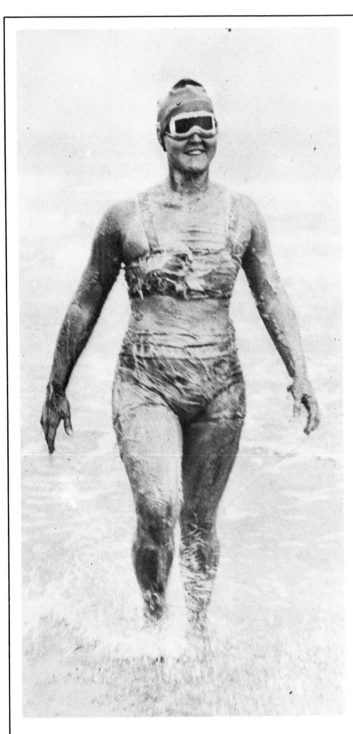

GERTRUDE EDERLE

August 6, 1926

Championship American swimmer Gertrude "Trudy" Caroline Ederle was determined to cross the choppy and dangerous English Channel. On August 6, 1926, she succeeded spectacularly, becoming the first woman to swim across the Channel and at the same time the first swimmer to cross using the crawl stroke. As if that weren't achievement enough, when she climbed out of the water on the English side, after only 14 hours and 30 minutes, she had broken all previous men's records for speed.

ALBERT EINSTEIN

ca. 1926

"God does not play dice with the universe," Albert Einstein liked to say. He spent a good part of his life proving just that—that the phenomena of the universe could be explained in an orderly manner because there was indeed a logic to them.

Born in Germany in 1879, he developed his famous theory of relativity there when he was only

twenty-six, but his genius was an irritant to his motherland. In 1933, while he was visiting the United States and England, the Nazi government confiscated his property and stripped him of his German citizenship. He is shown here with his wife, Elsa, around 1926. He settled in Princeton, New Jersey, to head the newly created Institute for Advanced Study. Einstein became an American citizen in 1940 and died in 1955.

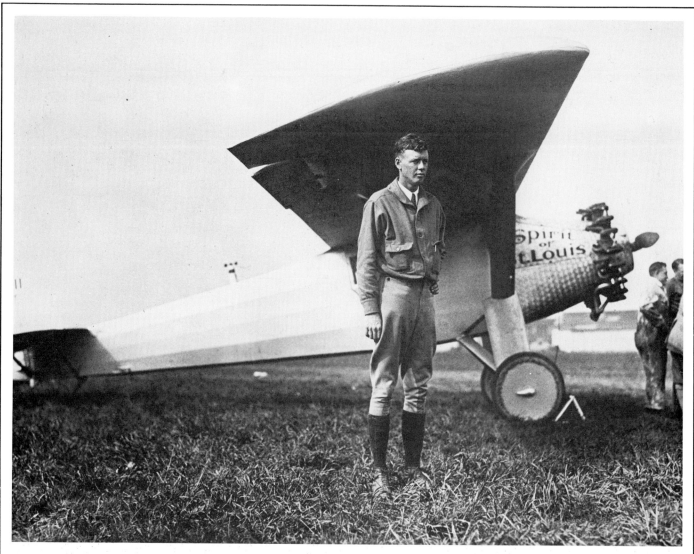

THE LONE EAGLE
May 20–21, 1927

The lanky, handsome young pilot had a set to his chin that showed unmistakable determination. Such determination served Charles A. Lindbergh well during his grueling 33½-hour flight that began on May 20, 1927.

He took off in his plane, *The Spirit of St. Louis,* at 7:32 A.M. from Roosevelt Field on Long Island, New York. "We (that's my ship and I) took off rather suddenly," he later stated to the *New York Times.* "We had a report somewhere around four o'clock in the afternoon before that the weather would be fine,

so we thought we would try it." "It" was a solo flight clear across the Atlantic, for the accomplishment of which a $25,000 reward had been offered by a New York hotel owner.

"[Later] I saw a fleet of fishing boats. . . . I flew down almost touching the craft and yelled at them, asking if I was on the right road to Ireland. They just stared. Maybe they didn't hear me. Maybe I didn't hear them. Or maybe they thought I was just a crazy fool. An hour later I saw land."

By the time he landed at Le Bourget Field outside Paris, more than 100,000 people had gathered to welcome the "Lone Eagle," as he came to be called. An American hero was born.

DEMPSEY--TUNNEY FIGHT
September 22, 1927

It was their second fight—a rematch. Jack Dempsey, the "Manassa Mauler," had lost his heavyweight championship title to Gene Tunney the year before.

It was billed as the battle of the ages. The fight began slowly, with no extraordinary blows. Then, in the seventh round, Dempsey threw his famed hard right and knocked Tunney off his feet. He stood over Tunney, snarling at him, ignoring the referee who was frantically trying to begin a count. Valuable seconds passed, until Dempsey went back to his corner, and the count at last began.

Tunney got up on the count of 9 and went on to a miraculous win in a 10-round decision.

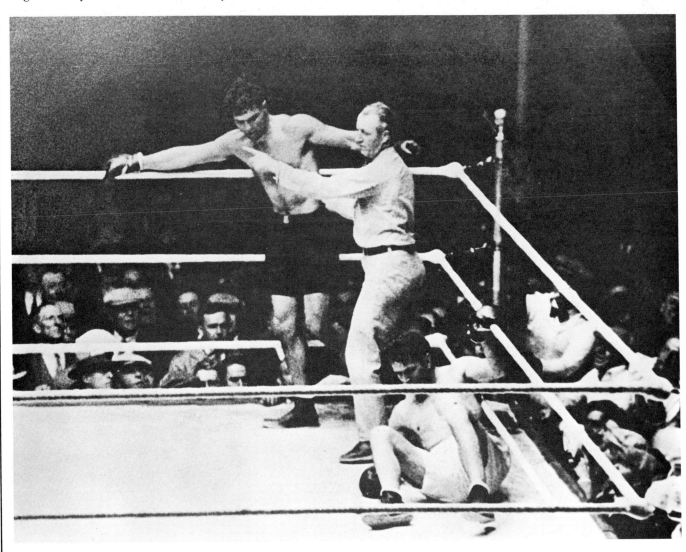

THE JAZZ SINGER

October 6, 1927

Talkies were on their way, but most movie studios weren't taking this new technology seriously. Warner Brothers, however, did. They contracted for the exclusive operation of the Vitaphone and enticed Al Jolson to appear in a film called *The Jazz Singer*, based on the story of Jolson's own show business career. *The Jazz Singer* is essentially a silent picture, so when, about halfway through the picture, Jolson looks at the camera, says "You ain't heard nothin' yet!," and begins to sing, it's easy to imagine how electrified the audiences became in 1927.

Jolson sang three songs in the movie (one of them the famous "Mammy") and spoke a few lines of dialogue. The movie was a box office hit when it was released in New York on October 6. Suddenly every movie mogul wanted the Vitaphone. The talking picture, and the movie musical, had arrived.

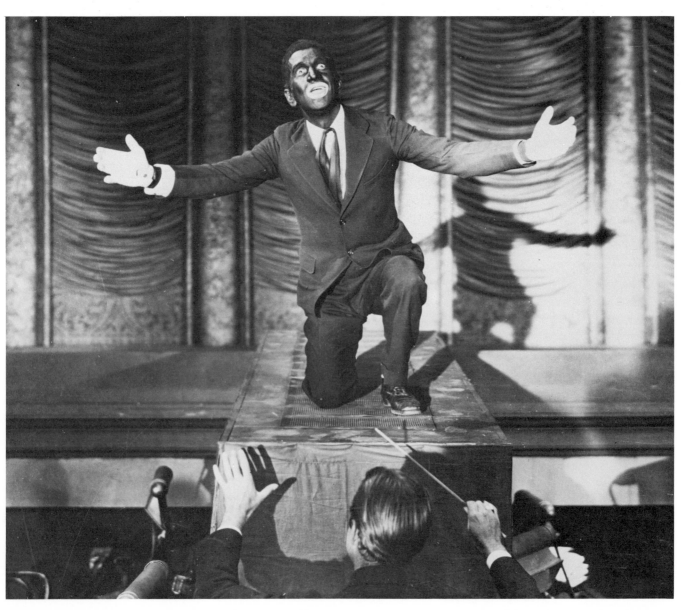

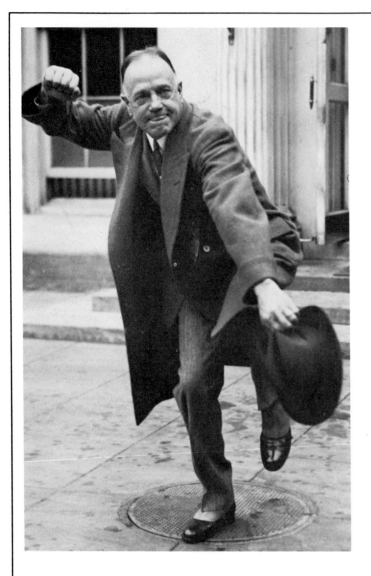

BILLY SUNDAY
1928

Billy Sunday, ex-baseball player and energetic evangelist, is shown here stumping for Herbert Hoover, Republican presidential candidate. Sunday, known best for his large-scale conversions (in one New York City revival meeting he garnered over 98,000 conversions) and his colorful speeches, was never one to shy away from speaking his mind on any subject. He denounced alcohol, foreigners, World War I's Kaiser, and high fashion, among other things. More traditional preachers flinched at his extravagant gesturing. (Sunday was famous for jumping, running, and falling down on stage while trying to make a point or to illustrate the evils of liquor. He was also known to shadowbox with "the devil.") However, no one could deny his results. Eventually, after World War I, Sunday's popularity, which peaked in 1917, dwindled. He finally took to rural areas to continue his preaching.

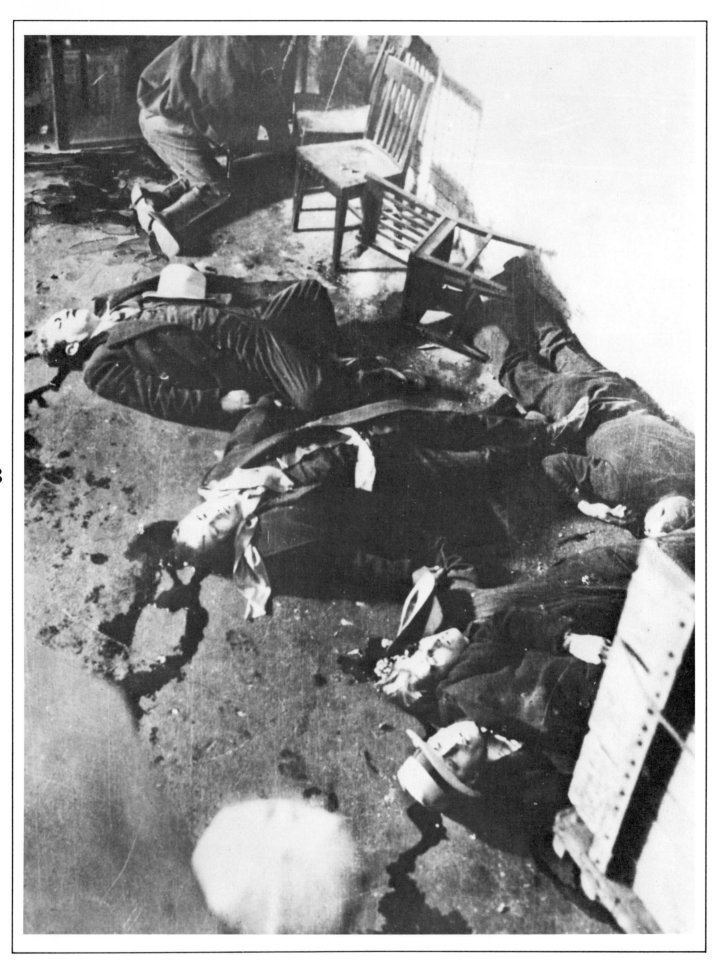

ST. VALENTINE'S DAY MASSACRE
February 14, 1929

It was the most shocking episode in a series of gangster wars in Chicago.

On St. Valentine's Day, 1929, five members of the Al Capone gang pulled up to the brick house on North Clark Street in Chicago where members of Bugs Moran's gang were waiting for a shipment of stolen liquor—precious cargo in those Prohibition days. Capone's men, dressed as police officers, went into the house, proceeded straight to the storeroom where the men waited, and feigned a police raid. The Moran gang was told to stand against the wall, and their guns were taken away. Thinking that this was indeed a routine raid, the men did as they were told. But after they were lined up, the six were cut down by machine guns. The Capone gang calmly walked out of the house, uninterrupted by the people in the street who also assumed they were police officers.

The victims were Peter Gusenberg, Al Weinshank, Arthur Hayes, John May, Frank Foster, and James Clark.

BLACK TUESDAY
October 29, 1929

It was the day the stock market crashed. Crowds are shown here on the steps of the Treasury building that faces the New York Stock Exchange, anxiously waiting for the day's trading to end.

On that day, after months of wild market booms, speculators sold 16,400,000 shares of stock. The crash, which cost investors an estimated $40 billion, plunged the country into the Great Depression.

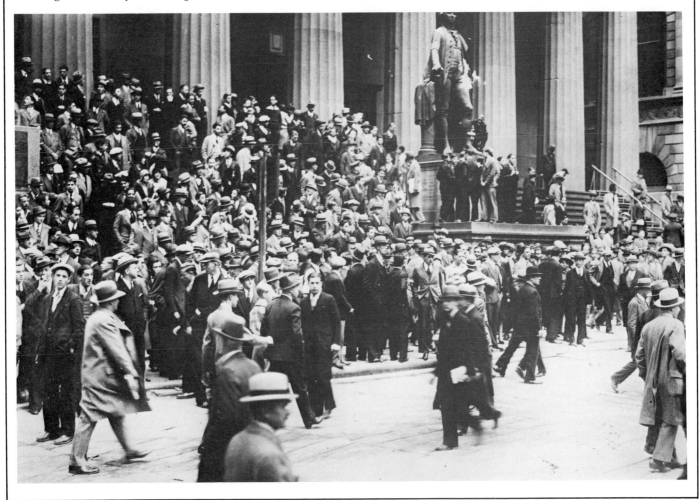

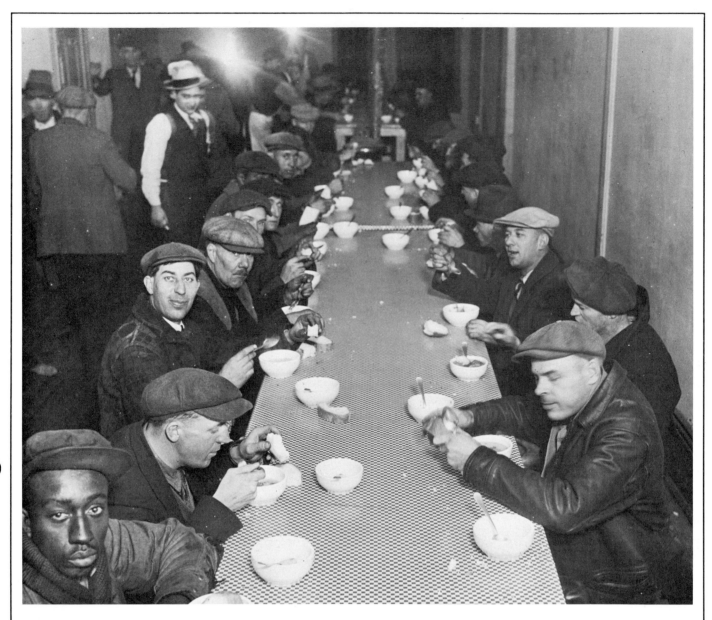

80

AL CAPONE'S SOUP KITCHEN
November 1930

It was seemingly a strange "racket" for a bootleg-ging gangster to be involved in, but in the midst of the Depression, the infamous Al Capone opened a soup kitchen in Chicago where unemployed men could enjoy a hot meal.

AMELIA EARHART
ca. 1930

She was the first woman to cross the Atlantic by air—as a passenger—in 1928. She was the first woman to fly solo across the Atlantic, the first wom-an to fly from Honolulu to the mainland alone, and the first woman to fly across the United States alone in both directions. She was also the first woman to receive the Distinguished Flying Cross.

She wanted to become the first woman to fly around the world, and in 1937 she tried. But her plane vanished near Howland Island in the Pacific and was never found. Her fate remains a mystery.

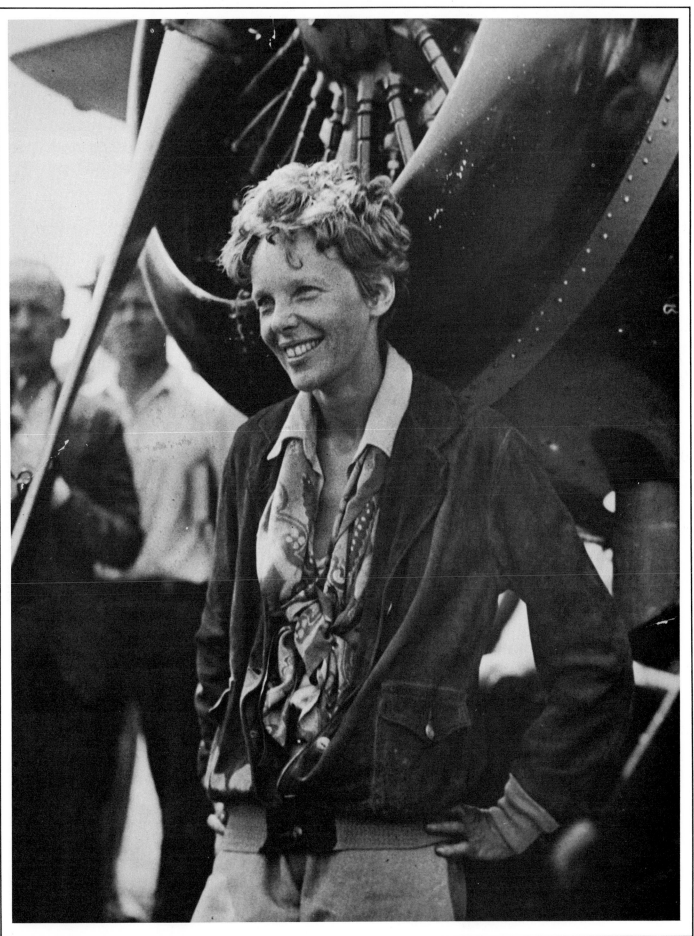

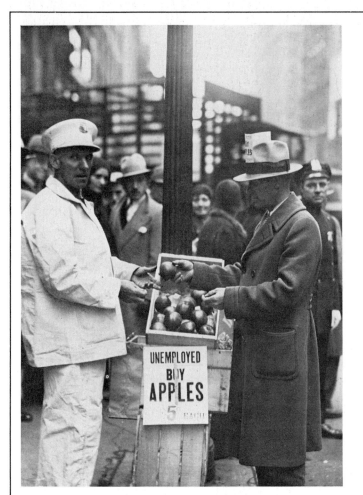

THE GREAT DEPRESSION
Early 1930s

The numbers coldly recorded the misery of the Great Depression: about one out of every four Americans couldn't find work. But it was the everyday street scenes that made the statistics come alive. This photo, taken in New York City in the early 1930s, is a grim reminder of the poverty and lost hopes of the nation. Apple stands lined the streets, as men supported their families on the change they earned from selling fruit. The sellers vied for the few customers in the crowds that passed by. "Most of the people," one seller noted, "just hurry by, looking away, or looking down—looking anywhere but straight at you."

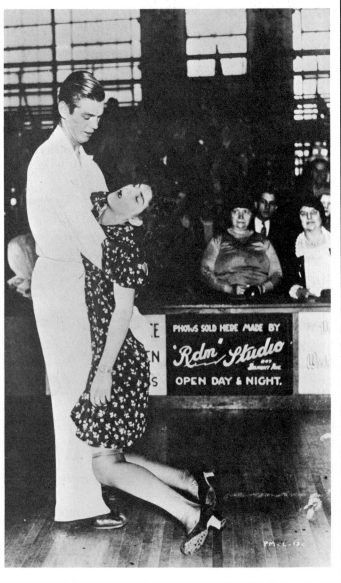

DANCE MARATHON
1930s

The object was simple: to see who could dance longer than anyone else. But the result was often sheer craziness—couples danced for days, sometimes weeks on end, with only short breaks. Several people were struck down by heart failure or illness.

The prize for the winning couple was money—often as much as a few thousand dollars.

This marathon began in the streets of Culver City, California. The couples danced eight miles down the highway to an Ocean Park ballroom, where they danced until they dropped.

THE DUST BOWL
Early 1930s

When the wind storms hit the 50 million acres in the Dust Bowl, parched and poorly farmed soil across five prairie states was swirled for miles and deposited as far away as the Gulf of Mexico or the Atlantic Ocean. It was the early 1930s, and the ravaging winds compounded the Depression poverty that had already hit many farmers. Farmers and their families sealed themselves in their farmhouses while the winds raged outside. When the howling finally stopped, they ventured outside to assess the damage, only to find their crops buried, their precious topsoil—and their dreams—gone.

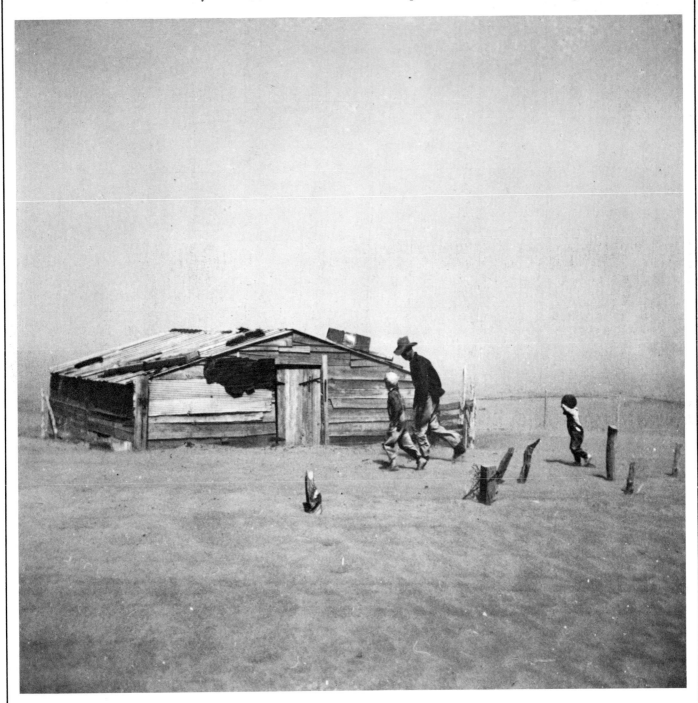

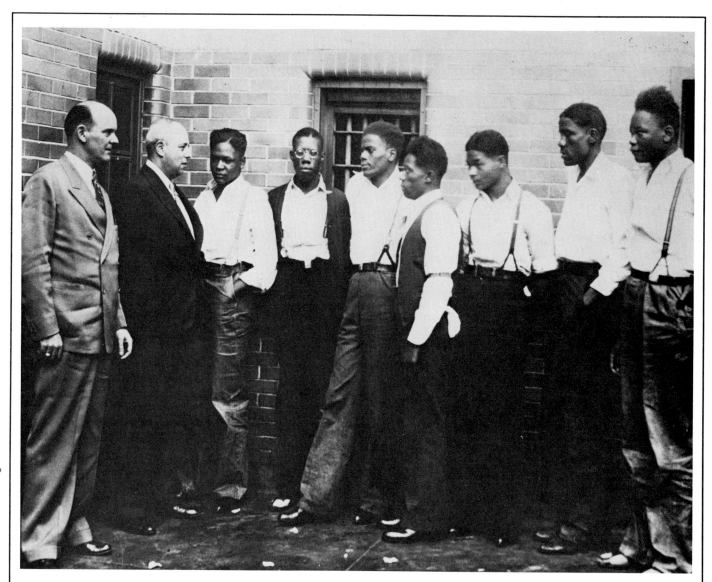

THE SCOTTSBORO CASE
1932

In pre-World War II Alabama, black men being charged and convicted of raping white women was a common occurrence. So no one was really surprised when nine black men (two of them juveniles) were indicted on March 31, 1931, on charges of having raped two white girls. The Alabama Supreme Court affirmed the convictions and the death sentence that the seven adults received.

But in 1932, when one of the "victims" recanted her testimony, the U.S. Supreme Court declared a mistrial. Suddenly, the Scottsboro Case became a celebrated cause.

Despite that, the man accused of being the ringleader was convicted and again given the death penalty. An Alabama judge later set aside that conviction on the grounds that it was against the weight of evidence. Again the man was tried, along with another defendant; again both were sentenced to death.

Once more the case was appealed to the U.S. Supreme Court, which once more reversed the convictions, for reasons of discrimination. The Scottsboro Case dragged through another grand jury indictment and four more trials until it was finally resolved.

Eventually, five of the prisoners were sentenced to terms that ranged from twenty to ninety-nine years. The remaining four were set free. One of the convicted escaped from prison in 1948 and fled to Michigan; that state refused to return him to Alabama. By June 1950, all had been paroled, thanks to the tireless efforts of the Scottsboro Defense Committee.

HITLER AND HINDENBURG

March 21, 1933

The aging and, from some reports, senile German president, Paul von Hindenburg, appointed Hitler chancellor of the country in 1933, fearing civil war if he refused the popular Nazi party. Hitler and propaganda genius Goebbels orchestrated the ceremony elaborately. It was held at Potsdam, in the Potsdam Garrison Church, above the tomb of Frederick the Great. The setting—the gracious home of Prussian kings—and the date—the day on which Bismarck had opened the first German parliament—had both been chosen with care. Hitler called the occasion the "Day of the National Rising," signifying the conciliation of the old and the new. Just before noon, Hitler and Hindenburg met on the steps of the Garrison Church and exchanged the handshake that was reproduced on postcards and posters. He would not have wanted to take power, said Hitler, without "the old gentleman's blessing."

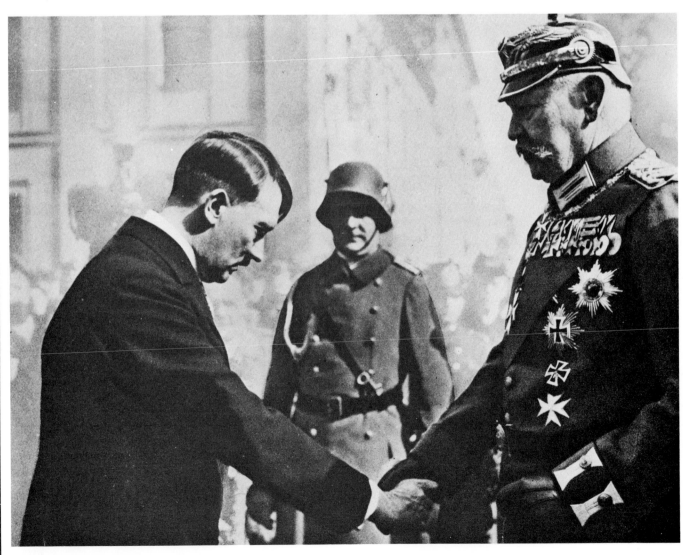

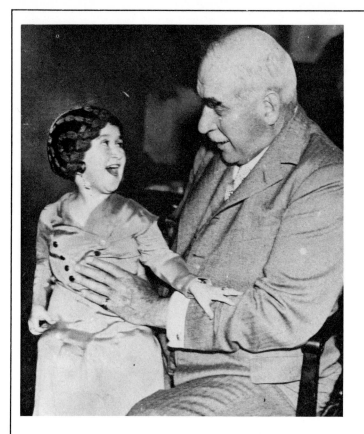

J. P. MORGAN AND THE MIDGET
June 1, 1933

J. P. Morgan, the banker and international financier, was notorious for his abhorrence of publicity. But when he was summoned to Washington to testify before the Senate Committee on Banking and Currency, he unexpectedly played a part in a publicity stunt. Morgan was waiting to be called into the committee when some midgets from the Ringling Brothers Circus appeared. They were wandering around the halls of Congress, having their picture taken with any senators and congressmen who would agree, when someone lifted a woman, Lya Graf, age thirty-two, up on Morgan's lap. The incident took only a few seconds, but the newspaper photographers present immortalized the moment.

BRUNO RICHARD HAUPTMANN
February 14, 1935

Bruno Richard Hauptmann, kidnapper-killer of the Lindbergh baby, is seen here after his conviction on February 14, 1935.

An ex-convict from Germany, Hauptmann committed a crime of violence against the American dream: the father, Charles A. Lindbergh, was an American hero; the mother, Anne Morrow Lindbergh, was a charming and talented ambassador's daughter; the child, a vulnerable innocent.

On March 1, 1932, Hauptmann climbed to the second-story window of the Lindbergh home near Hopewell, New Jersey, and kidnapped their 20-month-old son. Although Lindbergh paid $50,000 in ransom, the baby's body was found in the woods six weeks later—he had apparently died soon after the kidnapping.

Hauptmann was charged with the crime and, in a circuslike trial, was convicted and sentenced to die in the electric chair. It was this case that set the precedent for kidnapping as a federal offense, punishable by death.

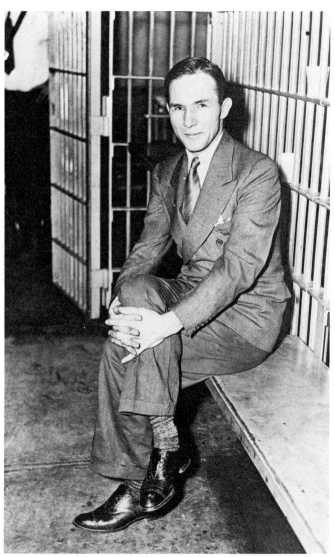

DIONNE QUINTS

1935

In a depression-weary world, the magical news of the Dionne quintuplets was captivating. Five identical, beautiful little girls were born to Elzire and Oliva Dionne on May 28, 1934, in Callander, a small town in northern Ontario, Canada.

Annette, Cecile, Emilie, Marie, and Yvonne became such a phenomenon that the Canadian government made them wards of the state, like any valuable resource. People traveled hundreds of miles to catch a glimpse of the babies. A movie was made based on their life, they were featured in most maga-zines, and books were written about them. This photo shows them with the physician who delivered them, Dr. Allan Roy Dafoe.

The Dionne sisters were the first quints to survive past infancy. But in 1954, Emilie died after an epileptic seizure, and Marie died in 1970 from a blood clot. The surviving quints lead quiet lives in St. Bruno, a suburb of Montreal. Annette is divorced and is raising four children. Yvonne, who never married, does volunteer work in a municipal library and receives a share of the trust fund that was set up for the children. Cecile, also divorced, similarly benefits from the trust fund money.

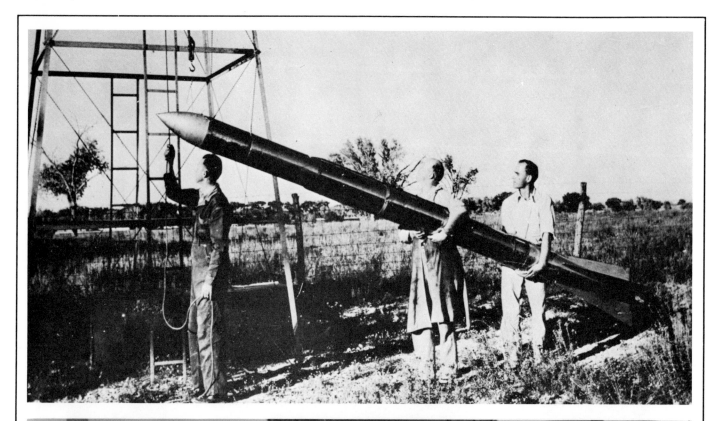

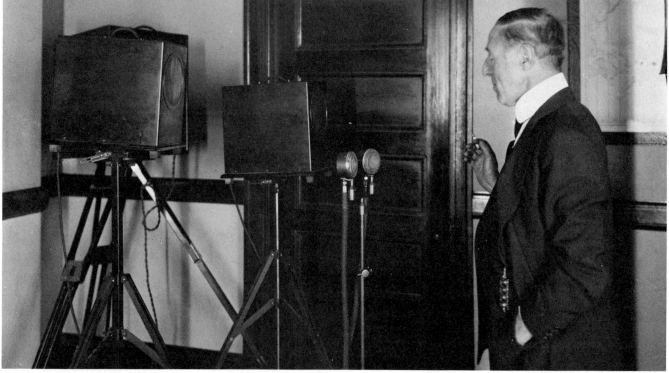

FIRST PORTABLE TELEVISION
BROADCASTING OUTFIT

ca. 1935

Famed film director D. W. Griffith demonstrates a breakthrough in television, a portable television broadcasting set in Schenectady, New York. Griffith spoke into a microphone as his picture was being transmitted, and in Los Angeles, two thousand miles away, avid spectators watched.

ROBERT GODDARD

1935

American physicist and rocket expert Robert Goddard's vision of the possibility of space travel began on a chilly day in October when he was seventeen years old. It was then, he later told the world, that he climbed a tree and looked toward the horizon, imagining a whirling object that would carry man into space.

Goddard doggedly pursued his dream, designing and building early high-altitude rockets. Shown here (center) at Mescalero Ranch in Roswell, New Mexico, Goddard is preparing to launch the liquid-fuel-propelled rocket that he had pioneered. Goddard is also credited with innumerable rocket devices and rocket theories that paved the way for modern space travel.

THE ABDICATION OF KING EDWARD VIII

1936

Edward and Wallis were in love and wished to marry. Ordinarily, of course, this would be of little interest to the world and would present no problems, but Edward and Wallis were no ordinary lovers. Edward was the King of England, newly crowned as King Edward VIII. Wallis was Wallis Warfield Simpson,

an American divorcée who was in the process of divorcing her second husband, and who was also clearly unacceptable to the British government as queen. A constitutional crisis ensued in London, resulting in Edward's abdication of the throne. He announced his decision to his British subjects in a speech over the radio in which he said that he could not go on without the help of the "woman I love." They were married on June 3, 1937, and lived quietly as the Duke and Duchess of Windsor.

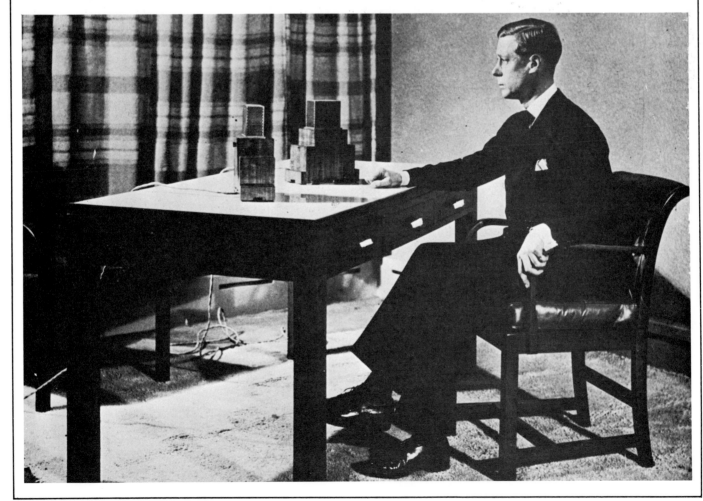

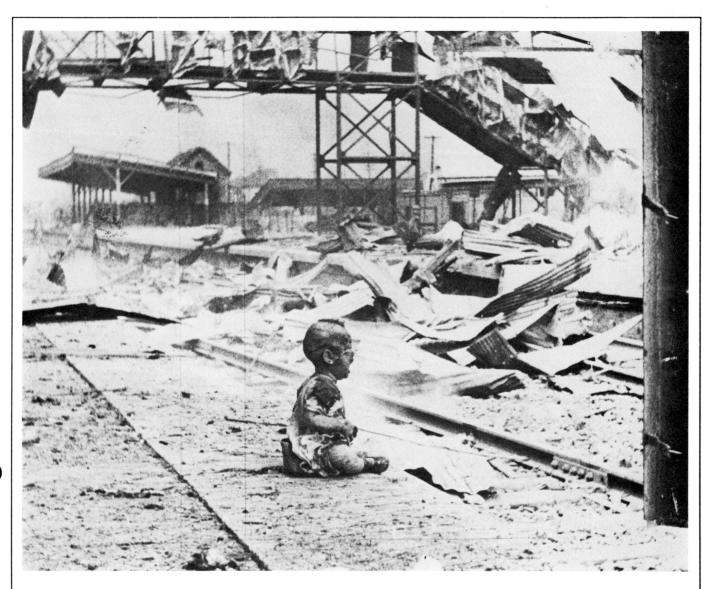

SHANGHAI RAILROAD STATION
August 28, 1937

On August 28, 1937, Japanese planes bombed a Shanghai railroad station that was crammed with some 1,800 civilians waiting to be evacuated from the war zone. The Japanese airmen later said they had mistaken the masses of civilians for a troop movement, but by then it was, of course, too late.

This powerful picture of a desolate child was sent by U.S. Navy ship from Shanghai to New York and was printed in the October 14, 1937, issue of *Life* magazine. Although this baby was carried to safety, an indignant and horrified world condemned the Japanese for bombing civilians.

NAZIS IN NUREMBERG STADIUM
Late 1930s

The scene of Nazi Germany's greatest moments ultimately became the site of its strongest repudiation: Nuremberg. There, in the late thirties, party rallies were held, dramatically choreographed with theatrical lighting, minutely timed marching, and rousing music. Here, an impressive display of military precision unfolds before the podium where Hitler spoke.

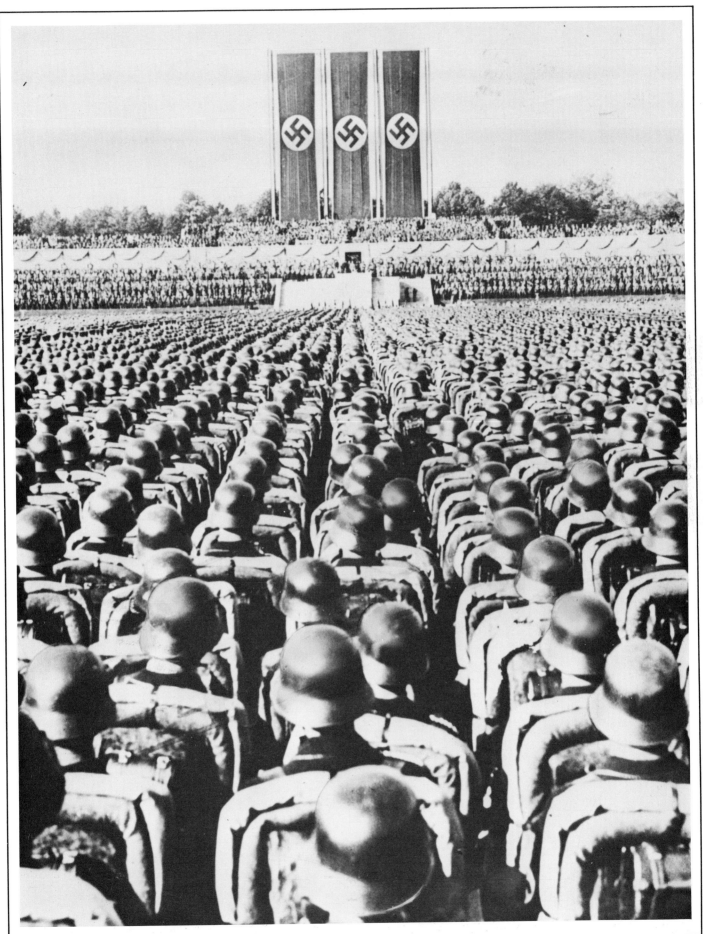

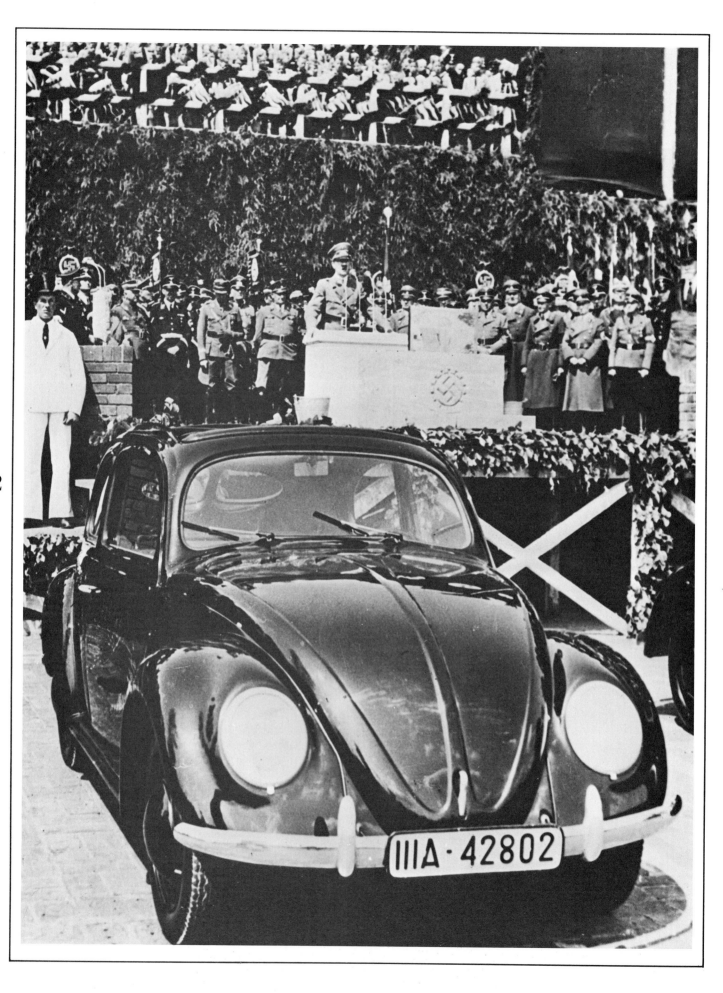

HITLER AND VOLKSWAGEN
May 26, 1938

At the cornerstone-laying ceremony of the Volkswagen factory in 1938, Hitler promised to solve Germany's "problems of motorization." The Volkswagen, although not actually available to the general public until after the war, was intended to be the "people's car." "It shall bear the name of the organization which is most concerned with filling the broadest masses of our people with joy and thus with strength." Both car and factory were to serve as symbols of the national socialist "Volk" community.

JOE LOUIS VS. MAX SCHMELING
June 22, 1938

It was one of the shortest fights in boxing history. Joe Louis, "The Brown Bomber," knocked Max Schmeling off his feet in the first round of the bout at Yankee Stadium. Louis, who had won the title exactly a year before, went on to knock Schmeling to the floor two more times—all in the first round. The challenger's manager put an end to the fight after only 2 minutes, 4 seconds.

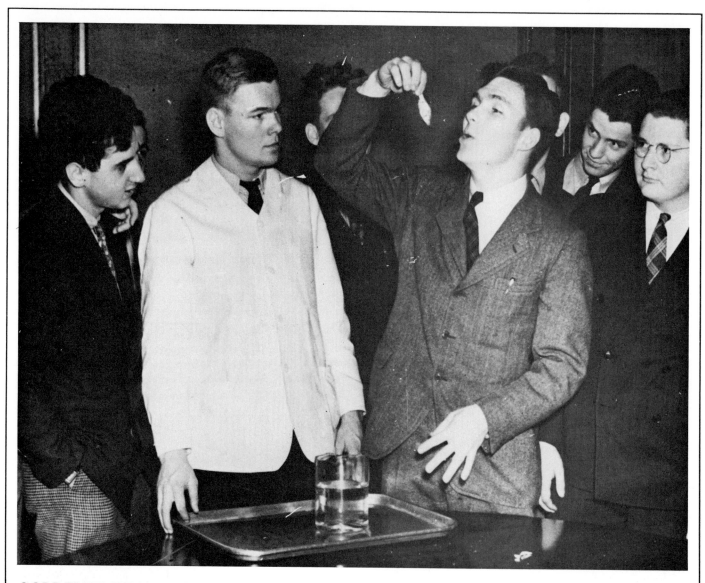

GOLDFISH SWALLOWING
1939

In the 1930s an improbable college student stunt swept the nation—goldfish swallowing. Here, students at Harvard University in Cambridge, Massa-chusetts, watch as a fellow student swallows a three-inch goldfish. The swallower won a ten-dollar bet, and the students later sat down to a dinner of fried filet of sole.

FDR IN CAR
1939

Nothing in Franklin Roosevelt's background indicated that he might be an extraordinary president, but from the day he entered office, in the country's darkest time, he seized power and used it without reluctance. Roosevelt is shown here in 1939—with a customary expression of confidence, optimism, and jauntiness.

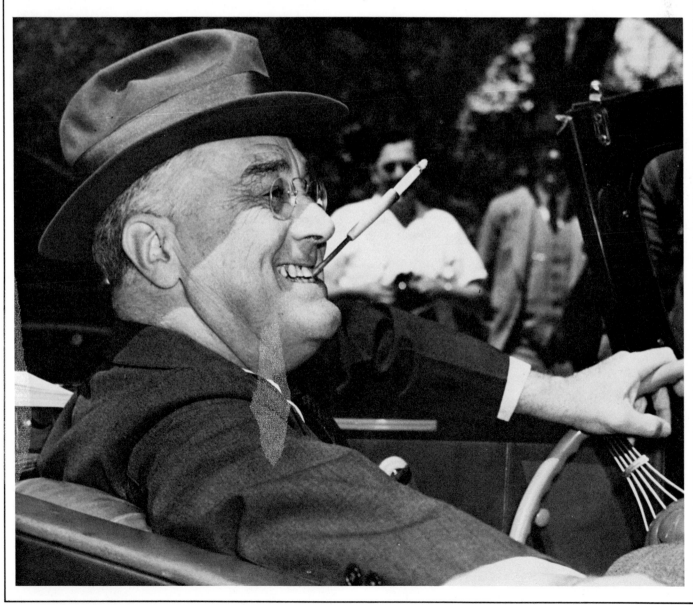

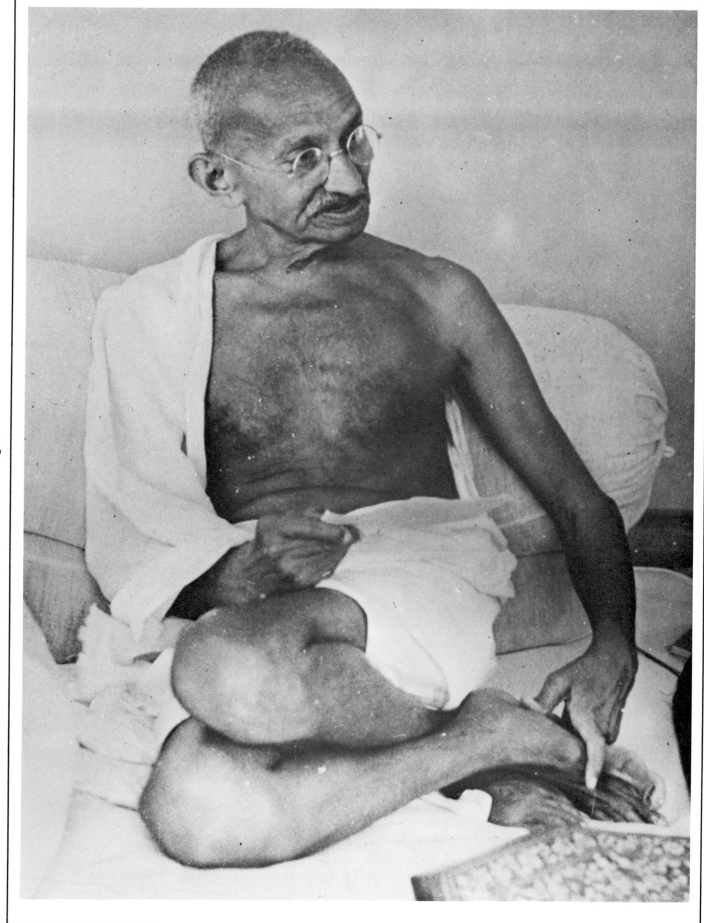

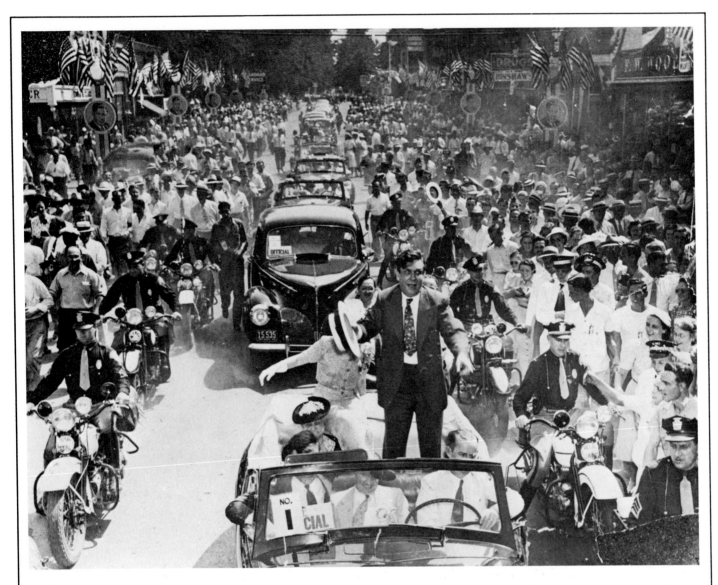

WENDELL WILLKIE

August 17, 1940

Wendell Willkie, newly nominated Republican
choice for President against Franklin Roosevelt,
rides into his home town—Elwood, Indiana—to de-
liver his acceptance speech.

 Life magazine, which first printed this picture,
described the scene: "This is the pageant of Ameri-
can politics, of America's eternal Main Street hailing
its ascendant son." Proof indeed that in America,
anyone can grow up to be president.

 Willkie lost his election bid—but not without a
courageous campaign in which he shunned personal
attacks on his opponents and acknowledged an un-
popular topic, the war overseas.

GANDHI

ca. 1940

He came to be known as Mahatma (Great Soul) Gan-
dhi, this frail man with a will of iron who pioneered
the way of nonviolent resistance and civil disobedi-
ence. With the eyes of the world on him, Gandhi
shamed the British into granting freedoms for the
Indians, until finally the British granted indepen-
dence to their former colony. Soon after, rioting
broke out between the Hindus and the Moslems in
India, and on January 30, 1948, Gandhi, the master
of nonviolence, was shot and killed by a fanatic.

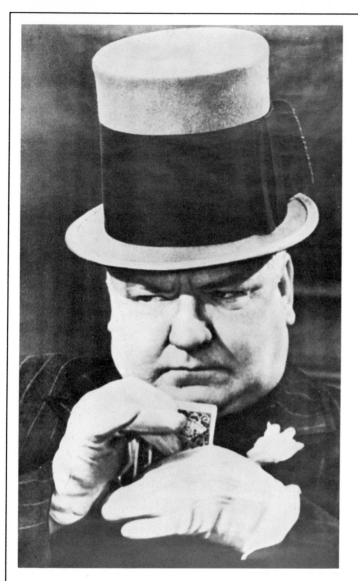

W. C. FIELDS
1940

Whose genius for pantomime and cryptic dialogue were second only to his irreverence and cynicism—who else but W. C. Fields?

America loved this raspy-voiced, hard-drinking, courtly-mannered comedian who gave us some of our favorite one-liners: "Never give a sucker an even break" and "Any man who hates children and dogs can't be all bad."

Fields, who started in show business as a juggler at the age of eleven, appeared first in silent films and then in sound, where his screen personality blossomed in such films as *You Can't Cheat An Honest Man* (1939), *My Little Chickadee* (1940), from which this still was taken, *The Bank Dick* (1940), and *Never Give A Sucker An Even Break* (1941).

Fields died in 1946. It is widely believed, though not true, that the great comedian's gravestone reads: "On the whole, I'd rather be in Philadelphia."

HITLER'S JIG

1940

Victory was sweet for Hitler at Compiègne, France, where he declared victory over France and dictated the terms of his peace to the French. Victory was so sweet, in fact, that he jumped a bit in happiness.

The West saw movies of Hitler doing a ridiculous little jig. However, it was later discovered that technicians in England, at the BBC, had engineered that jig by running the same footage back and forth, forward and backward, in the successful hope that the German leader would be seen as a fool.

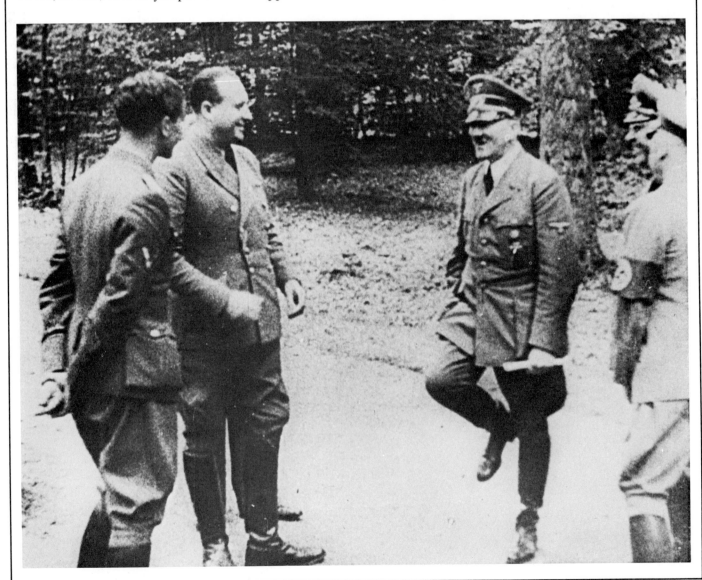

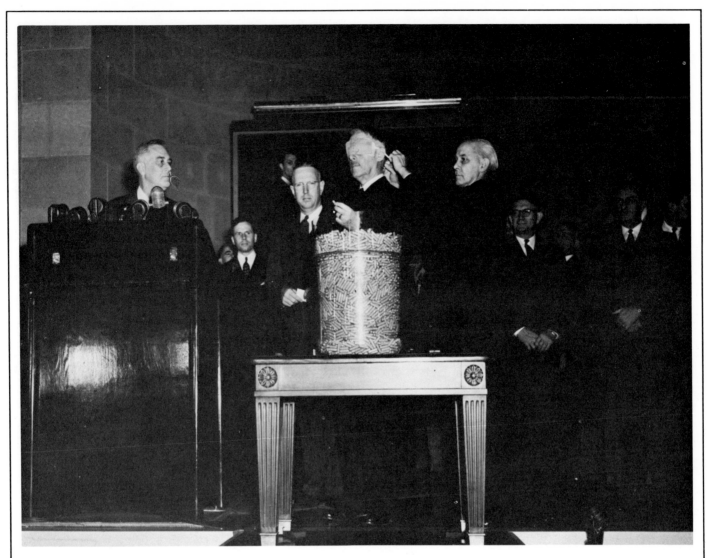

FIRST PEACETIME DRAFT

October 1940

War was imminent—Europe was in the midst of a bitter fight, and it appeared to be only a matter of time before the United States would be involved. Even though this was clearly apparent, FDR's proposal for the first peacetime draft in the history of the nation drew fierce opposition. Still, in September of 1940, Congress passed the measure. One month later, Secretary of War Henry Stimson picked the first number in the National Lottery.

WINSTON CHURCHILL

ca. 1940

England's darkest hours were eased by Prime Minister Winston Churchill, who promised the people "blood, sweat, and tears," but ultimate victory. Here, he opened the new headquarters of the 615 County of Surrey Squadron, Royal Auxiliary Air Force at Croydon, where he was named honorary air commodore. Characteristically, he bites down on his cigar, and gives a gruff V for victory sign.

J. EDGAR HOOVER

ca. 1940

At the age of twenty-nine Hoover became director of the Bureau of Investigation, later renamed the Federal Bureau of Investigation. There he built a first-rate criminal detection agency, instituting a central file for fingerprinting, a school for police, and a crime laboratory. In later years, his attacks on communism bordered, some thought, on the obsessive. However, in the heyday of the gangsters, Hoover was a nationally revered hero.

102

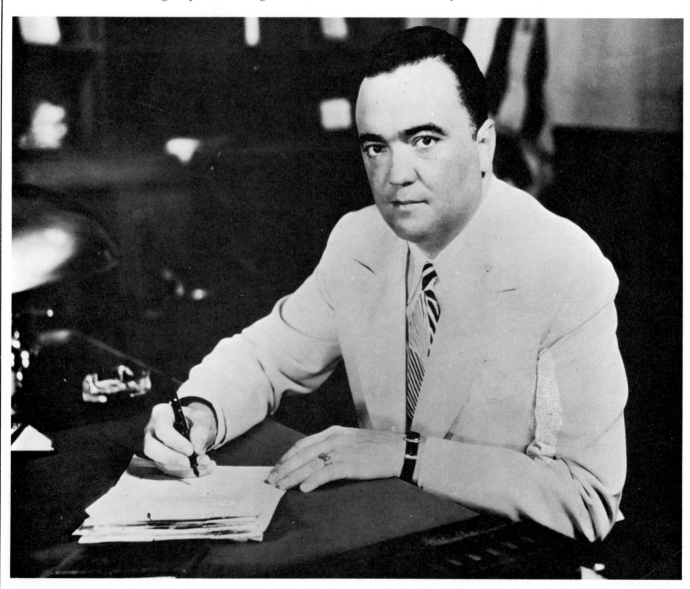

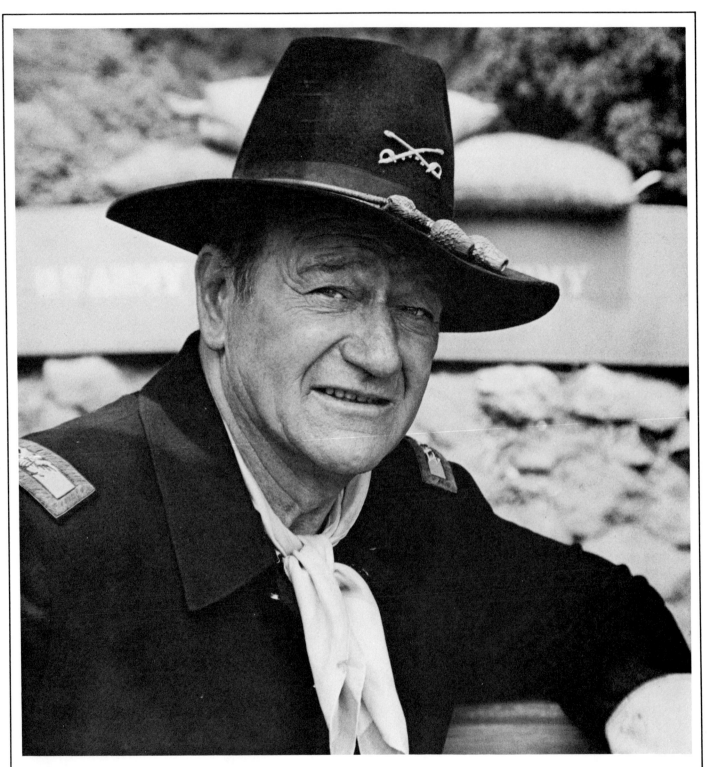

JOHN WAYNE

1941

In the forty-odd years spanned by his career, John Wayne was best known for one type of role—the rugged individualist, the tough but affable hero, the man of action in (more often than not) a western. So successful was Wayne in capturing the hearts of Americans that shortly before his death in l979, Congress awarded him a congressional medal, inscribed simply *John Wayne—American*. Here, Wayne is seen in an early film, *Shepherd of the Hills*. Some of his other successful movies were *Stagecoach, Fort Apache, Rio Grande, The Quiet Man, The High and the Mighty,* and *True Grit.*

MARSEILLES, FRANCE
February 1941

France had fallen to the Nazis, and in Marseilles
stunned, angry, and frightened citizens choked back
their tears as the flags of the French regiments were
carried away to exile across the Mediterranean.

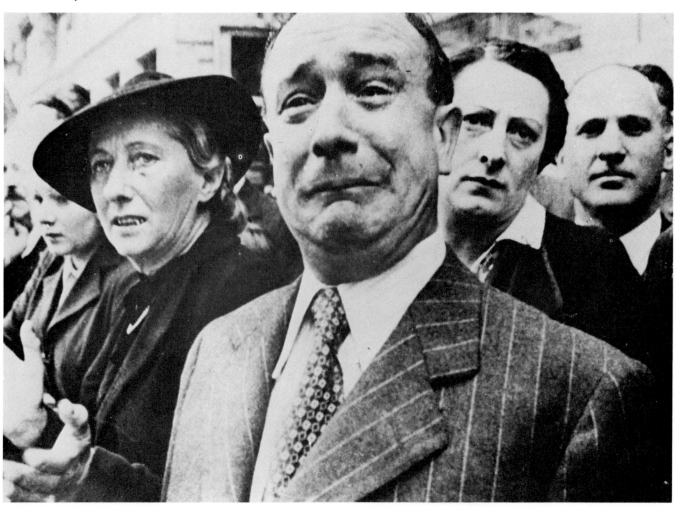

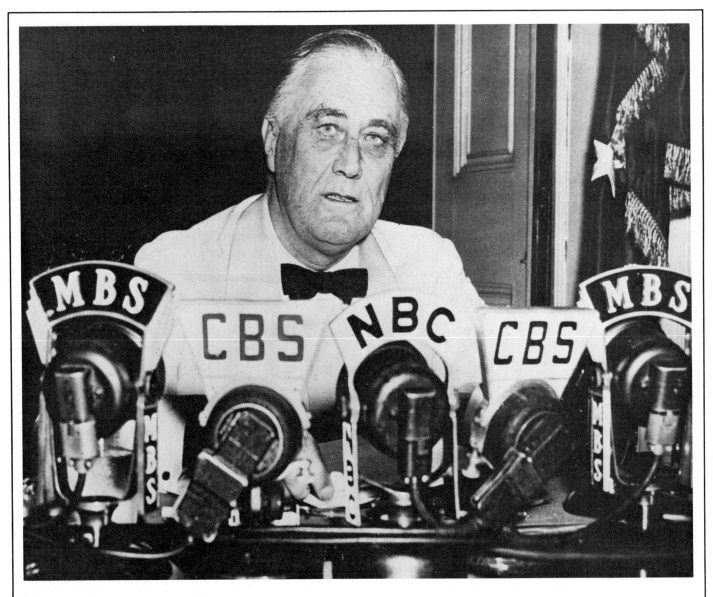

FDR'S FIRESIDE CHATS

May 27, 1941

These chats were Franklin Delano Roosevelt's own special brand of drama. Families all over America would turn on their radios and settle down to hear FDR speaking from the East Room of the White House, chatting, it seemed, with each one personally, attempting to explain issues and policies.

Although FDR (a wealthy man) had little in common with the average person, he reached the people better than almost any other chief executive.

Here, in his seventh Fireside Chat, FDR declared an unlimited national emergency.

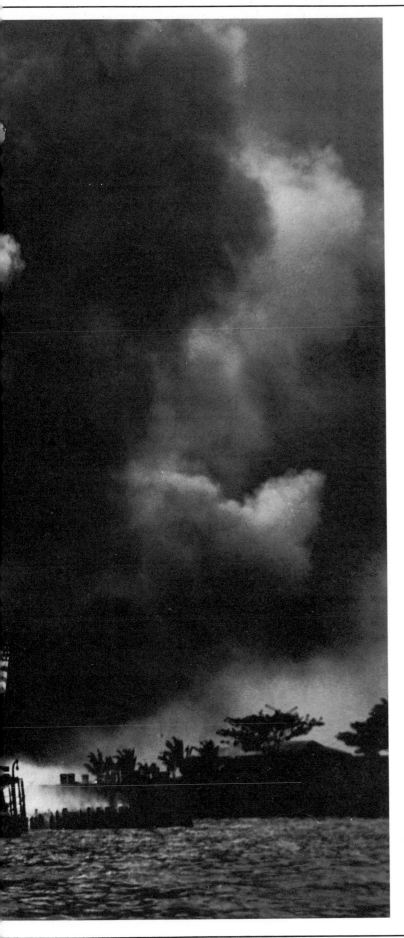

PEARL HARBOR
December 7, 1941

The Japanese attack on Pearl Harbor ought not to have been a surprise.

U.S. intelligence sources, which had steadily been decoding messages as they were transmitted from Tokyo to Japanese diplomats in Washington, knew that Japan was gearing up for something. In decoded messages, a deadline was given for the peace talks between the U.S. and Japan; if a resolution wasn't reached by November 29, then "automatically things are going to happen." On December 5, the Federal Bureau of Investigation warned officials at Pearl Harbor that the Japanese consulate was burning its confidential papers, and the night before Hawaii was attacked Roosevelt read yet another intercepted message—one that broke off all negotiations between the two countries.

At the same time, the military knew how vulnerable Pearl Harbor was, and how crucial it was to U.S. strength in the Pacific. Japan knew, too. For ten years prior to the attack, every graduating class at the naval institute in Japan found the same exam problem on their final—detail how you would carry out a surprise attack on Pearl Harbor.

Despite all of the blatant signposts, when Sunday morning dawned in Honolulu, the Americans were unprepared. The losses showed the lack of preparation. In only 2 hours, 8 battleships and 3 light cruisers were damaged or sunk; 188 planes were destroyed and almost 2,500 men were killed.

The Japanese had succeeded far beyond their expectations—their losses were minimal. Yet as the victorious force headed toward home, one of the leaders voiced disappointment that more American vessels had not been in port at Pearl. "I am afraid," he reportedly said, "that we have merely awakened a sleeping giant."

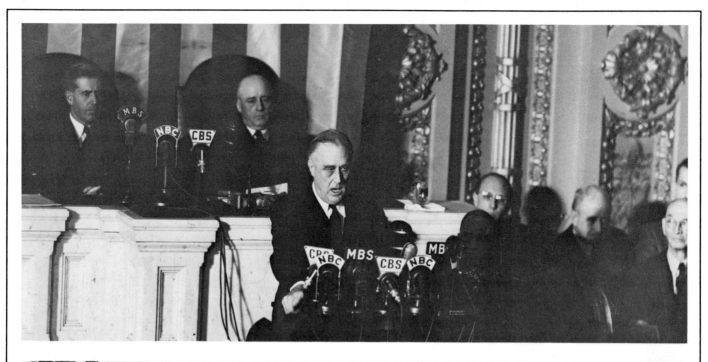

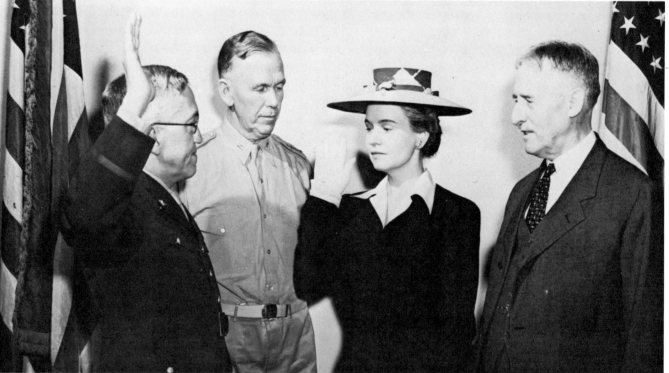

OVETA CULP HOBBY
May 16, 1942

One of the first American women to gain access to positions of power and authority, Oveta Culp Hobby organized the Women's Army Corps (WACs) and became a colonel and its first leader. Her program enabled women to serve in the Armed Forces in 239 noncombatant positions. She is shown here being sworn in, with General George Marshall and Henry Stimson as witnesses.

After the war, she served as the first Federal Security Administrator, then as the first Secretary of Health, Education and Welfare when HEW was formed in 1953.

After two years as the head of HEW, she returned to her home state of Texas to become the president of the *Houston Post*.

A DECLARATION OF WAR
December 8, 1941

A stunned and serious President and Congress met to declare war on Japan the day after Pearl Harbor was attacked. Roosevelt recalled the events of the day before, calling it "a date which will live in infamy," and Congress, which had of late been decidedly isolationist, resolved with FDR that the United States would "win through to absolute victory."

WORLD WAR II BOMBING OF SINGAPORE
1942

Singapore, often called the "Gateway to the Orient," was viewed as a crucial step in Japan's military strategy to rule the Pacific. Despite the presence of the British and the naval base at Sembawang, the Japanese were able to attack Singapore successfully and force the British to surrender on February 15, 1942. Here a mother and grandmother sob inconsolably after a bombing raid that left their child dead.

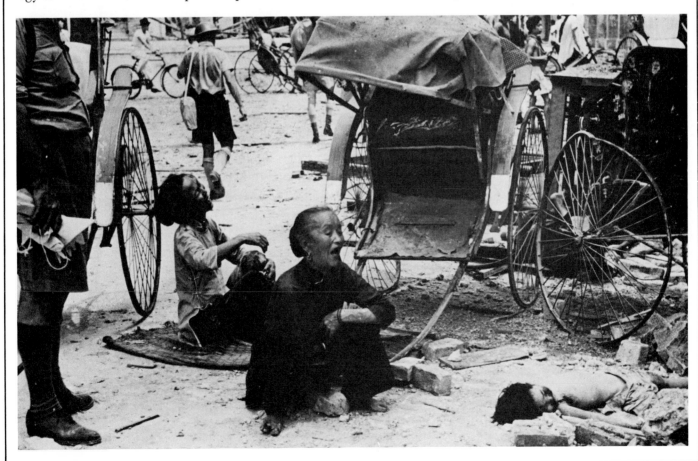

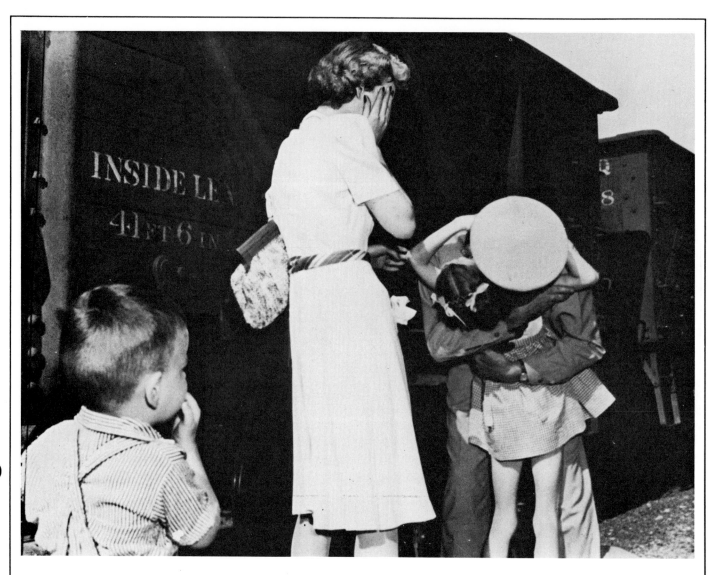

COMING HOME
July 15, 1943

Lieutenant Colonel Robert Moore had been overseas, fighting in the North African campaign against the German Field Marshal Rommel. He carried home with him the Distinguished Service Cross as he returned to Villisca, Iowa, his hometown. Everyone in the small town was waiting for him at the station, but most important of all were his wife, Dorothy, and his daughter, Nancy. When they rushed up to meet him, *Omaha World-Herald* photographer Earl Bunker recorded the emotional family reunion. As Moore swept up his daughter in an embrace, his wife stood nearby, overcome by her happiness and good fortune, knowing full well the agony other soldiers' families were experiencing. The poignant photograph won a 1944 Pulitzer Prize.

TEHERAN

November 28–December 1, 1943

It was the first of the "big three" leaders' conferences that Stalin attended and it resulted in the decision to invade France in June of 1944. The American general, Eisenhower, was made commander of the entire operation and the plans for D-Day were set.

During the conference at Teheran, Stalin secretly pledged that Russia would join the fighting in the Pacific against Japan after Germany was defeated. Stalin, Roosevelt, and Churchill, in the midst of war, looked ahead to peacetime, and to the formation of a United Nations organization to handle postwar problems.

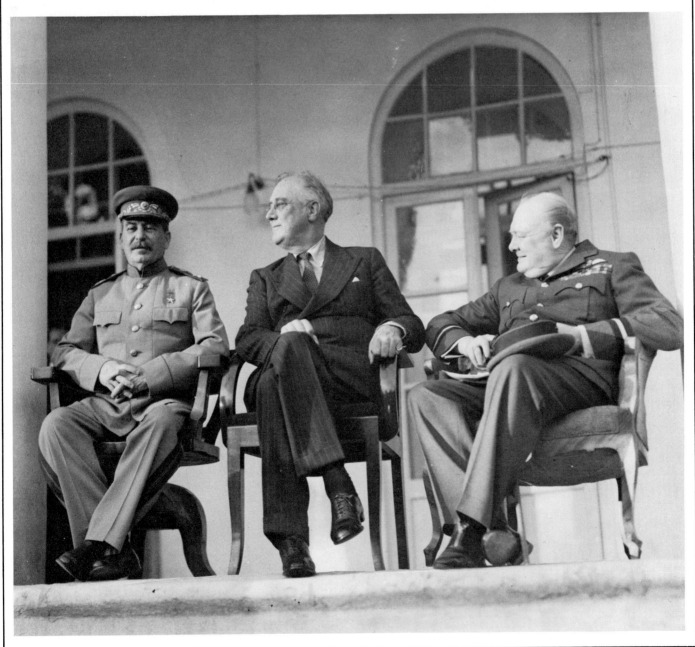

ULM, GERMANY

1944

By 1944 World War II was turning in favor of the Allied forces. Extensive air raids began on Germany, destroying military and industrial targets.

Ulm, an active river port city and rail junction, was almost completely demolished by the bombing. The cathedral, which dates back to the fourteenth century and is the largest Gothic cathedral in Germany, survived.

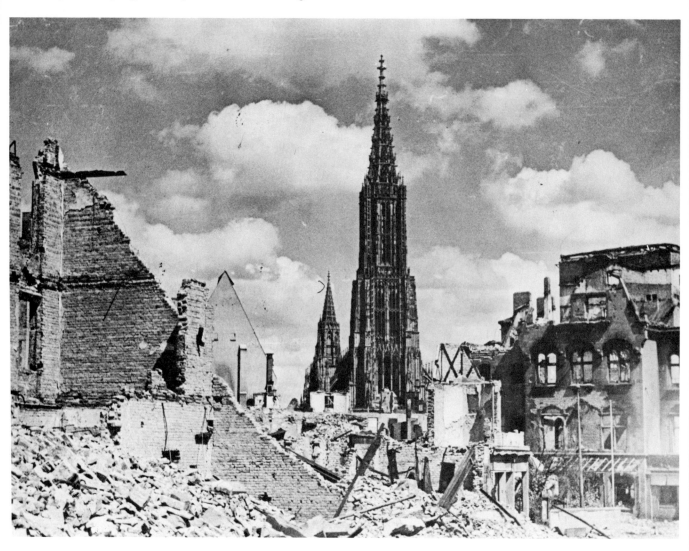

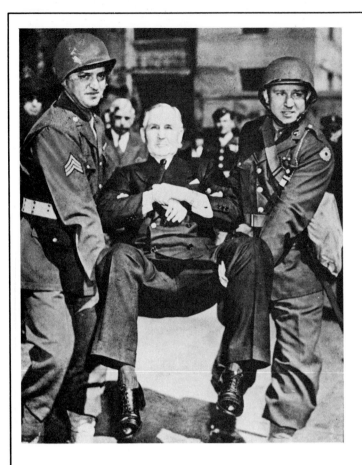

SEWELL AVERY
April 27, 1944

The Montgomery Ward department store chain, despite the war effort, went on strike after a labor contract expired, and FDR pressured Montgomery Ward chairman Sewell Avery to extend the expired contract. Avery, a staunch individualist, refused, decrying the "New Dealers." The Under Secretary of Commerce pleaded with Avery, as did then-Attorney General Francis Biddle, but to no avail. In the end two soldiers, Sergeant Jacob Lepak and Private Cecil Dies, were forced to carry Avery bodily out of his Chicago office.

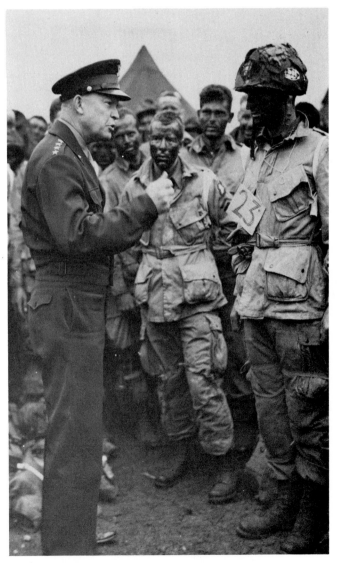

D-DAY
June 6, 1944

"You are about to embark upon a great crusade," General Dwight D. Eisenhower told his men assembled for the Normandy Invasion.

The Allied troops, led by their Supreme Commander, were part of a stunning attack force—almost 3 million men and 16 million tons of arms were deployed to the Normandy coast. Nine thousand ships were offshore, and more than 11,000 planes offered air support.

The attack, postponed a day because of bad weather, began at 6:30 A.M. on June 6, l944. Allied losses were heavy, but resulted in the establishment of a second front, a 50-mile stretch of French beach. The liberation of Europe had begun.

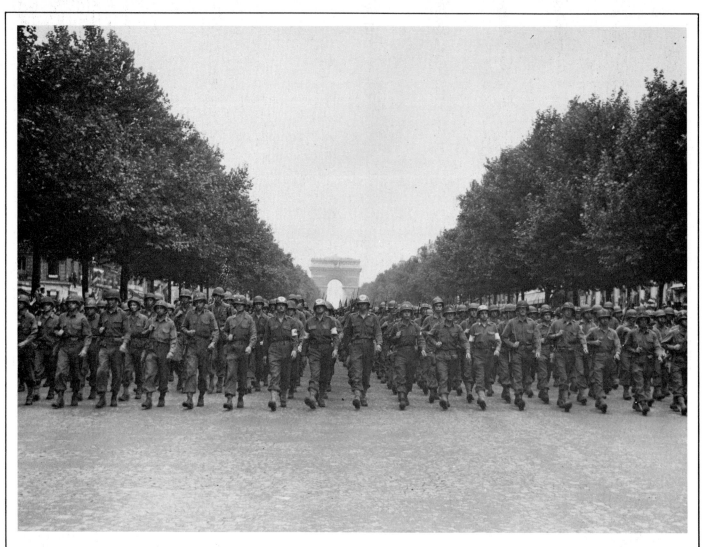

THE LIBERATION OF PARIS

August 25, 1944

Here American troops march along the Champs Elysées in Paris. After four years under Nazi rule, France was liberated, and the Allied forces had obviously reason for celebration. Germany was retreating on all fronts, and the Russians were gaining on them to the east. But the fighting was not over yet; the Battle of the Bulge still loomed ahead.

LEYTE GULF

October 23–26, 1944

By late 1944, the Americans were hopping from island to island in the Pacific, slowly winning the area back from the Japanese.

The battle for Leyte Gulf was decisive. The Japanese suffered tremendous losses—three battleships, four carriers, ten cruisers, and nine destroyers—almost its entire fleet. In terms of tonnage of equipment involved, this was the largest naval battle in history.

General Douglas MacArthur, Supreme Commander of Allied Forces in the Southwest Pacific, is shown here as he strides ashore onto Leyte Island with a group of United States and Philippine officers.

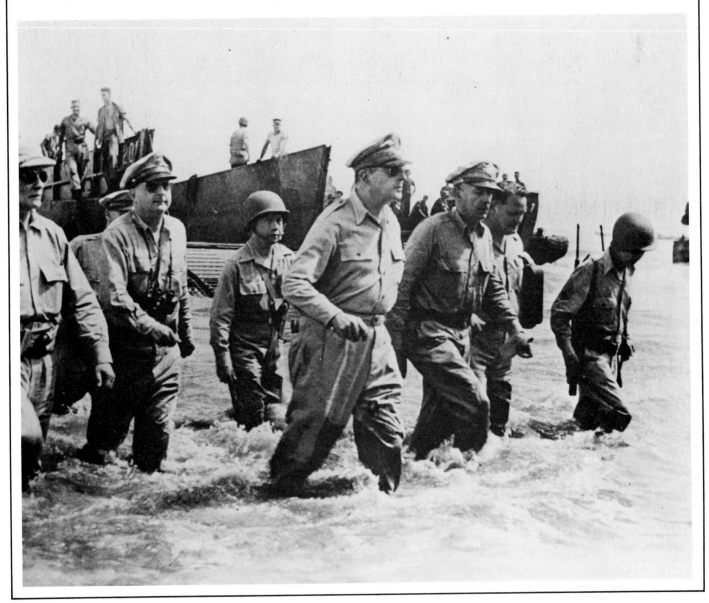

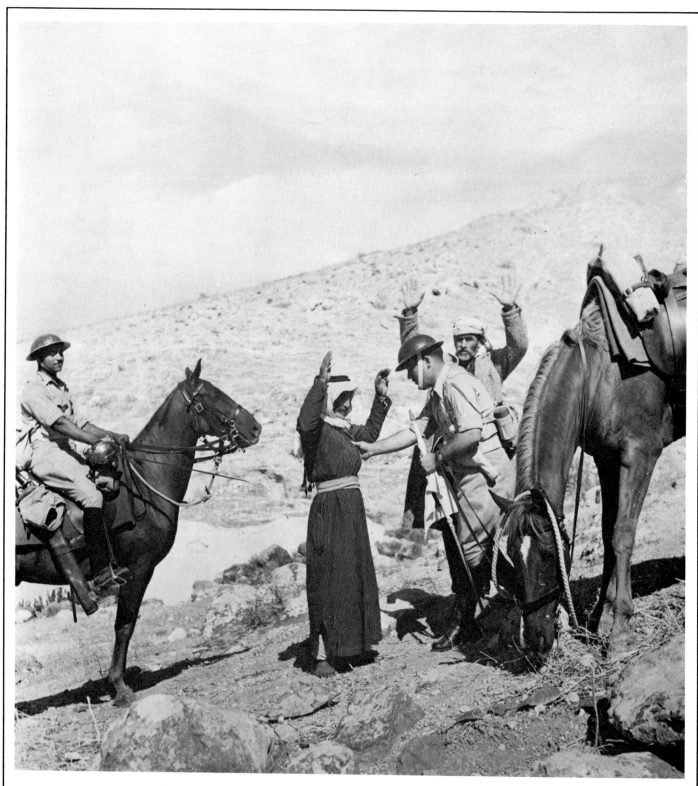

ARABS INTERCEPTED
AT THE ISRAELI BORDER
1945

The tension is as old as history. Crammed into a relatively small area in the Middle East are the Israelis, who carved a homeland for themselves out of a desert in the years after World War II, and the Arabs, the enemy who had sworn to eradicate them. Here, Arabs are intercepted at the Israeli border.

In 1978 a glimmer of hope shone through the grim situation, when the president of Egypt and the Israeli prime minister met for the first time to discuss the prospects for a lasting peace.

YALTA

February 4–11, 1945

Left to right: CHURCHILL, ROOSEVELT, STALIN

The fighting had been going on for almost five years for the United States, longer for Europe. The three leaders of the Allied nations were visibly worn when they met at Yalta to plan their strategy. They arranged the founding conference of the United Nations, and Russia reiterated her pledge to join in the fighting against Japan.

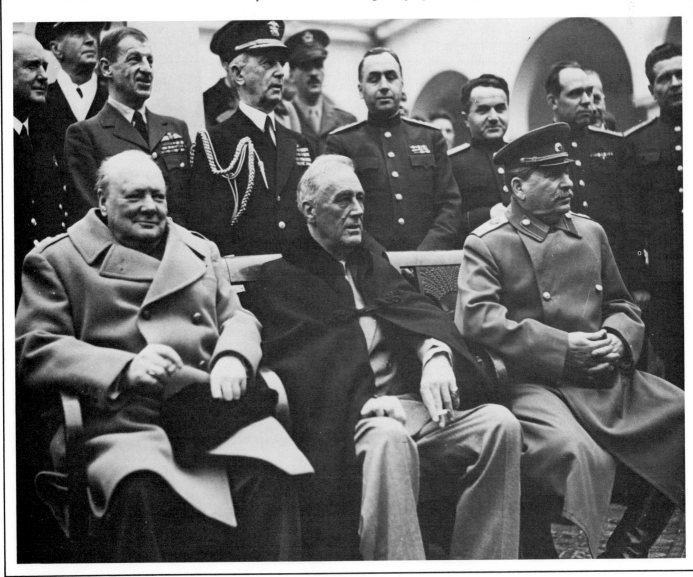

IWO JIMA

February 23, 1945

The picture is a familiar one and has become the symbol of the hard-fought battles and team effort that characterized the U.S. involvement in World War II.

This popular photograph of the raising of the flag on Iwo Jima was posed—reenacted for a photographer after the original flag had been hoisted.

A Marine sergeant had recorded the actual flag raising for the Marines' magazine *Leatherneck*, but just after the photos were taken, a Japanese soldier burst out from hiding and hurled a grenade at the photographer's feet. The sergeant dove down the slope to avoid the blast and, when he took inventory, discovered his camera had been smashed in the tumble and the film destroyed.

Taken by Joe Rosenthal, this photograph won a Pulitzer Prize in 1945.

MUSSOLINI

April 29, 1945

After the collapse of the German-backed government in Italy, Benito Mussolini was caught, tried in a summary court-martial, and sentenced to death.

On April 29, 1945, at four o'clock in the morning, twenty-three corpses were unloaded in the Piazzo Loreto in Milan. Among the bodies were fifteen prisoners from the Fascist troops; Starace, the former Party Secretary; Mussolini; and Mussolini's mistress, Clara Petacci. The bodies were hung upside down from the roof of a petrol station with rough signs of identification. That evening, they were removed and buried.

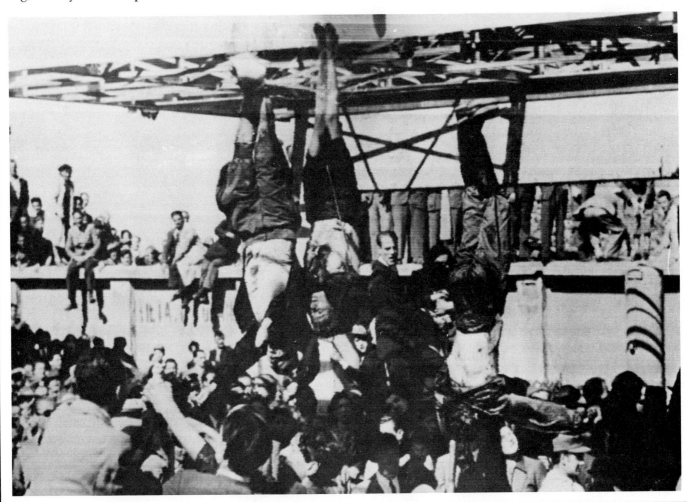

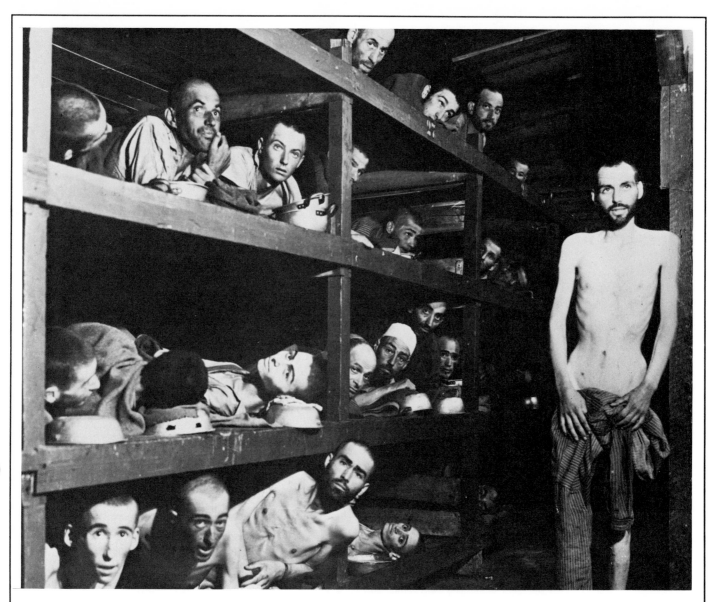

THE HOLOCAUST
1933–1945

The Nazis shocked the world with their power and aggressiveness. But it wasn't until they began to lose the war, and until the Allies advanced into German territory, that the world realized the horrible legacy the Nazis had left—a legacy of concentration camps, genocide, and torture.

The liberation forces found labor camps filled with starving workers who had been stripped of their possessions and separated from their families.

They also discovered that six million Jews had been systematically exterminated. Some groups were shot, others gassed, and still others perished from starvation, exposure, or disease. Before their deaths, many were used for unthinkable "scientific" experiments.

Here, slave laborers at Buchenwald concentration camp are photographed inside their barracks.

V-E DAY
May 8, 1945

There was yet another victory to be won in the Pacific, so enthusiasm was tempered by that knowledge. However, after four long years of World War II, America was justifiably jubilant when peace was declared in Europe and a German surrender was signed. Here, a sailor celebrated with a kiss in Times Square.

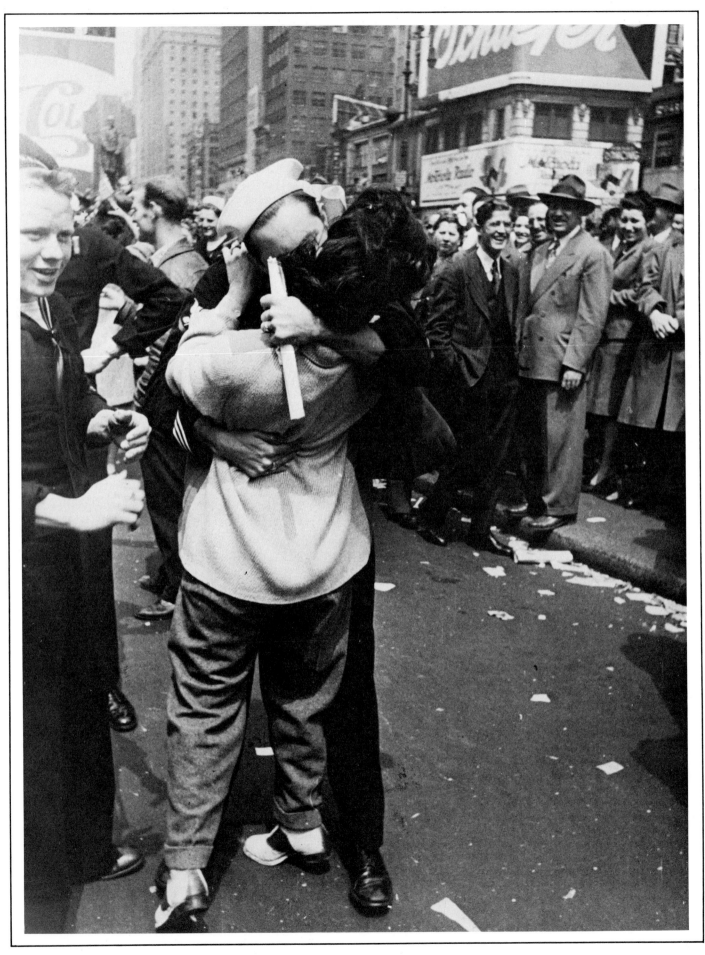

121

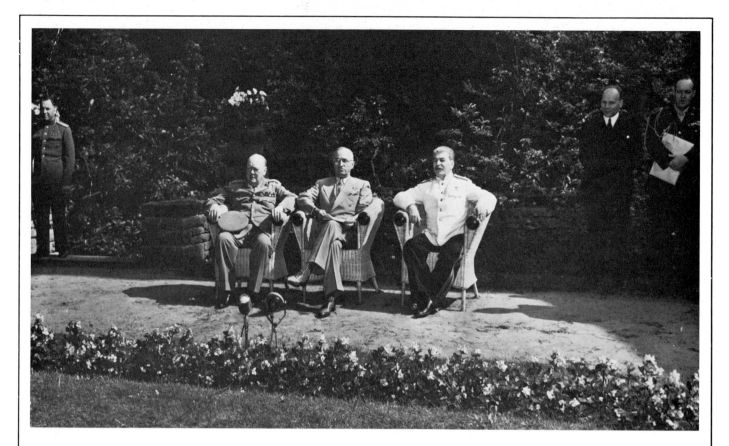

POTSDAM

July 25, 1945

Left to right: CHURCHILL, TRUMAN, STALIN

The war's end was clearly in sight, and the Allied leaders met to agree on just how the Axis powers were to be disarmed and ruled.

The Potsdam Agreement was forged—dividing Germany into four zones of occupation. The agreement was designed to abolish Nazi ideology and to prevent Germany from ever again becoming a military power.

This photograph was taken the day before the Potsdam Declaration was released. While the declaration did not specifically mention the atomic bomb, it made clear that Japan had two alternatives—either surrender unconditionally or face total destruction.

Ultimately, the Potsdam Agreement was violated. The French, because they were not represented at the conference, did not feel bound by the dictates of the agreement and moved to block the Allied Control Council. But there were additional problems with the Allied Control Council, which was intended to deal with matters affecting all of the occupied zones. Relations between the USSR and the West began to cool, and the Council was dissolved.

HIROSHIMA

August 6, 1945

Not even the size of the mushroom-shaped cloud, as awful as it was, betrayed the scope and power of the bomb that produced it. This armed services photograph was taken by a serviceman who was aboard one of the three planes that dropped the atomic bomb over Hiroshima. The weapon was the result of the ultrasecret Manhattan Project, which had corralled the nation's top physicists in the southwest. Until the bomb was dropped, no one knew for sure whether it would operate properly; a weapon of this kind had been tested only once before. In the days and months and years ahead the nation and the world learned just how well it had worked.

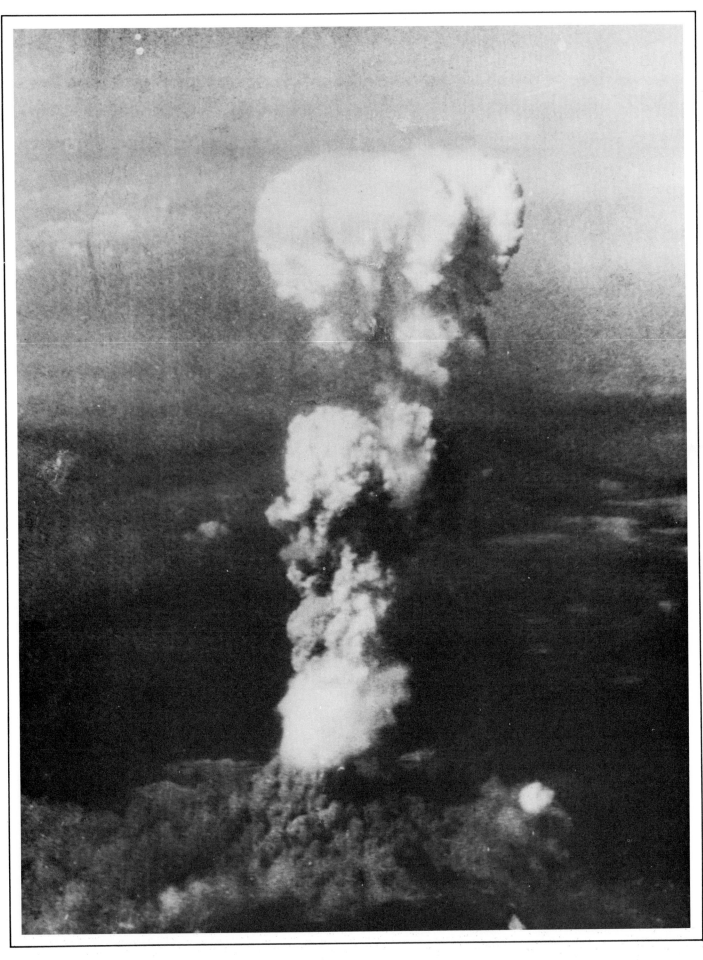

123

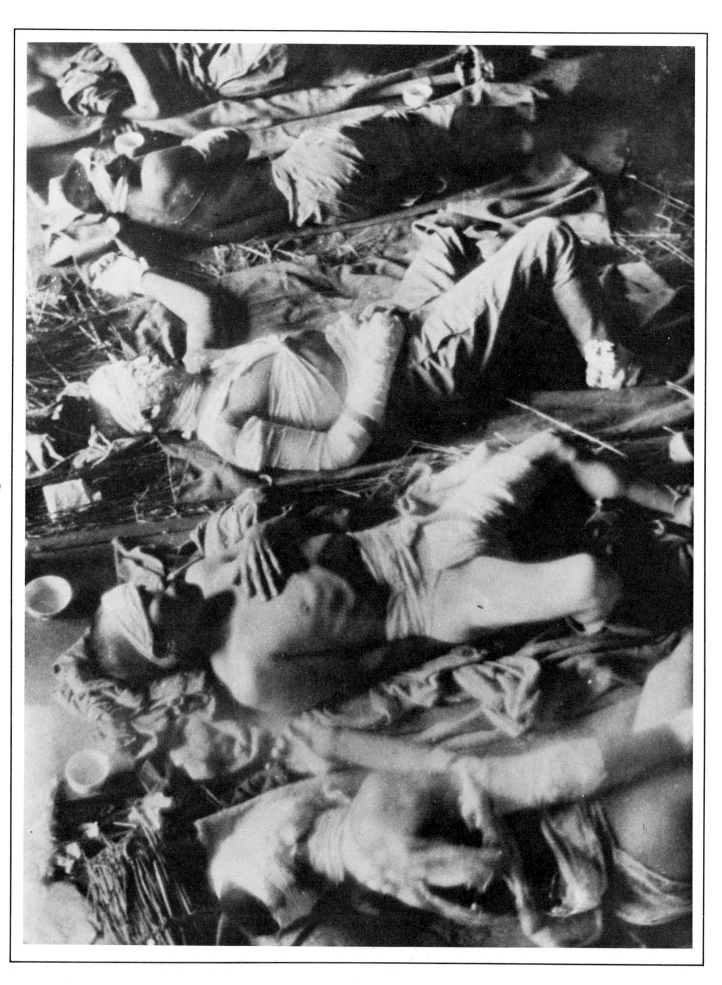

HIROSHIMA

August 6, 1945

When the United States exploded an atomic bomb 1,800 feet above Hiroshima, all buildings within a half mile of ground zero were immediately demolished. The heat ignited fires throughout the city, flash-burns killed people directly exposed to the heat within a mile of the point of explosion. The blast pressure radiated out, sending a shock wave that caused damage within a two-mile circle.

Intense radiation killed victims within a mile of ground zero, and radiation caused sickness that showed up in a day or two for persons within two miles.

In all, 140,000 were killed or injured by the blast, and an indefinite number later perished from the effects of radiation. The city was destroyed within approximately five miles of the blast, and after Nagasaki was similarly hit three days later, the Japanese government surrendered, marking the end of World War II.

JAPANESE SURRENDER, WORLD WAR II

August 1945

The Nagasaki atomic bomb on August 9 and the Russian invasion of Manchuria and declaration of war against Japan left little doubt that the Japanese

were finished in World War II. On August 14 the Allies received a surrender, and a few weeks later, aboard the battleship *Missouri* in Tokyo Bay, the surrender agreement was signed. MacArthur signed for the United States and the Japanese Foreign Minister, Mamoru Shigemitsu, formally signed for Japan.

125

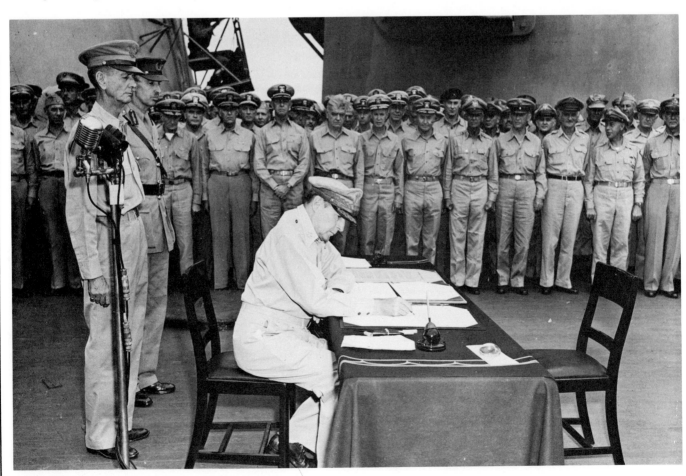

NUREMBERG TRIALS

November 1945–October 1946

As World War II wound down, Germany's persecution and extermination of Jews and other ethnic and religious groups became an international issue. The Allies brought Germany's leaders to trial. The trials were held in Nuremberg, Germany, the site where the Nazis had held their national assemblies and congresses, where they had voted in the "Nuremberg Laws" that forbade a German to marry a Jew, and where the hated swastika was declared the national symbol.

Hitler and some of the other top ten leaders were dead, but twenty-two high officials of Nazi Germany came to trial, including Hermann Goering, Rudolf Hess, and Joachim von Ribbentrop. No country's leaders had ever been brought to account for crimes after a defeat—and a significant precedent was set.

In this photograph of the accused, Rudolph Hess sits second from the left with his arms crossed. Ernst Kaltenbrunner, absent at the beginning of the trial due to a cranial hemorrhage, sits in the front row, fifth man from the left.

126

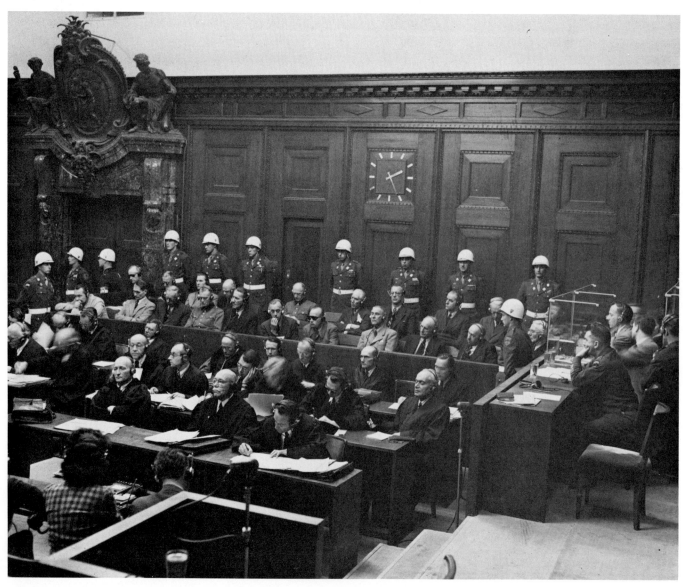

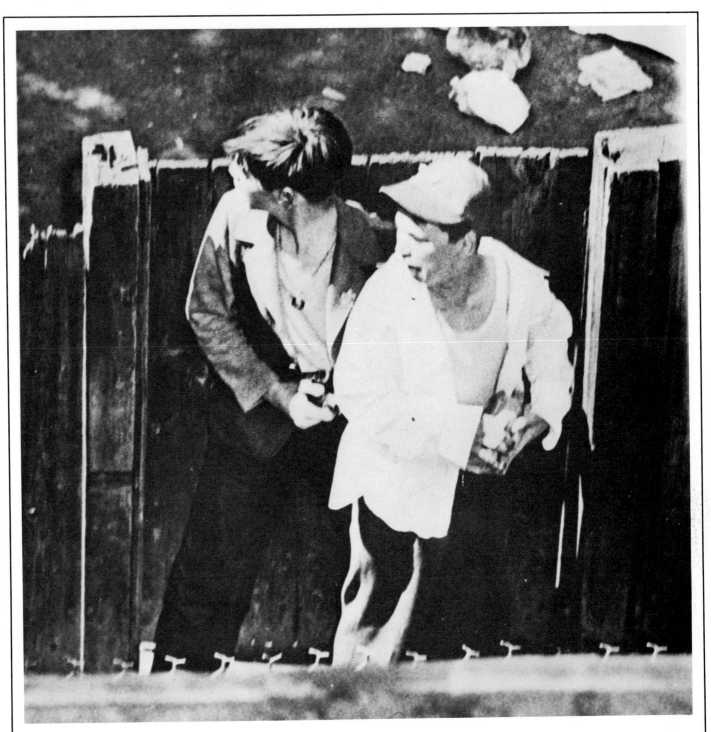

CHILD'S PLAY
June 23, 1947

The gunman, Ed Bancroft, was only a boy fifteen years old, and no one knew where he had gotten the gun or why he wielded it so ferociously. But when Boston policemen stopped to question the child who was carrying a suspiciously bulky piece of cloth, he shot at their car, wounding one of the officers, and started to run.

Ducking down a street, and finally into an alley, he took a hostage, another fifteen-year-old, Bill Rowan, and threatened to kill him. Soon three divisions of police arrived, and one officer crept up from behind while the boy was being distracted. Bancroft was disarmed.

This photo, winner of a 1948 Pulitzer Prize, was taken from the roof of a building that overlooked the alley by *Boston Herald* photographer Frank Cushing.

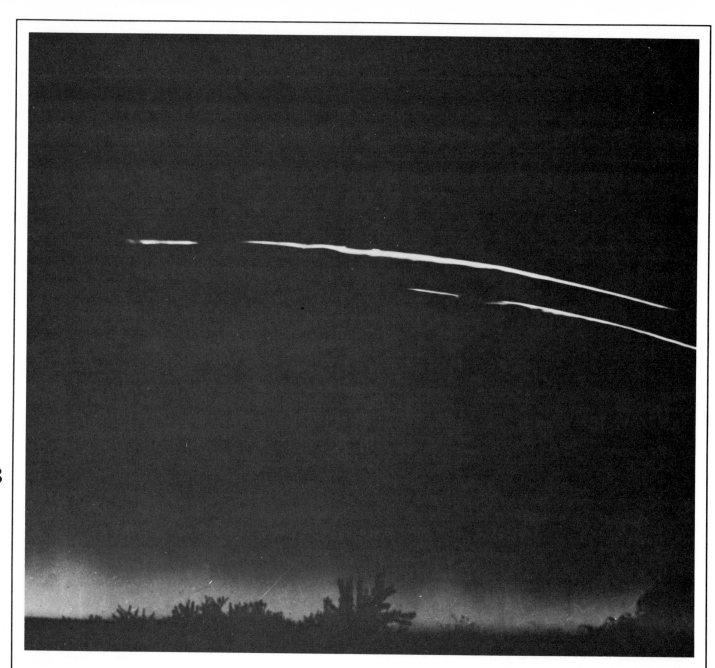

128

UFO SIGHTING
July 8, 1947

Reports came in from all over Kentucky about three glowing objects that flashed across the sky at about 10:30 at night, but no one, including the authorities, could figure out what these strange lights were. The weather bureau reported that most of the callers dubbed the objects "flying saucers." They went down in reports as "unidentified flying objects," the first of numerous such reports. Over the years, scientists have offered many terrestrial explanations for the sightings, but to many they're still "flying saucers."

THE BIRTH OF ISRAEL
May 14, 1948

Late afternoon, May 14, 1948. David Ben-Gurion, soldier and statesman, read a statement: "By virtue of the national and historic right of the Jewish people and the resolution of the United Nations, we hereby proclaim the establishment of the Jewish state of Palestine . . . to be called Israel."

A dream that had been kept alive for hundreds of years, a dream that had survived the Diaspora and the Holocaust, was thus realized: the rebuilding of the Jewish state.

Israelis knew that their work had only begun. That same day they were invaded by the Arabs, who would threaten their security for years to come.

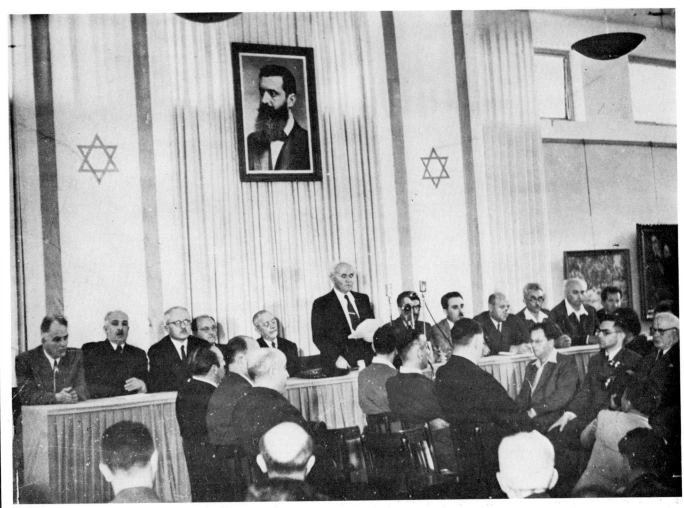

BABE RUTH
June 13, 1948

The band in Yankee Stadium struck up "Auld Lang Syne" as George Herman (Babe) Ruth slowly walked onto the field for the last time. The fans and Ruth knew that their "old acquaintance" certainly had not been forgotten. The fans loved this man, whose record of 714 home runs stood until 1974.

The Babe had quit playing ball in 1935 because of illness. On this day in 1948 he leaned on his bat for a moment, and the world took notice of just how sick he was. Two months later, the "Sultan of Swat" was dead from cancer.

This Pulitzer Prize-winning photograph was taken by Nat Fein of the *New York Herald Tribune.*

130

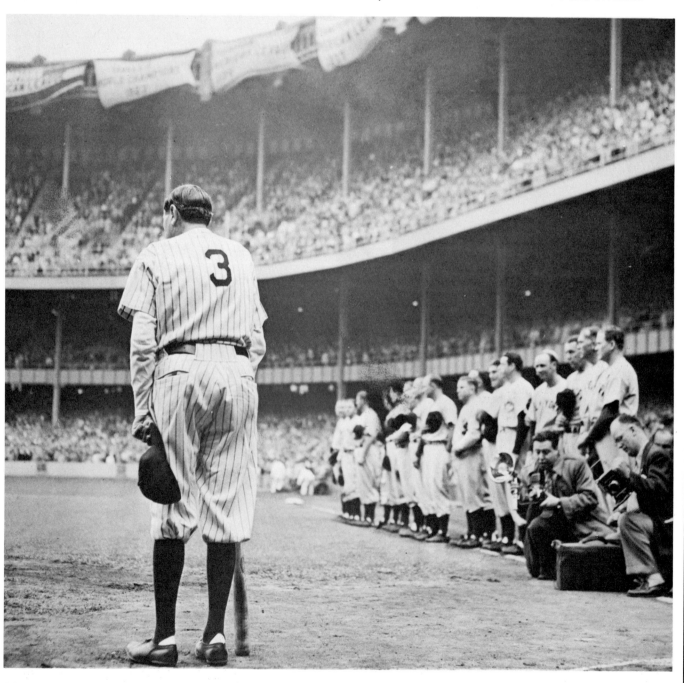

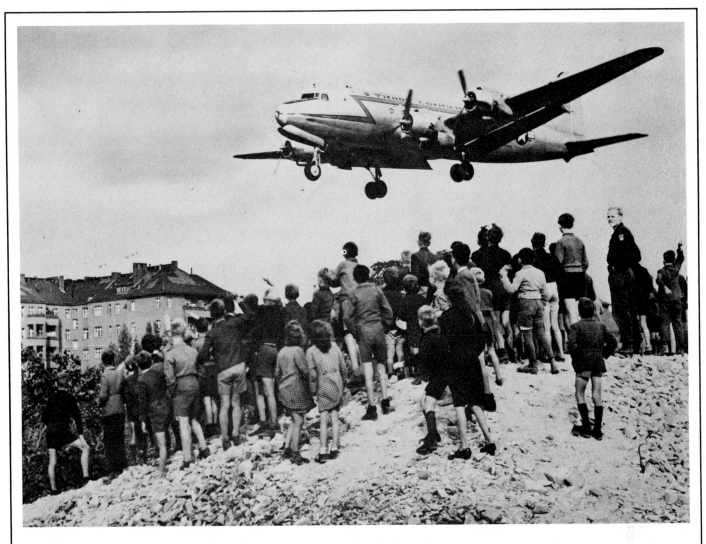

THE BERLIN AIRLIFT

June 1948–September 1949

"Operation Vittles," was the high-spirited slang name for the mission, but the nature of the trips was deadly serious. The Soviet Union, in an attempt to drive the Western forces out of Berlin, had blocked all rail, water, and highway traffic through East Germany to West Berlin. France, Great Britain, and the United States responded by flying in supplies, food, coal, and petroleum for the besieged Germans.

Technically, the missions were a wonderment. In more than 250,000 flights made by British and American planes, more than 2 million tons of supplies were delivered—a figure greater than all of the weight carried by commercial flights in the U.S. during the year 1949.

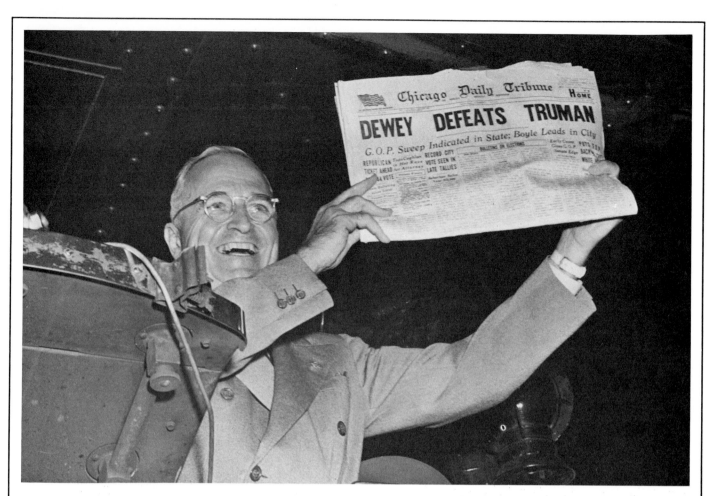

HARRY TRUMAN
November 4, 1948

"Give 'em Hell Harry" never looked so happy.

It was November 4, 1948, and Harry Truman was running for the presidency. He had already served almost a full term after the death of Franklin Roosevelt, but this was his first time at the top of the ticket.

All of the public opinion polls were running against him. The Gallup poll showed that 49.5 percent of America wanted Mr. Dewey in the White House, while only 44.5 percent planned to vote for Truman. The Roper poll found that 52.2 percent of the voters preferred Dewey over a scant 37.1 percent for Truman.

The pollsters were not the only ones predicting a Dewey victory. Newspapers all over the country agreed. In New York, the *Times,* the *Herald Tribune,* the *Sun,* and the *Journal American* all agreed that it looked like a Dewey-Warren win.

Election night stretched out interminably. It wasn't until 4 A.M. that the results seemed clear. Truman, against all odds, declared victory from campaign headquarters in Kansas City.

Later that morning, he boarded the train back to Washington. At the first stopover, in St. Louis, someone handed him a copy of the previous day's *Chicago Daily Tribune.* The headline—and Truman's grin—told it all.

Don't jump the gun on the man from Missouri.

AXIS SALLY
March 10, 1949

Mildred (Axis Sally) Gillars leaves the U.S. District Court building in Washington after being found guilty of treason. Gillars's undoing was the part she played in a radio broadcast, "Vision of Invasion," in which she tried to discourage the very successful Normandy landing.

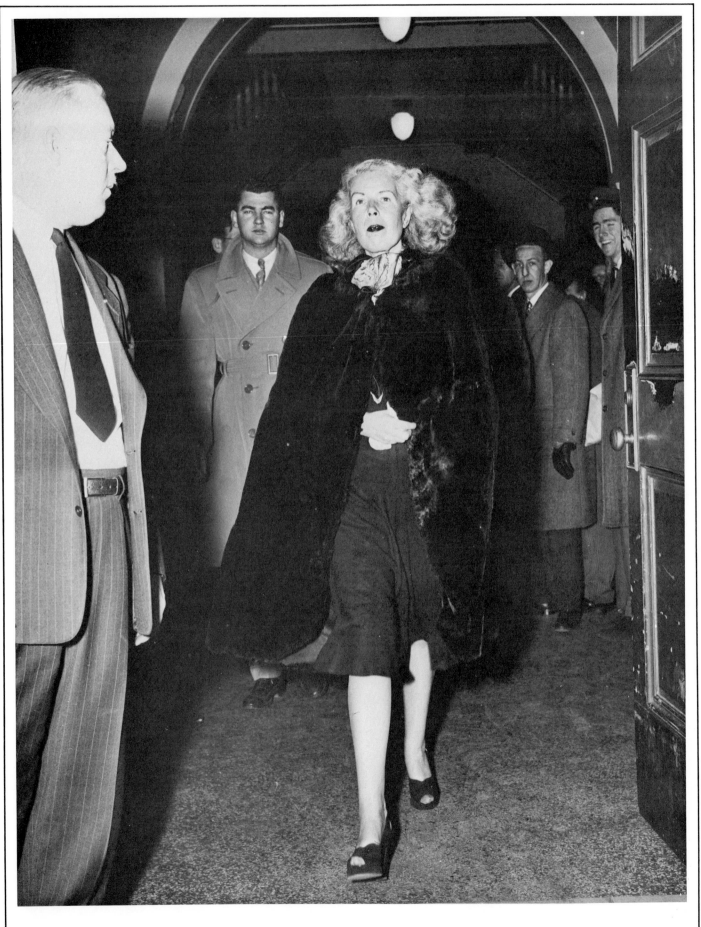

133

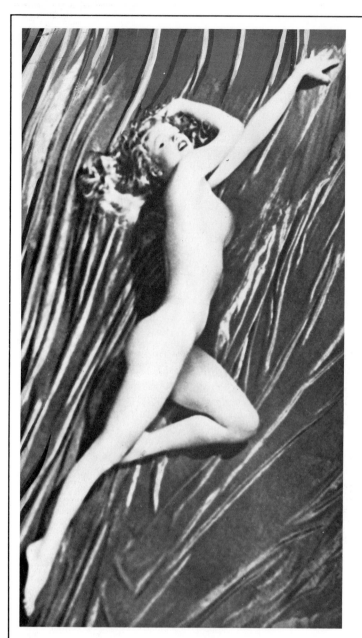

MARILYN MONROE
1949

She was the epitome of the superstar who was adored by millions but felt love from no one.

First she was Norma Jean Baker, the illegitimate child of a woman who entered a mental institution when Norma Jean was five years old. She was raised in orphanages and married at fourteen.

Then, after some modeling success, she became Marilyn Monroe, one of the world's most famous sex symbols, projecting femininity, sensuality, and a childlike vulnerability.

She began in the movies with just bit parts, but by the time of her tragic death on August 5, 1962, at the age of thirty-six, she had appeared in a number of features that showed her real talent as an actress: *Niagara* (1952), *Gentlemen Prefer Blondes* (1952), *The Seven Year Itch* (1955), *How to Marry a Millionaire* (1953), *Bus Stop* (1956), *Some Like It Hot* (1959), and her last film, *The Misfits* (1961).

She was *Playboy*'s Playmate of the Month in its initial 1953 issue, but this nude calendar photograph caused an immediate stir. In 1949, desperately in need of money, she struck this pose for fifty dollars. The calendar eventually sold almost eight million copies. The photo had its first national exposure in *Life* magazine, which successfully defused the troublesome issue by publishing a sympathetic account of Miss Monroe's problems at the time it was taken.

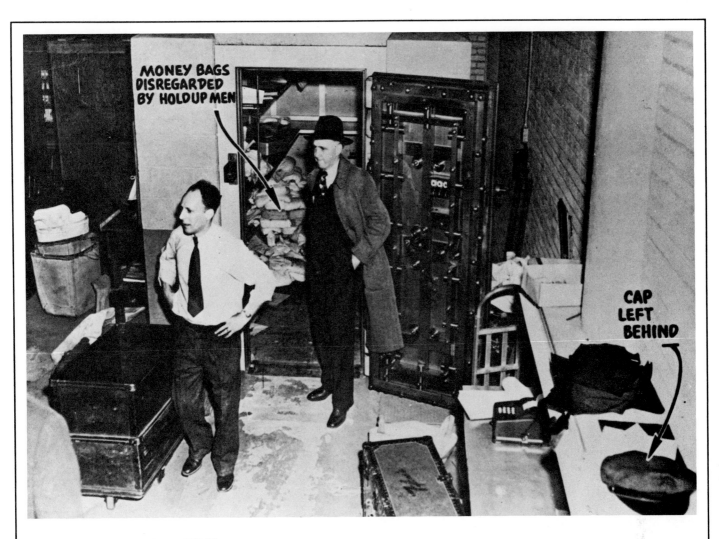

MONEY BAGS
DISREGARDED
BY HOLDUP MEN

CAP
LEFT
BEHIND

THE BRINKS ROBBERY

January 17, 1950

Nine gunmen carried out a million dollars in cash, a half a million in checks. When they left, they were cursing because they had to leave some behind. They had just robbed the Brinks Armored Car Company in Boston, tying up five guards in the process.

It was later discovered that the locks at Brinks were ridiculously easy to pick.

Six years later, just six days before the statute of limitations ran out, eleven men were caught and $50,000 of the money was recovered. The gunmen turned out to be small-time hoods, not members of organized crime as had originally been suspected.

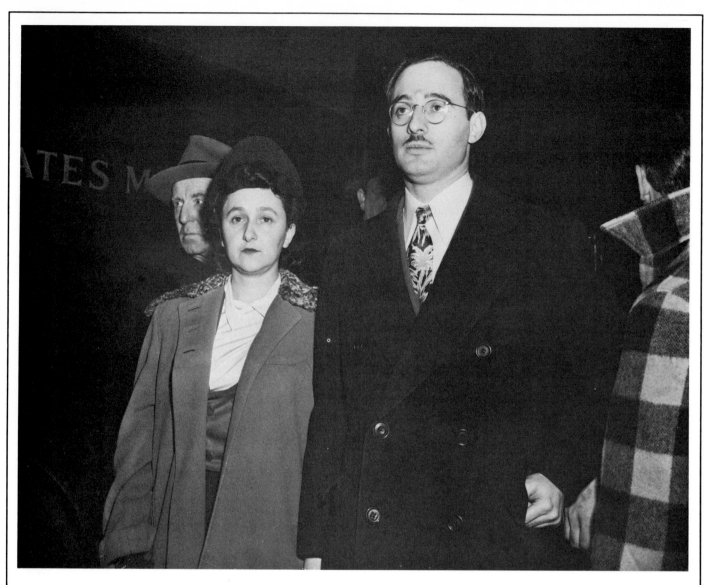

JULIUS AND ETHEL ROSENBERG
March 21, 1951

The first civilians ever to get the death penalty in an espionage case, Julius and Ethel Rosenberg were indicted for conspiring to transmit classified military information to the Soviet Union. In a case that still swirls in controversy, the Rosenbergs were found guilty after Ethel Rosenberg's brother testified that they had persuaded him to obtain top secret information on nuclear weapons so that they could pass it on. The Rosenbergs were executed on June 19, 1953, but serious questions remain as to the reliability of the witness, the harshness of the penalty, and the impartiality of the jury.

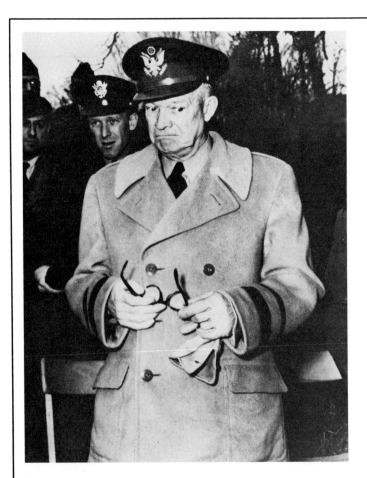

DWIGHT D. EISENHOWER
April 11, 1951

"Well, I'll be darned." That was General Dwight D. Eisenhower's immediate reaction in Koblenz, Germany, to the news that President Truman had summoned General Douglas MacArthur back from Korea and relieved him of his command.

Later, in response to a reporter's query concerning the controversial firing, Eisenhower said simply, "When you put on a uniform, there are certain inhibitions which you accept."

137

ADLAI STEVENSON
1952

This was the first of Adlai Stevenson's two unsuccessful campaigns for the presidency of the United States. Stevenson had a reputation for being an intellectual, an aristocrat, an "egghead." Some people doubted his ability to understand to the average American.

But when Stevenson spoke to the Democratic party, on July 26, 1952, as their presidential candidate, he spoke quietly and soberly to all Americans: "Let's talk sense to the American people. Let's tell them the truth, that there are no gains without pains."

Sometime after the Democratic Convention in Chicago, Stevenson stopped in Flint, Michigan, for a rally. Sitting in a comfortable chair, stealing a few moments to work on his speech before facing the crowd, Stevenson was photographed by a local newspaperman. Anyone who had ever trudged a few too many miles in an old pair of shoes could sympathize with all the pains this man was going through to make his gains.

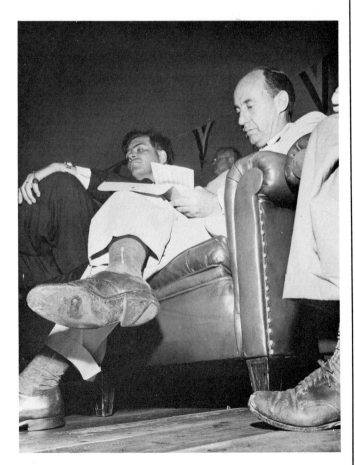

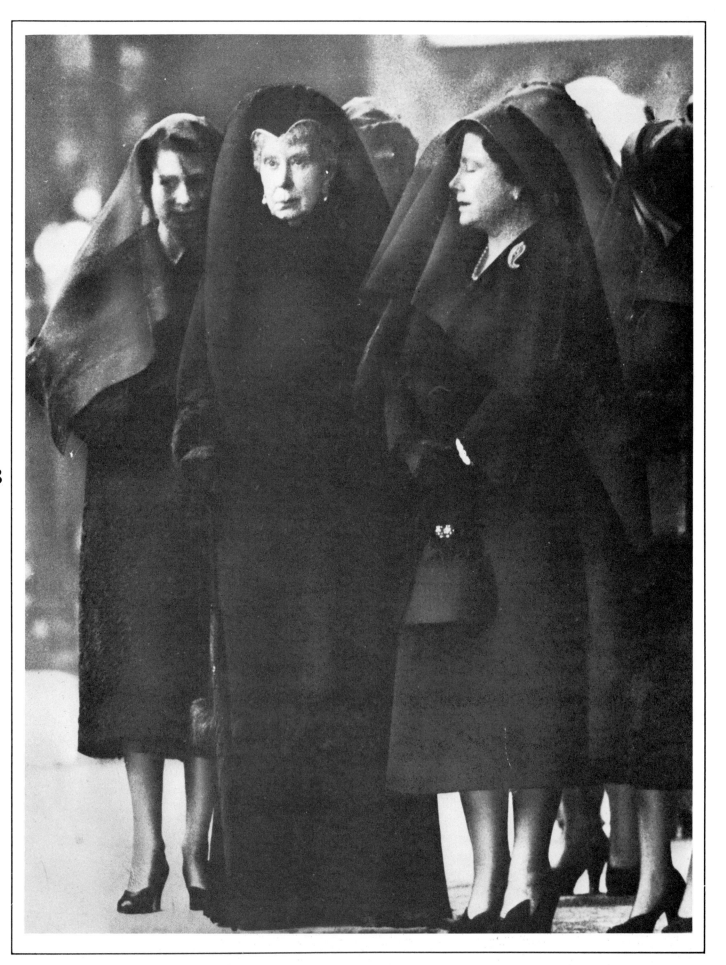

138

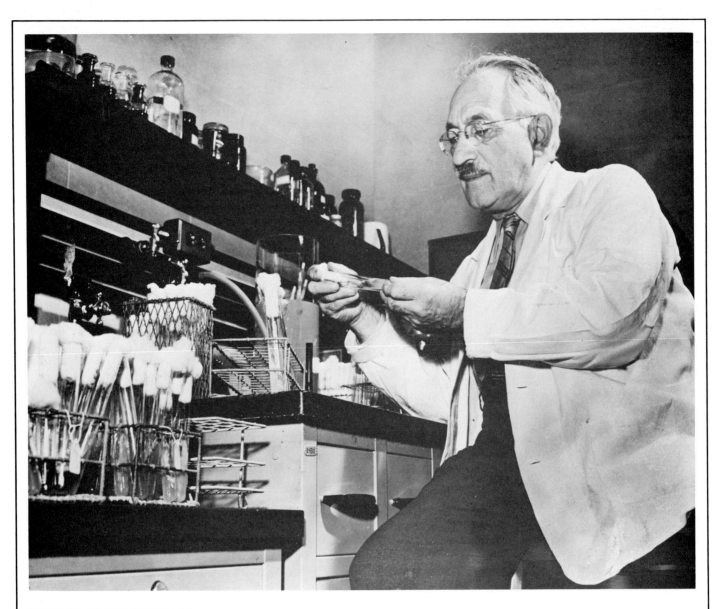

SELMAN WAKSMAN
1952

The 1952 winner of the Nobel Prize for Medicine was Selman Waksman, an American biochemist who discovered several antibiotics, most notably strepto-mycin and neomycin. The two were discovered in the rich soil near Waksman's laboratory at Rutgers University in New Jersey.

THREE QUEENS IN MOURNING
February 15, 1952

Queen Elizabeth II, Dowager Queen Mary, and the Queen Mother Elizabeth stand under a canopy at Westminster Hall in London. The coffin of King George VI is carried in to lie in state as the royal family watches with dignified grief. *Life* magazine quoted a Rebecca West description of Queen Mary's expression—"the astonished protest that women feel when their children have died before them."

TRUMAN, EISENHOWER, NIXON, AND HOOVER
January 20, 1953

At no time does the American system seem to work more smoothly than at presidential inauguration time. In 1953, as Dwight David Eisenhower was taking over the White House from Harry Truman, President Herbert Hoover and future President Richard Nixon (Eisenhower's Vice-President) were on hand for the changing of the guard.

JOSEPH STALIN
March 5, 1953

Joseph Stalin's death, on March 5, 1953, marked the end of an era of repression and tyranny in Russia.

Though Russia's economy advanced under Stalin's power, he masked the benefits by employing an absolute autocracy that inhibited and silenced much of Russia's populace throughout most of his twenty-nine-year reign.

Stalin, born Iosif Vissarionovich Dzhugashvili, was accused of tyranny by numerous leaders, including Khrushchev, who in 1956 denounced the dictator's tactics.

In 1961, the Kremlin moved Stalin's body from the mausoleum, where it rested next to Lenin's body, to a cemetery near the Kremlin Wall.

140

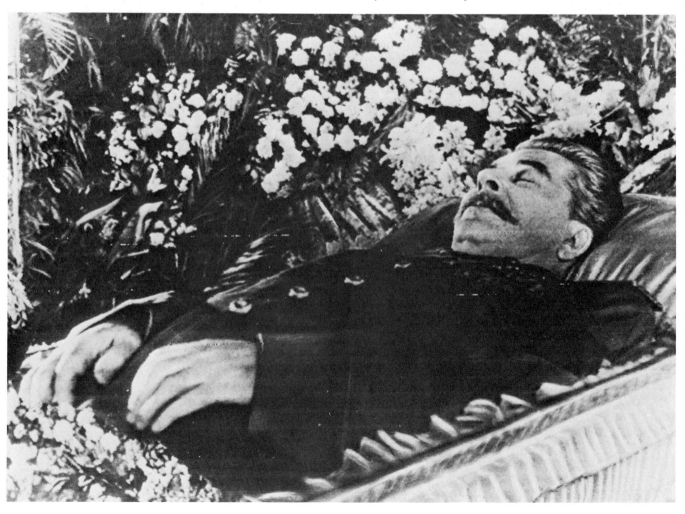

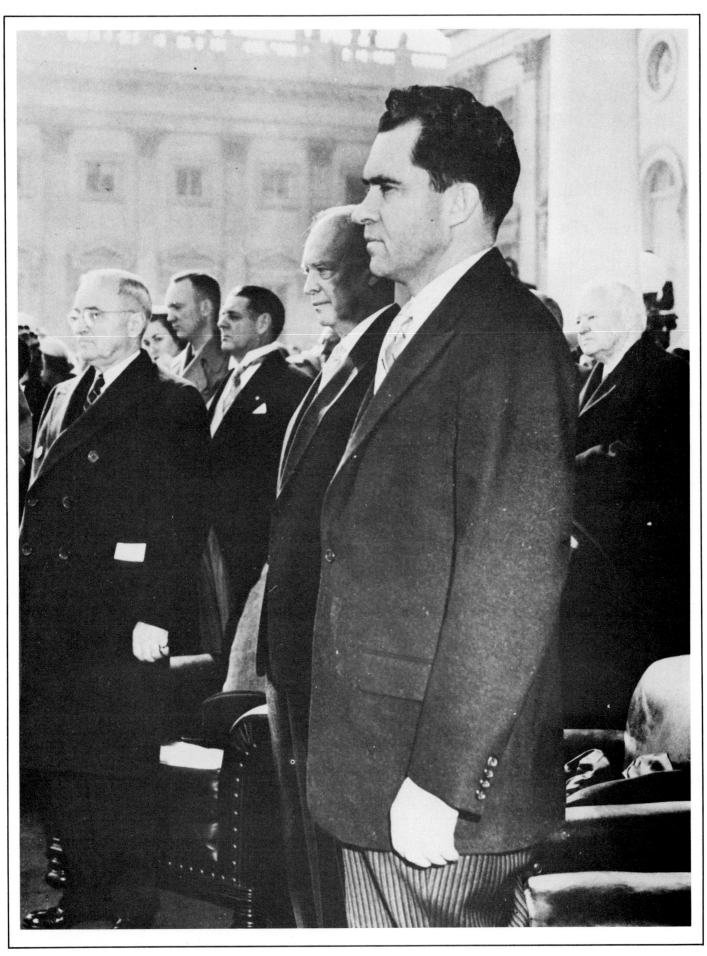

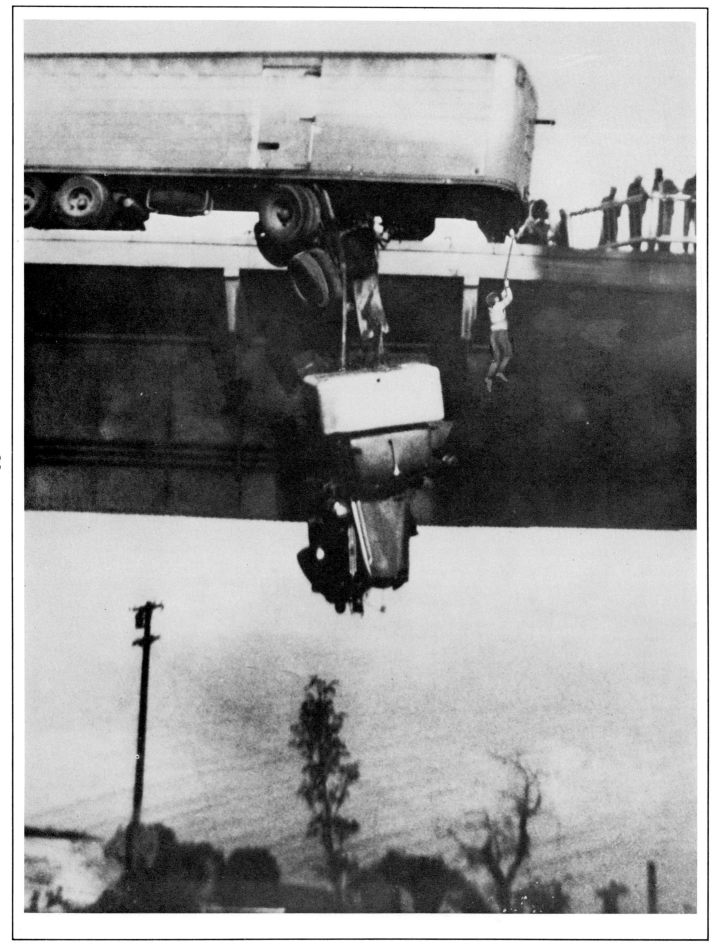

142

PIT RIVER BRIDGE RESCUE
May 3, 1953

The lives of two men were hanging by a thread that, miraculously, held on long enough. Walter and Virginia Schau were on a weekend fishing trip, driving toward Redding, California, and approaching the Pit River Bridge, when they saw that a tractor trailer ahead of them had just plunged off the bridge. Two truck drivers were trapped inside. While Walter Schau and the driver of another car lowered a rope down to the cab of the truck, his wife snapped this Pulitzer Prize-winning photograph on a small hobby-ist's camera. Meanwhile, P. M. Overby ascended to safety. Minutes later his colleague, Hank Baum, was also lifted to the bridge, and not a minute too soon. The burning fuel in the truck seeped into the cab and as the whole cab was engulfed in fire, the thread snapped and the cab fell.

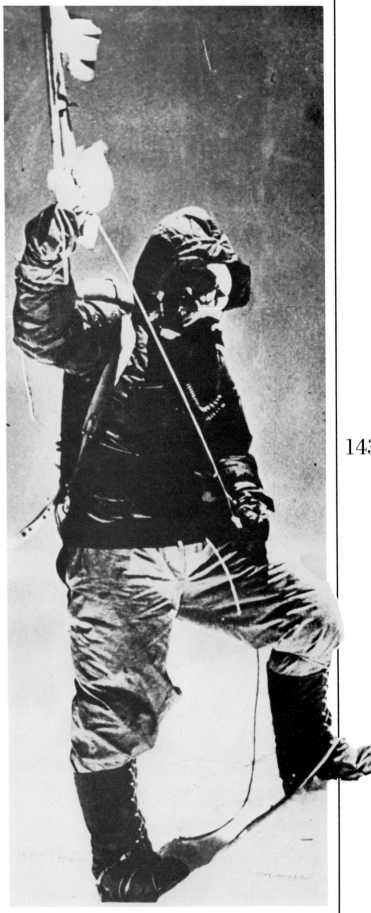

143

THE CONQUEST OF EVEREST
May 29, 1953

The Everest summit, at 29,028 feet, towers above the whole world. The British explorer Sir Edmund Hillary and a Nepal man, Tenzing Norkay, got a glimpse of it all when they became the first men to reach the top of the highest mountain. In this photo, Norkay firmly plants the flags of Great Britain, India, and Nepal at the summit.

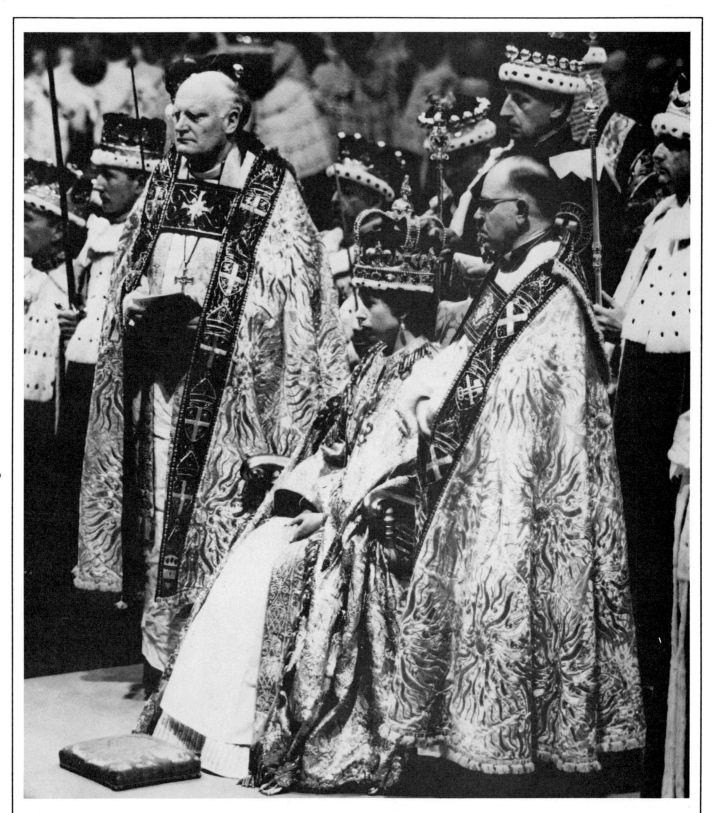

144

QUEEN ELIZABETH'S CORONATION
June 2, 1953

A somber, newly crowned Elizabeth II, only twenty-six years old, sits in Westminster Abbey, flanked by the Bishop of Durham and the Bishop of Bath and Wells. "Lilibet," as she was called since childhood, had been heir to the throne of England since she was eleven years old, and had been performing most of the duties of head of the royal family since 1948, when the health of George VI, her father, had begun to fail.

CHARLIE CHAPLIN AND CHOU EN-LAI
1954

The parties involved in the Korean War were scheduled to meet in Geneva to discuss the unification of Korea and the withdrawal of all foreign troops. Chou En-lai was present, representing the Chinese.

Charlie Chaplin, living in Switzerland in self-imposed exile, received a telephone call from the Chinese Embassy, asking if he would permit his film *City Lights* to be shown for Chou. He agreed.

The following day, Chou invited Chaplin to dinner in Geneva. Chaplin described the evening's beginning in his 1964 autobiography: "When we arrived, to our surprise, Chou En-lai was waiting on the steps of his residence to greet us. Like the rest of the world, I was anxious to know what had happened at the conference, so I asked him. He tapped me confidentially on the shoulder. 'It has all been amicably settled,' he said. 'Five minutes ago.' At dinner we drank Chinese champagne (not bad) and like the Russians, made many toasts. I toasted the future of China and said that although I was not a Communist I wholeheartedly joined in their hope and desire for a better life for the Chinese people, and for all people."

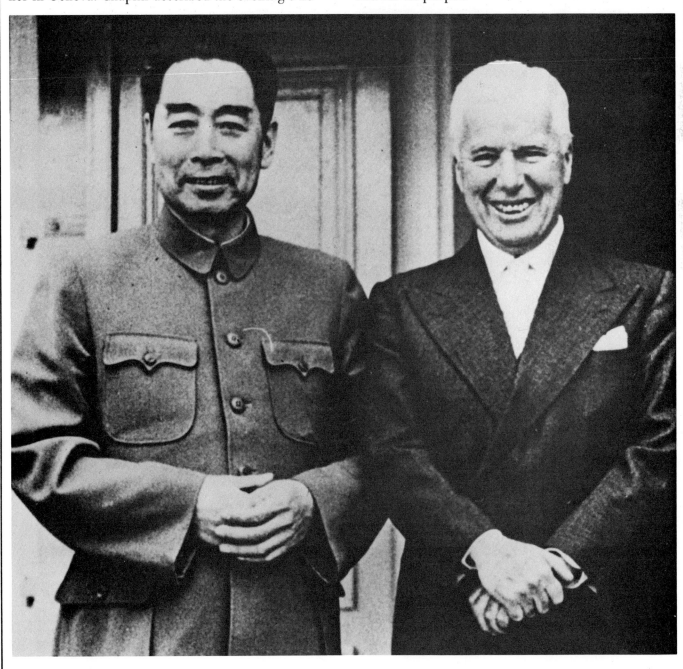

146

THE POLIO VACCINE
March 10, 1954

Jonas Salk developed his vaccine for polio in 1953. He is shown here inoculating one of the 1,830,000 school children who took part in the government's massive test program in 1954. The vaccine was judged to be both safe and effective, and was licensed in 1955.

The vaccine, which earned Salk a Congressional Medal of Freedom, contained strains of all three known types of polio virus. Although there is still no cure for the disease once it has struck the nervous system, it can now be effectively prevented.

A FAMILY'S TRAGEDY
April 2, 1954

Mrs. John McDonald clutches at her husband in frantic helplessness. Their nineteen-month-old son, Michael, was playing on the beach beside them until moments ago. Now he is missing, and the only logical explanation is the pounding waves, which could have carried him away in seconds. The photographer who took this Pulitzer Prize-winning photo, Jack Gaunt, was a photographer for the *Los Angeles Times* and, like the McDonalds, a resident of Hermosa Beach.

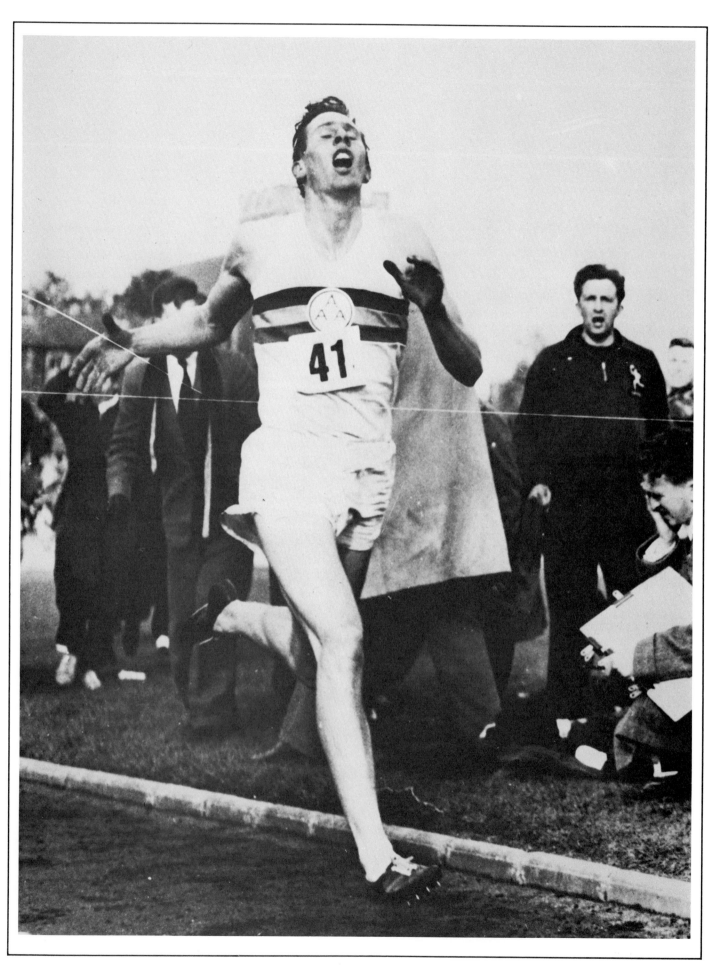

ROGER BANNISTER
May 6, 1954

Runners had been slowly chipping away at the record for the fastest mile, but still, the under-four-minute mile seemed like an unconquerable barrier. That is, until Britain's Roger Bannister burst across the finish line at Oxford's Iffley Road track, turning in a time of three minutes, fifty-nine and four-tenths seconds. Later that summer, in August, Bannister edged out an old opponent to bring the record down even lower, to three minutes, fifty-eight and eight-tenths seconds.

JOE McCARTHY
November 4, 1954

In the early 1950s, America was terrified at the thought of Communist infiltration. Senator Joseph McCarthy, until then a fairly quiet Wisconsin Republican, seized the issue as his own and began his infamous "witch hunts." Before the country came to its senses, McCarthy had terrorized the State Department and government employees, charged two presidents with treason, and ruined countless government and private careers.

McCarthy was a media sensation. His theatrics during televised hearings emphasized the drama of his obsession. He was renowned for his document-waving before Senate hearings and television cameras, one of the more famous incidents being his announcement of "205 names known to the Secretary of State as being members of the Communist party and who nevertheless are still working and shaping the policy of the State Department." What he actually had was a three-year-old letter from the former Secretary of State allowing that tenure for 205 State Department employees, who remained nameless, might be denied for many reasons, including drunkenness.

The paper he holds in this photograph allegedly contained a warning from the FBI (and signed by J. Edgar Hoover) to the army about security risks. The letter was never put into the hearing record.

149

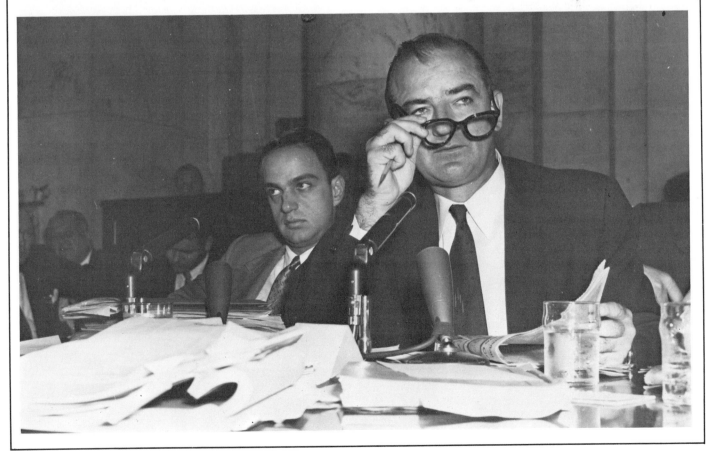

PLANE CRASH IN LONG ISLAND
November 2, 1955

The homes and neighborhoods in East Meadow are neat and orderly. Sidewalks and streets cut across the landscape like lines on a piece of spotless graph paper. Captain Clayton Elwood and Sergeant Charles Slater might have been enjoying the doll-house view of this New York suburb as they were flying back to Mitchell Field in their B-26, when an engine malfunctioned and the plane began to lose altitude.

The plane crashed in a fiery heap in the middle of a street. Both Elwood and Slater were killed. A house and a car in the neighborhood caught fire when they were hit by pieces from the blaze, but no one on the ground was injured.

George Mattson of the *New York Daily News* happened to be flying over the area and took this photo. It is one of a series for which the *Daily News* won the Pulitzer Prize in 1956.

ELVIS PRESLEY
1956

He was a national sensation. A national scandal to some, the twenty-one-year-old truck driver from Memphis simply explained that he loved to play rock and roll on his guitar. His hits, "Heartbreak Hotel," "Blue Suede Shoes," "Don't Be Cruel," and others, earned the adulation of teenagers nationally and made him a millionaire many times over.

Although his style and songs were not new (his was a mix of black rhythm-and-blues and country ballads), when he died in 1977 at the young age of forty-two, he was hailed as the king of rock and roll.

150

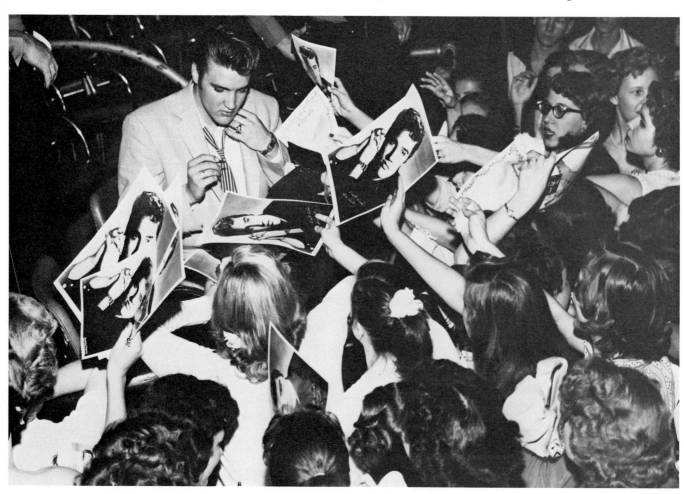

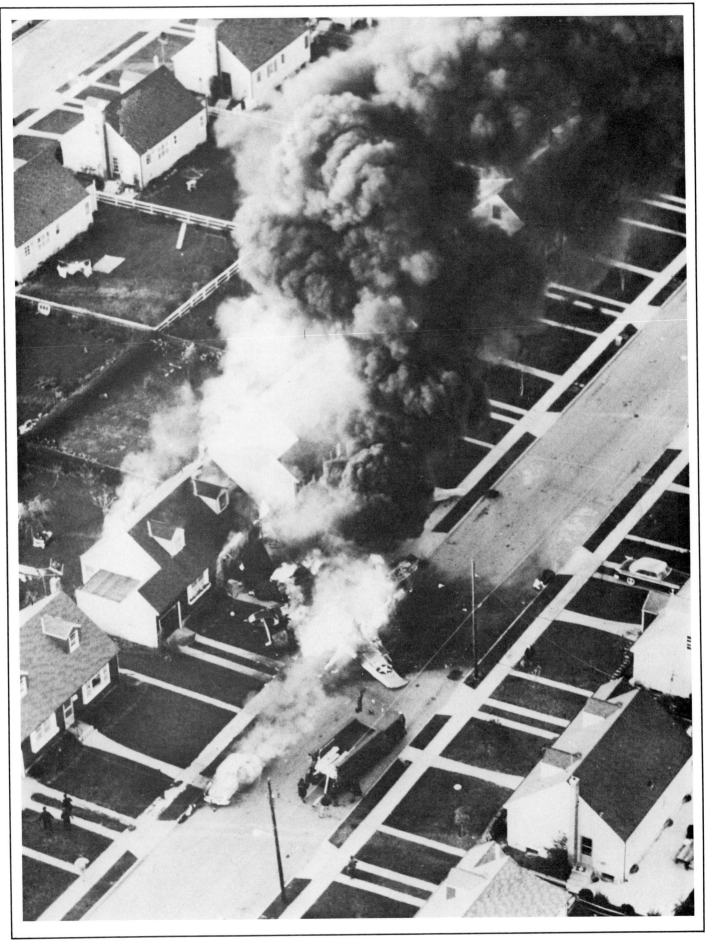

151

ANDREA DORIA
July 25, 1956

It was foggy and almost midnight off Nantucket Island, Massachusetts, but since it was the ship's last night at sea, many of the passengers still had not gone to bed. Those who were awake were witness to, and part of, the greatest maritime tragedy in years—the collision of the Italian liner *Andrea Doria* and the Swedish ship *Stockholm*.

Operating in a state that was later explained as "radar blindness," the two ships collided at 11:22 P.M. The *Stockholm* sustained a forty-foot gash in her bow, but was able to steam slowly into port. *The Andrea Doria* slipped beneath the surface of the ocean, barely eleven hours after the collision, taking fifty-nine lives and millions of dollars in passengers' possessions with her.

This photograph, taken by *Boston Herald Traveler* photographer Harry Trask, won a Pulitzer Prize in 1957.

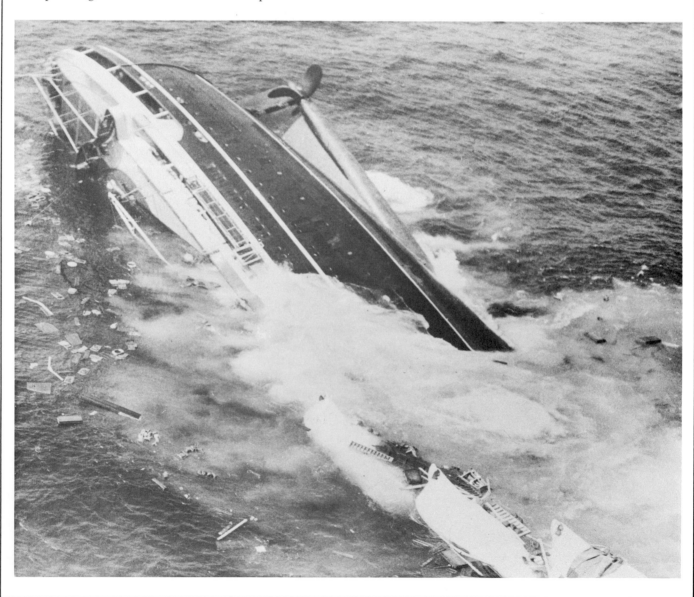

SPUTNIK I
October 8, 1957

It is just a blur in the sky, barely noticeable, but the Russian creation, Sputnik I, has the distinction of being the first artificial earth satellite. It both surprised and impressed United States officials.

This satellite trail was made by Sputnik, as seen from the Australian Commonwealth Observatory on Mt. Stromlo. The photograph was taken on October 8, 1957, three days after the satellite was launched.

Sputnik I was a small vessel, weighing barely 200 pounds. But it was impressive enough to launch the United States on its own ambitious space program. The eventual result was the creation of the National Aeronautics and Space Administration (NASA) and a commitment to the future of the exploration of space.

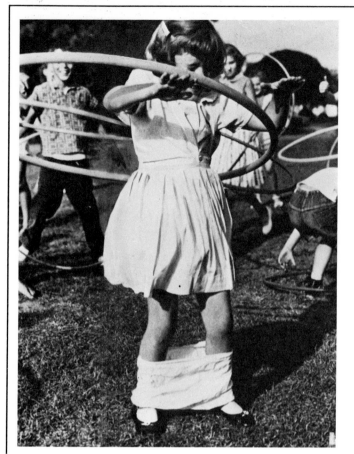

HULA HOOPS
September 25, 1958

Actually, the whole idea came from down under. The two men who owned the California-based toy company Wham-O heard that children in Australia had taken to playing with bamboo hoops, and that they loved it. Wham-O started manufacturing plastic hula hoops and the idea caught fire across the country. Five-year-old Shirley Tillery, of Columbia, South Carolina, hula-ed and found herself bloomerless.

TELEPHONE BOOTH CRAMMING
April 6, 1959

It's never been clear what gets a fad going, but there's usually no mistaking *who* gets it going—the young. During the late fifties, college students all over the country suddenly were competing to see how many could fit into one telephone booth.

Georgia Tech, along with several other schools, claims the record of twenty-three. This photo was taken at Georgia Tech. Jackie O'Cain, a coed from Macon, is on top of the booth (in a poor imitation of the earlier flagpole sitters) with twenty-three Lambda Chi Alphas inside. Minutes after this photograph was taken the total rose: twenty-three young men and one startled dog—their mascot, Nebbish.

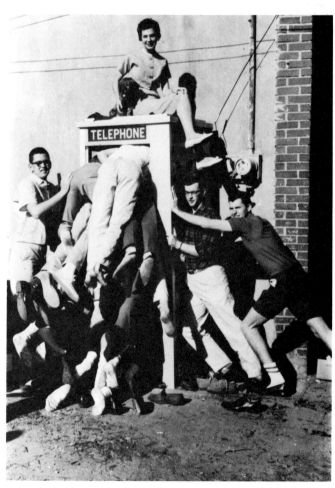

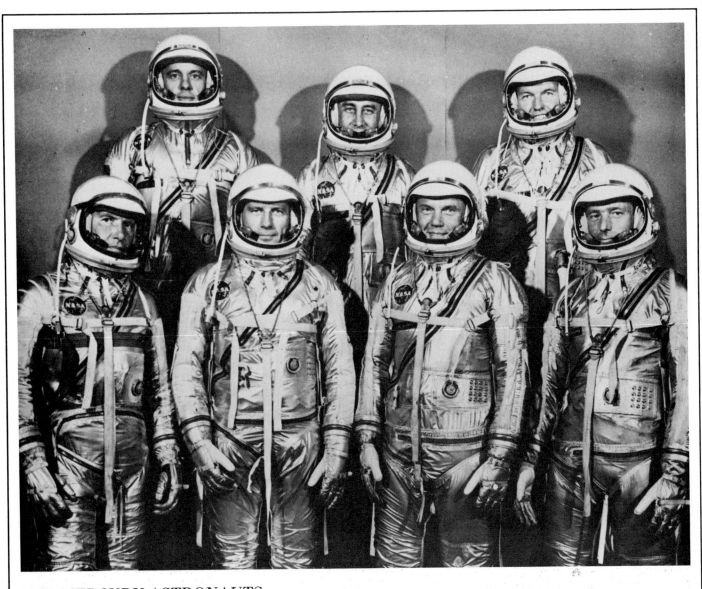

THE MERCURY ASTRONAUTS

April 1959

Front, left to right: WALLY SCHIRRA, DEKE SLAYTON, JOHN GLENN, SCOTT CARPENTER

Back, left to right: ALAN SHEPARD, GUS GRISSOM, GORDON COOPER

In 1958, when NASA began planning its man-in-space programs, it began searching for men to train as astronauts. The job was obviously not for just anyone—it required, as one NASA spokesman said, "an ordinary superman."

Courage and a clear head were obvious requirements. Astronauts would have to be young enough to be in top physical condition, but old enough to have acquired maturity and emotional stability. They had to be younger than 40, no taller than 5 feet 11 inches (the space capsule only had room for shorter men), and no heavier than 180 pounds. They had to have earned a degree in engineering or its equivalent, and they had to be military test pilots. There were 508 applicants who met these requirements, but after strenuous interviewing and investigation, 7 were winnowed from the group.

On April 9, 1959, the 7 who had made the cut were assembled and introduced to America in a press conference. One reporter asked which of the astronauts was ready to go up in space at that very moment. Seven hands shot up in the air.

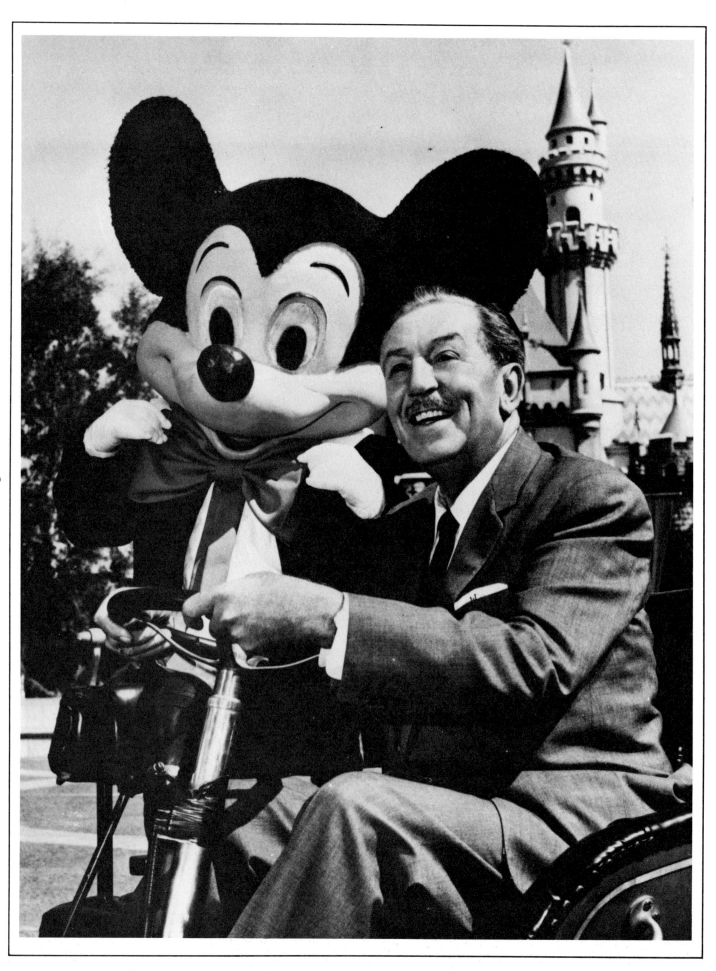

MICKEY AND THE MASTER

ca. 1959

He was Disney's first, and America's favorite, animated character. Once, trying to explain the universal appeal of Mickey Mouse, Disney said, "The best any of us have been able to come up with is the fact that Mickey is so simple and uncomplicated, so easy to understand, that you can't help liking him."

Mickey made his debut in 1928, in a black-and-white animated feature called *Steamboat Willie*, moving on to conquer television, and finally capturing hearts in Disneyland and Disney World. Disneyland opened in 1955 and Mickey became its official host in 1959.

Mickey Mouse is shown here with his creator riding a fire truck in Disneyland.

THE KITCHEN DEBATE

July 24, 1959

Vice-President Richard Nixon escorted Soviet Premier Nikita Khrushchev through the American National Exhibition in Moscow while carrying on a running debate on the merits of each country's way of life. They stopped at the kitchen exhibit and Nixon described the workings of the automatic washing machine, adding that most families in the United States had one. Khrushchev replied that many, even most, Russians also had such labor-saving devices, and from that small point they took off on a debate on the merits of washing machines, capitalism, and the free exchange of ideas.

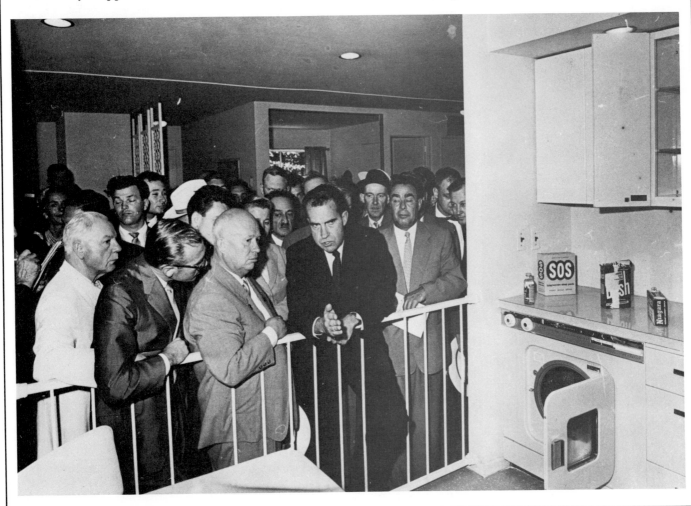

158

CASTRO AND KHRUSHCHEV MEET
September 20, 1960

A happy moment in Soviet Premier Nikita Khrushchev's visit to the United Nations was his meeting with Cuban Premier Fidel Castro on the floor of the General Assembly. The two embraced, Khrushchev patted Castro on the stomach, and they were off to compare notes on their countries.

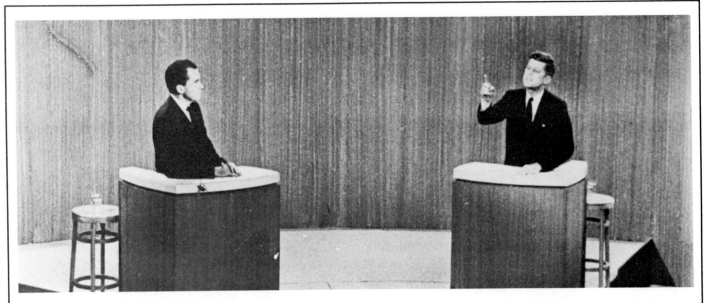

THE GREAT DEBATES
Fall 1960

The nation was uneasy about the senator from Massachusetts who was running for president. John Kennedy was younger than any president ever elected, and he was a Roman Catholic, as no president had ever been. Richard Nixon's eight years as Eisenhow-er's vice-president made him the more obvious choice on the basis of experience.

The Nixon-Kennedy debates were broadcast live on television—the first such confrontation in our nation's political history.

Kennedy, tanned and calm, appeared confident that he could face and successfully handle the nation's problems. Nixon's sweaty brow and nervous gestures seemed to indicate of a lack of confidence on his part.

Political strategists credit the psychological impact of Kennedy's demeanor during the debates—rather than the substance of either candidate's statements—as a major factor in his narrow election victory in November.

A STRONG DENIAL
October 12, 1960

Soviet Premier Nikita Khrushchev placed his right shoe on the desk in front of him during his 1960 visit to the United Nations. Minutes later he would use it to pound forcefully on the surface of the desk while emphasizing his point—denying allegations of a delegate from the Philippines that Russia had swallowed up Eastern European countries and was depriving people there of civil and political rights. The discussion was quickly forgotten, but the gesture, the wink, and the sly smile he aimed at Soviet Foreign Minister Andrei Gromyko, sitting next to him, was remembered as one of the many flamboyant and dramatic incidents during his visit.

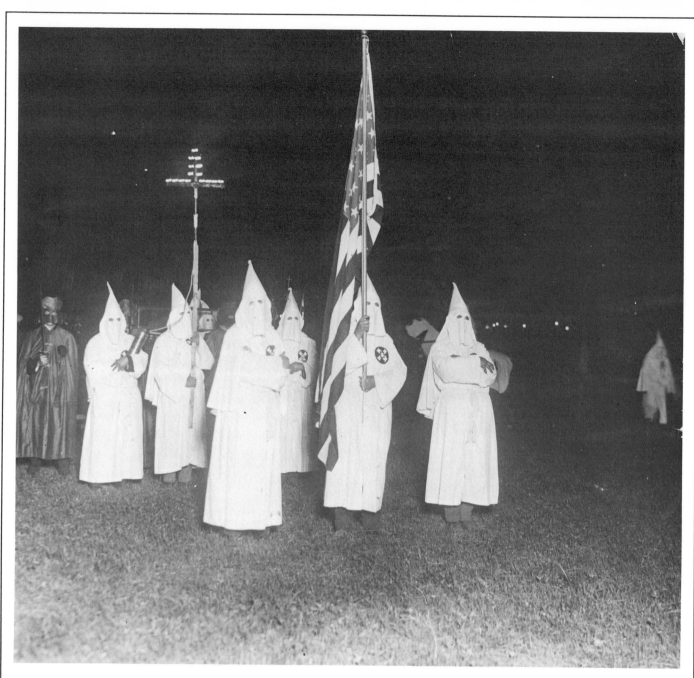

160

KU KLUX KLAN

1960

The members of this dreaded secret society dress up in white hoods and robes as if to suggest Confederate soldiers who have come back from the dead. The Klan was organized after the Civil War to oppose reconstruction policies and to maintain "white supremacy." Its tactics included cross burnings, the threat of physical harm, and sometimes the carrying out of that threat. The Klan, run by a Grand Wizard, has now spread throughout the country, periodically raising its ugly head.

SEGREGATION
1960

America's oldest, most embarrassing, and most unsettling problem has always been the unequal treatment of the races. "Separate but equal" was a catchphrase for years. Obviously, however, separate usually meant vastly unequal. Civil rights became a national issue after World War II and Truman addressed it, but the enforcement of and compliance with national policies and judicial decisions are far from complete. Separate fountains, pictured here, separate seating sections in buses and trains, separate bathrooms and schools—all were outlawed, but racism now takes other, more insidious, forms.

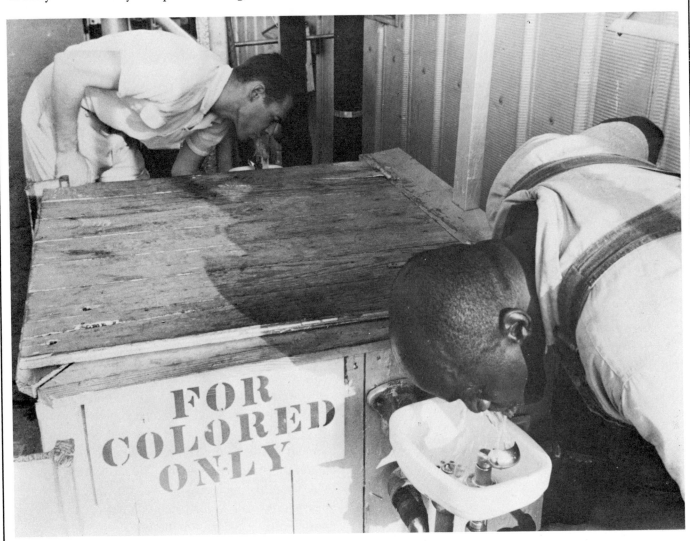

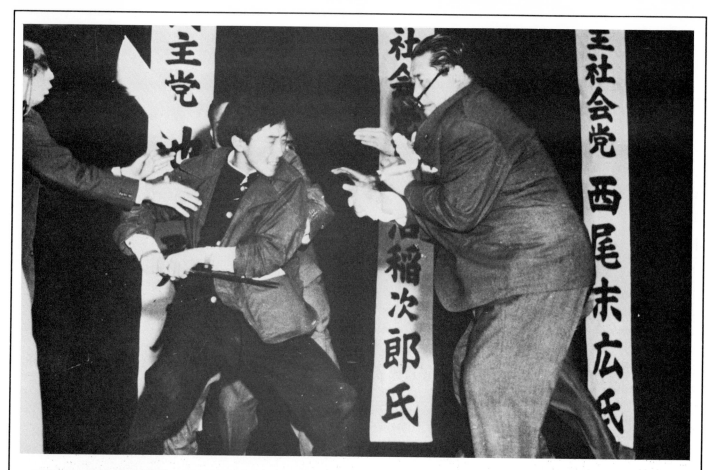

162

A JAPANESE POLITICAL ASSASSINATION

October 12, 1960

Japanese Socialist leader Inejiro Asanuma futilely tries to fend off a second thrust as a seventeen-year-old ultrarightist student, Otoya Yamaguchi, lunges at him with a deadly sword. Asanuma died before reaching a hospital, the victim of irreconcilable political creeds and of a young and violent fanatic. The assassin later committed suicide.

JFK INAUGURAL ADDRESS

January 20, 1961

The young, vigorous new president, hatless in the twenty-two-degree chill of January, invited a nation to hope. "Let us begin anew" opened the era of Camelot in the White House as John Kennedy challenged the American people. The most famous excerpt from his inaugural address, to "ask not what your country can do for you, ask what you can do for your country" became the nation's new challenge.

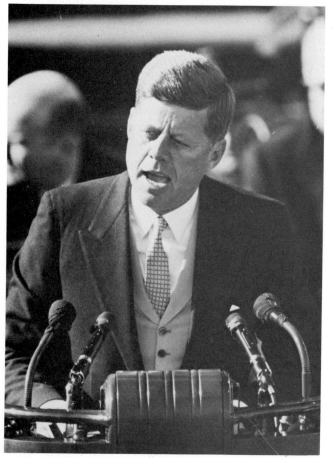

KENNEDY AND EISENHOWER
AT CAMP DAVID
April 22, 1961

John Kennedy had only been president for three months when he was confronted by the Bay of Pigs crisis. He traveled to Camp David, the presidential retreat in the Maryland mountains, to meet with Eisenhower.

The two spoke briefly to the press, then walked up the flagstone path to confer in private, unaware of the dramatic picture they made. An Associated Press photographer, Paul Vathis, snapped this Pulitzer Prize-winning photograph of the former and current presidents sharing the burden of the Office.

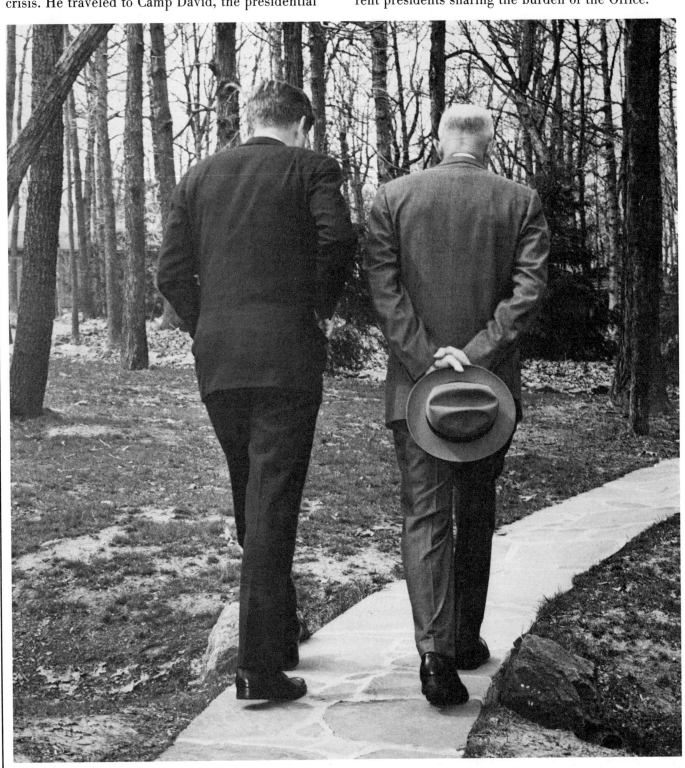

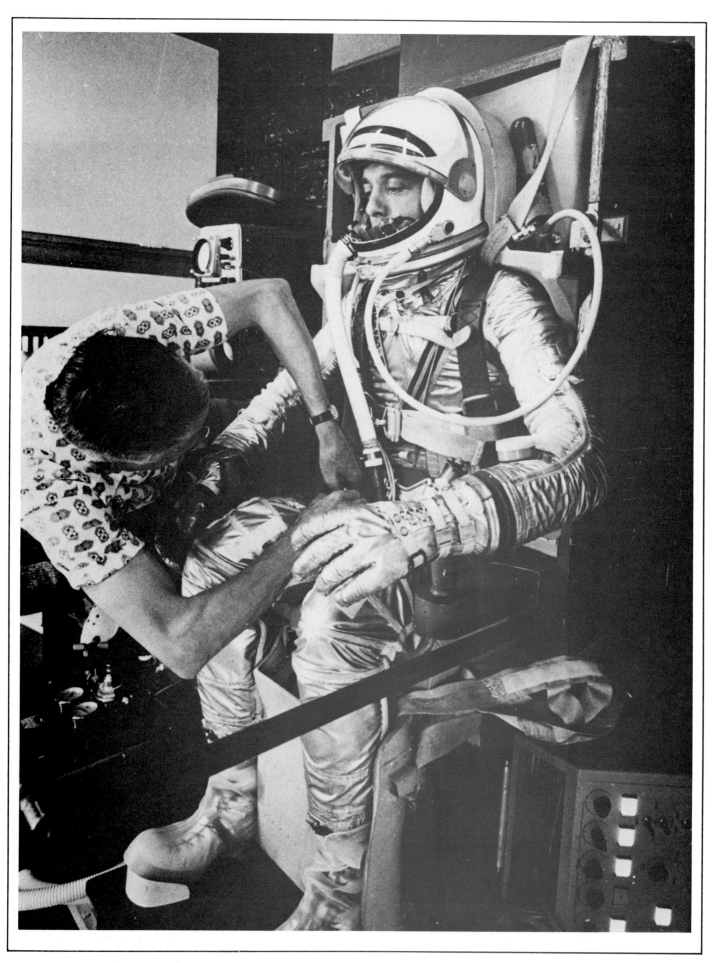

FIRST AMERICAN IN SPACE
May 5, 1961

Alan B. Shepard, Jr., waits patiently while a technician adjusts the pressure hoses on his space suit. On May 5, 1961, Shepard became the first American to travel into space, when, after launch was postponed once because of bad weather, his Mercury space capsule lifted off its launching pad at Cape Canaveral in Florida. Shepard's historic flight lasted only about fifteen minutes, but his was the first of many daring flights that paved the way to the moon.

THE BERLIN WALL
August 18, 1961

Every month thousands in East Berlin were slipping over the barbed wire divider into West Germany, looking for freedom and better living conditions. Some estimate that in the decade following World War II, one out of every five East Berliners left to live in West Germany. So, in August 1961, the East Germans and the Soviets erected a twenty-five-mile wall of concrete and barbed wire. The eleven-foot-high wall cut off over two million East Germans from friends and loved ones on the other side.

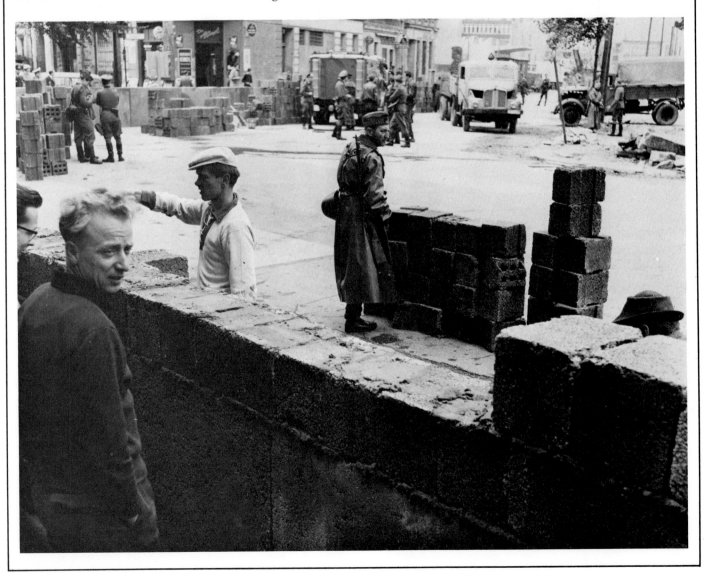

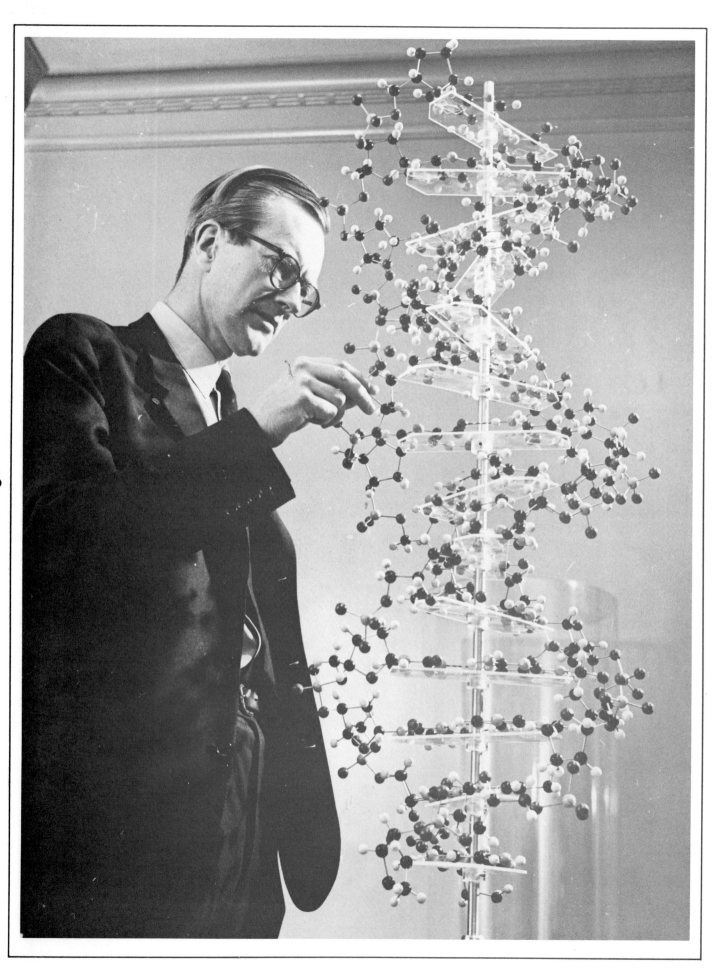

MAURICE WILKINS AND DNA

October 18, 1962

The very structure of life was being investigated at the University of London. Irish scientist Maurice Wilkins was attempting to map the structure of DNA, the substance that carries a genetic blueprint for each human being. Through a highly technical X-ray procedure, Wilkins concluded that DNA most likely had a helical molecular structure. Later, two other molecular biologists, J. D. Watson, an American, and F. H. Crick, an Englishman, determined that DNA is indeed a double-stranded helical structure. The three men shared a Nobel prize in 1962 for their work.

BUDDHIST MONK

June 11, 1963

Tense relations between Buddhist monks and the Diem regime that led Vietnam were escalating. There were basic philosophical differences: the government was staunchly Roman Catholic, while the people of Vietnam were overwhelmingly Buddhist. Monks charged that Diem's military leaders were oppressive, that they had stormed pagodas, wrecked shrines, and arrested hundreds of monks. The Diem government accused the Buddhists of being Communists.

These conflicts became even more strained in early May of 1963, when the state's police tried to suppress a demonstration in honor of the birthday of Buddha. A month later a seventy-three-year-old Buddhist monk's self-immolation in a Saigon street tragically and graphically represented the idealogical struggle and turned the world's attention to Southeast Asia.

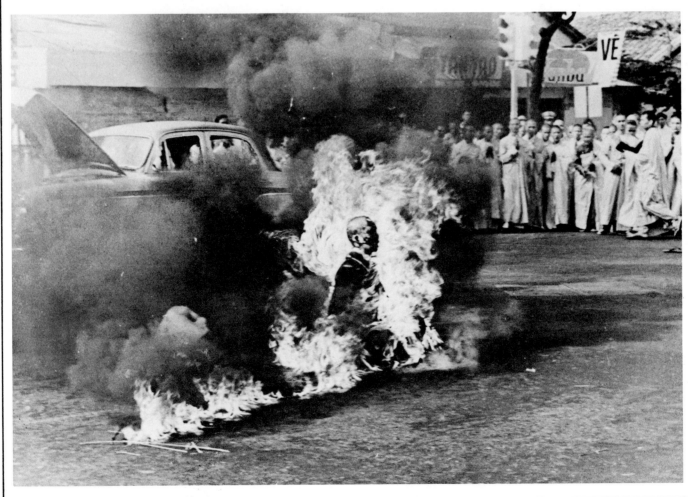

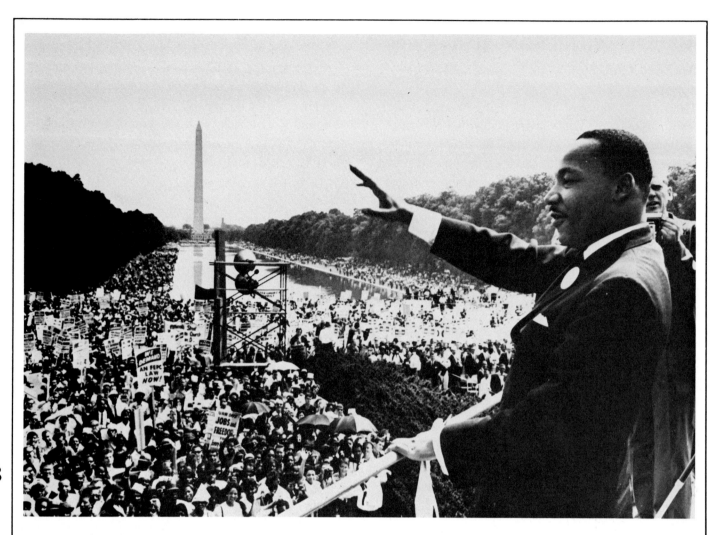

I HAVE A DREAM
August 28, 1963

Over 200,000 listened as Dr. Martin Luther King, Jr., spoke passionately and eloquently in the shadow of the Lincoln Memorial. The event was the March on Washington for Jobs and Freedom on August 28, 1963. He spoke of a dream that he had—one that would bring the nation's people together.

"I have a dream that one day this nation will rise up and live out the true meaning of its creed: 'We hold these truths to be self-evident, that all men are created equal.'

"I have a dream that one day on the red hills of Georgia, the sons of former slaves and the sons of former slave owners will be able to sit together at the table of brotherhood.

"I have a dream that my four little children will one day live in a nation where they will not be judged by the color of their skin but by the content of their character."

Dr. King was murdered by an assassin in Memphis, Tennessee, on April 4, 1968.

ASSASSINATION OF JOHN F. KENNEDY

November 22, 1963

The Democratic party in the state of Texas was bitterly divided, so political advisors thought it would be best if John Kennedy traveled through the state in person, trying to reconcile the factions. Everyone was mildly surprised at the warm reception the people of Dallas gave to Kennedy—his actions of late had not pleased most Texans.

During a motorcade through the streets of Dallas, shots were fired at the President. There was confusion and terror, and bystanders scrambled for cover, not knowing where the shots had been fired from or whether there were more coming.

All of the films and photographs taken of these first few moments show Jacqueline Kennedy then climbing onto the back of the limousine. It was not clear whether she was trying to assist Clinton Hill,

the Secret Service agent, who immediately leapt onto the back of the car, or if, in the chaos of the moment, she was actually climbing out of the car. In any case, Hill used his body as a protective shield to guard Mrs. Kennedy. In later testimony about the assassination, she did not even remember the incident.

The President's car sped to Parkland Hospital, but it was clear on arrival that he was mortally wounded. He died at 12:30 P.M.

The Warren Commission later determined that there were at least three shots fired, and that all of the shots were fired by a single assassin, Lee Harvey Oswald, from the Texas Book Depository. In subsequent years the findings of the Warren Commission have been challenged, and the controversy is still going on concerning many facets of the case.

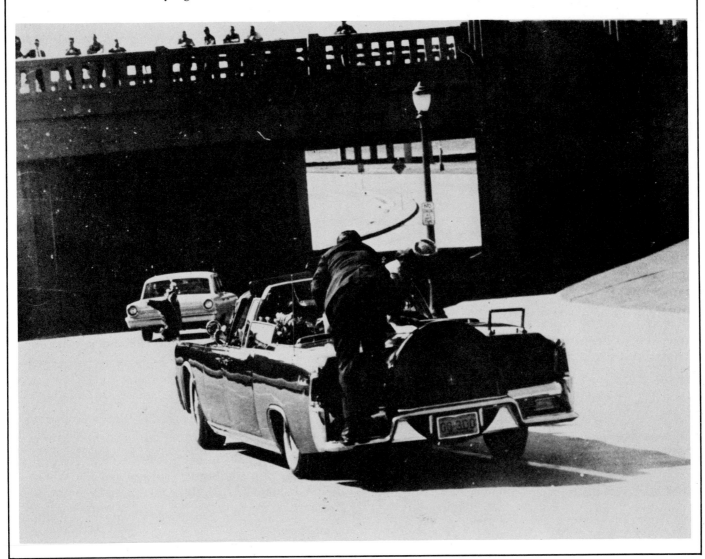

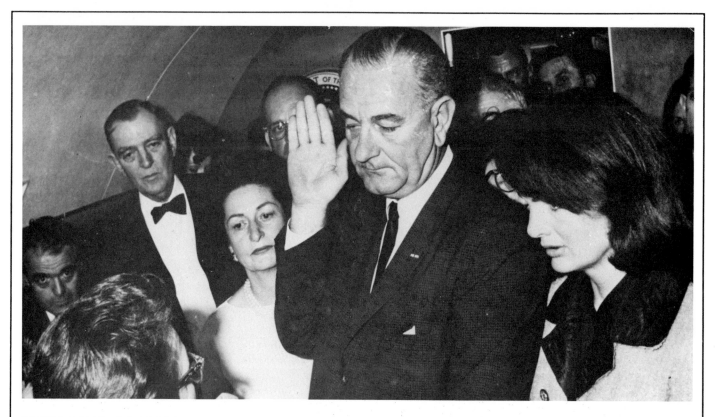

LYNDON B. JOHNSON

November 22, 1963

John F. Kennedy died at 12:30 P.M. At 3:40 a new president was sworn in—Lyndon B. Johnson.

Johnson had been riding in the car behind Kennedy's in the motorcade through Dallas and was driven immediately to Love Field, where *Air Force One* was waiting. Mrs. Kennedy arrived shortly after three o'clock with her husband's body in a bronze casket. In the cramped cabin, Johnson's wife on one side and Mrs. Kennedy on the other, an old family friend of the Johnsons, Judge Sarah T. Hughes, administered the oath of office. Did he swear to uphold the constitution? "I do," Johnson said simply. The President gave his first order—to get the plane going and get back to Washington.

ASSASSINATION OF LEE HARVEY OSWALD

November 24, 1963

It was just before noon, two days after the assassination of President John F. Kennedy, and the Dallas police were scheduled to transfer his alleged assassin, Lee Harvey Oswald, from the county jail to the city jail. An anonymous death threat had been called in about Oswald, but in light of the sorrow and bitterness that the nation was feeling, such a threat was not surprising and wasn't taken very seriously.

The television cameras were trained on the corridor, and a small crowd had gathered in front of the jail. Oswald was led down the hallway, flanked by a policeman and a detective. Suddenly, Jack Ruby, a local nightclub owner, pushed his way through the crowd. He stepped up to Oswald, pointed a revolver into his abdomen, and fired. Oswald grimaced, slumped over, and died shortly thereafter. A shocked nation trying to recover from its anger and grief over Kennedy's death watched the murder on television. It seemed as if the days of violence would never end.

There were cries of conspiracy, and to this day, the judgment is in dispute. Ruby, who later died of cancer, said he had read that the President's widow might have to return to Dallas and testify in a trial against Oswald. He wanted to spare her that agony.

The photographer, Robert Jackson of the *Dallas Times-Herald,* won a Pulitzer Prize in 1964 for this photograph.

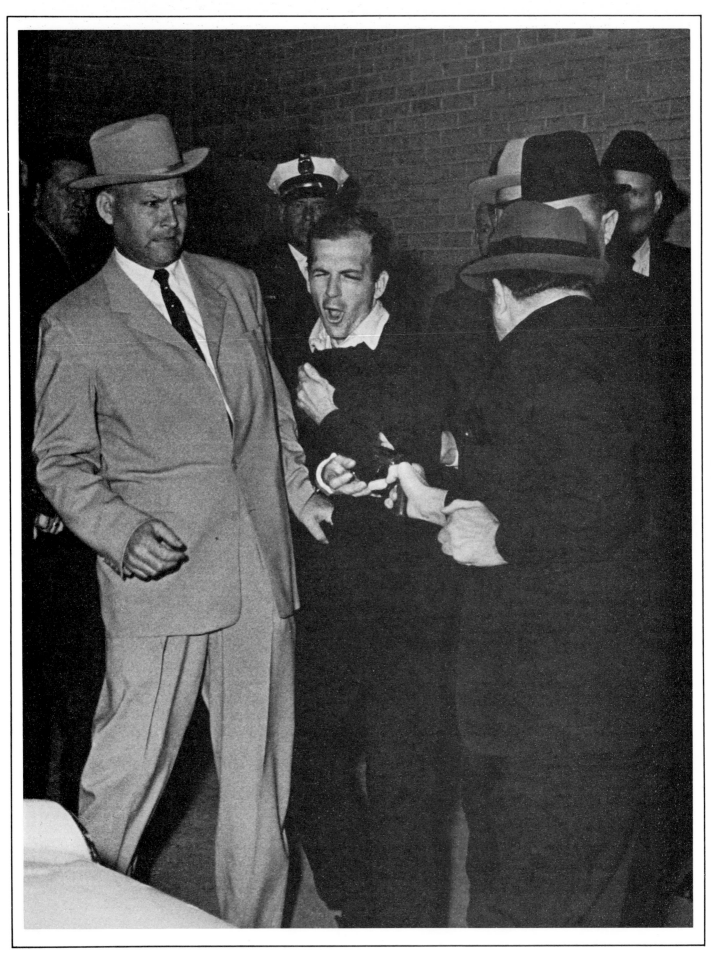

171

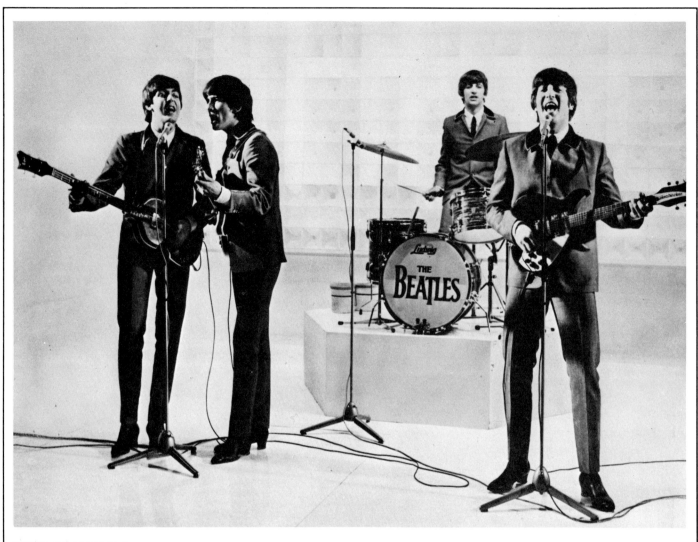

THE BEATLES

February 1964

"England again rules the colonies" was how some of the cornier headlines described the phenomenon. But corny as it might have been, it was hard to argue the point. Within a year of their first U.S. appearance on the "Ed Sullivan Show" in February 1964, the four young men from Liverpool were an undeniable sensation.

Devoted fans waited hours to catch a glimpse of the four when they were on tour, squealing and screaming as they passed by. Their records sold at the rate of two and one-half million copies every month. Their feature movie, *A Hard Day's Night,* brought in over one and one-half million dollars the first week it was shown.

The song-writing team of Paul McCartney and John Lennon became one of the most respected in the music business, and by the time John, Paul, George, and Ringo decided to break up their act to perform separately in 1970, the Beatles had set the beat for a decade and a generation.

VIETNAM

January 1, 1965

An oxcart is loaded with bodies after a battle in Binh Gia, South Vietnam, which lasted more than a week and in which an estimated 200 American troops died. In the coming year in Vietnam, American troop strength would increase nearly eightfold.

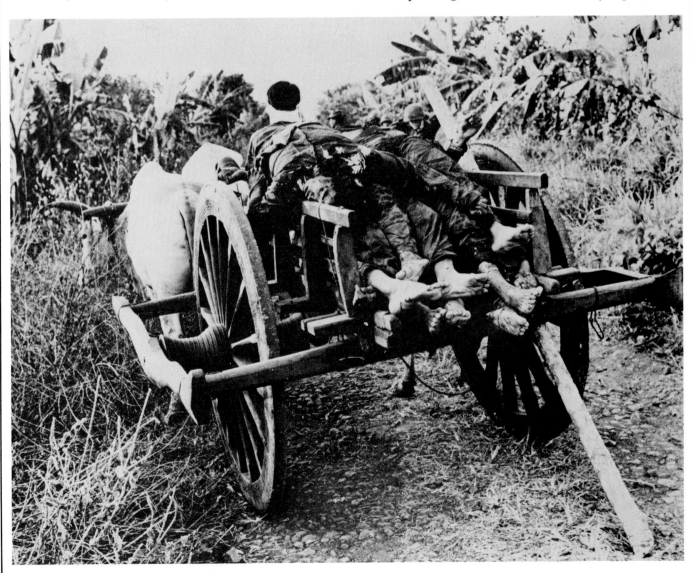

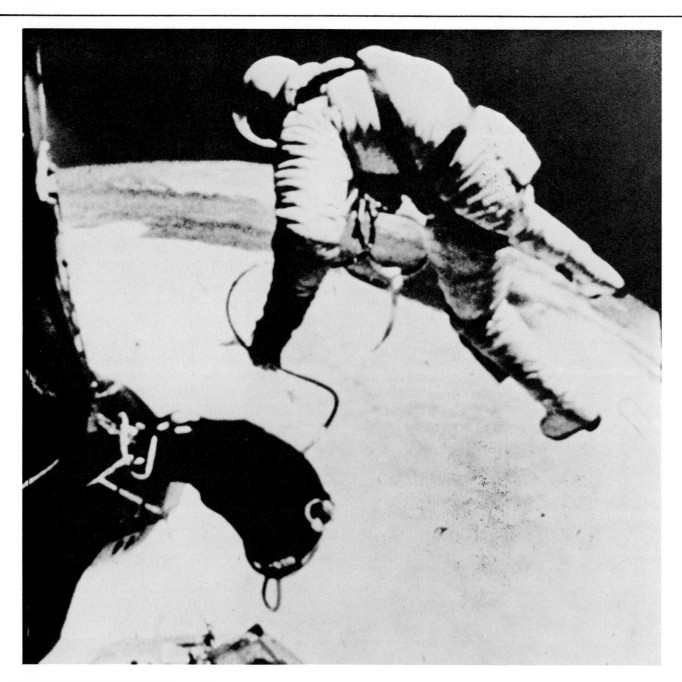

174

ED WHITE'S SPACEWALK

June 3, 1965

"I'm not coming in," teased Major Edward H. White as he floated around his space capsule. "This is fun."

White was the first American ever to step outside his capsule into space. He was connected to the craft by a twenty-five-foot tether for the twenty minutes he spent outside. While he floated—a human satellite crossing North America from the Pacific to the Atlantic—the command center in Houston, Texas, measured his physiological responses.

White and his partner in the Gemini 4 mission, Major James A. McDivitt, spent four days in orbit, practicing and developing techniques to be used in space rendevous maneuvers and the Apollo program.

Houston kept radioing the astronaut to come back inside. It took several orders to get White back in, but not before he managed to lose a mitten and a helmet visor to the vast blackness.

Two years later, White, along with Virgil "Gus" Grissom and Roger Chaffee, died in a tragic fire while training for the next mission—the first in the Apollo series.

THE GREAT BLACKOUT
November 9, 1965

It hit at the city's busiest time: 5:27 P.M. A regional power failure paralyzed the Northeast region of the United States, including most of New England, New York State, and even parts of Ontario. But it was New York City that felt the effects of the blackout most. Millions were in the midst of trying to get home when the power went out. An estimated 800,000 people were trapped for hours in elevators, subway cars, and commuter trains. Most others were stopped dead in their tracks wherever they happened to be.

But in the atmosphere of chaos and frustration, there was also a camaraderie—most New Yorkers went out of their way to try to accommodate the city's temporary residents.

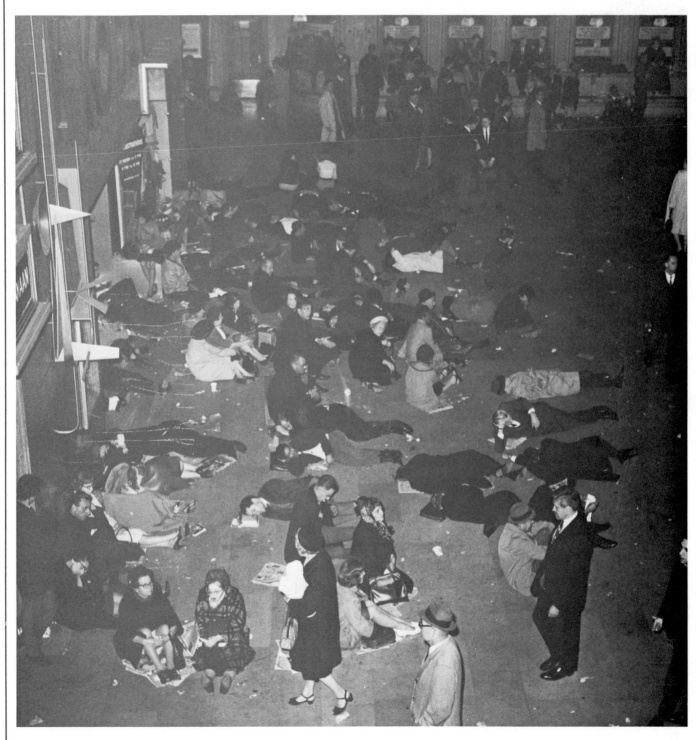

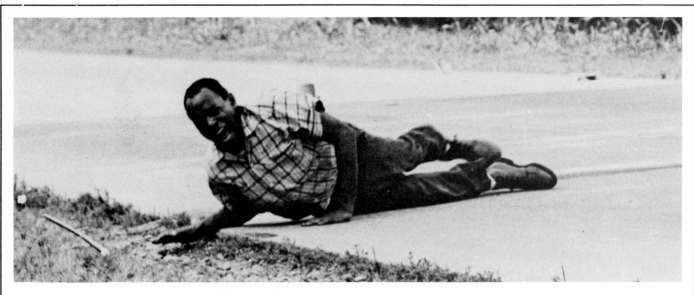

SHOOTING OF JAMES MEREDITH
June 6, 1966

The man who integrated the University of Mississippi takes on another journey. James Meredith, determined to show the blacks of Mississippi that it is safe to register to vote, and to show others the fear that was a way of life in Mississippi, marched alone and unarmed from Memphis, Tennessee, to Jackson, Mississippi. Occasionally during the 220-mile trip, he was joined by another marcher, but the gunman who was waiting for him just 12 miles from the Mississippi border was only interested in Meredith. He fired, hitting Meredith, shown here crawling to safety. An Associated Press photographer, Jack Thornell, covered the march and captured Pulitzer prize-winning photos. Later, in the hospital, doctors removed more than fifty shotgun pellets from Meredith's body. The graphic and horrifying assault had its effect on the nation though, and the civil rights movement's resolve was steeled.

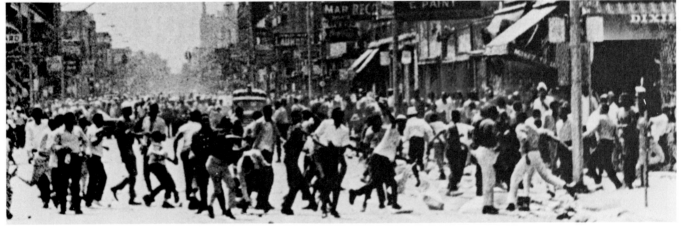

DETROIT'S LONG HOT SUMMER
July 23, 1967

The stifling and oppressive heat of summer was reflected in the temper of the cities in the mid-sixties. Racial riots, looting, lawlessness, and chaos flared as quickly as a summer storm.

Early on a Sunday morning in Detroit, four policemen raided a "speakeasy" on Detroit's 12th Street. People gathered, bottles and stones were thrown, and the looting began. This was the predominantly black section of Detroit, but the looting wasn't confined to blacks. Fires began and the riots raged on for most of the week. By Thursday, 43 were dead, about 5,000 homes burned, and 7,000 National Guards, 600 state troopers, and 4,700 paratroopers had been called to the scene.

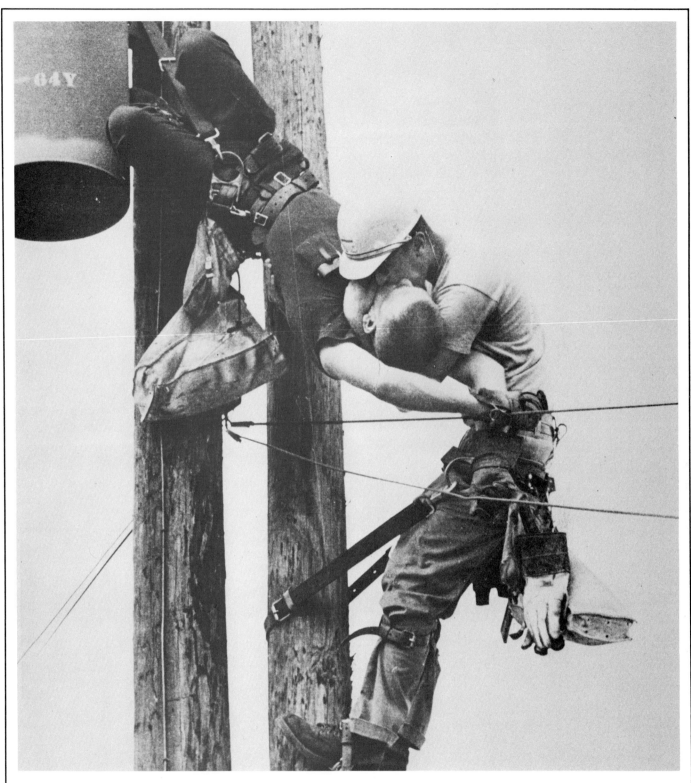

A COLLEAGUE'S REVIVAL

July 17, 1967

An ordinary day, a tragic accident, and an extraordinary rescue in Jacksonville, Florida. Two power company repairmen were working on a line when suddenly Randall Champion was severely shocked by a wire. His co-worker saw what had happened and reacted with quick intelligence. Jim Thompson climbed the pole to where Champion dangled and instantly began mouth to mouth resucitation. Champion was revived, narrowly escaping death. The photograph, taken by a *Jacksonville Journal* photographer, won a Pulitzer Prize.

DR. CHRISTIAAN BARNARD
1967

The South African astonished us all on December 3, 1967, when he performed the world's first heart transplant operation at Groote Schuur Hospital, Cape Town.

Dr. Barnard performed several more transplants before rheumatoid arthritis forced his retirement from surgery.

FIRST HEART TRANSPLANT PATIENT
December 12, 1967

On December 3, 1967, Louis Washkansky became the first heart transplant patient in history. The fifty-five-year-old South African was feeling well enough just nine days after the operation to be photographed eating a meal of boiled eggs and porridge.

Washkansky showed remarkable improvement, and was moved out of the intensive care ward of his Cape Town hospital. He even gave radio interviews and left his bed. Washkansky died eighteen days after the operation, but his death was not a result of his body's having rejected the transplant as surgeon Christiaan Barnard had feared: double pneumonia was blamed for his death.

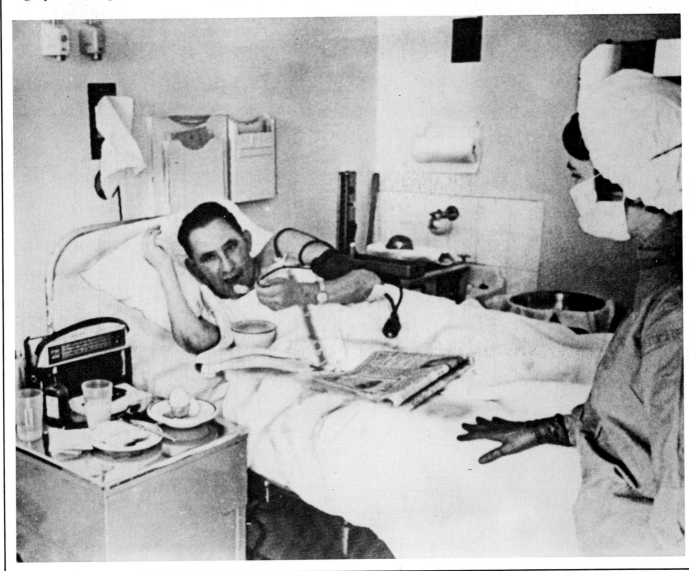

LOAN SHOOTING
February 1, 1968

This photograph coincided with a turning point in America's feeling about the Vietnam War. The Vietcong's Tet offensive was sweeping through the country. The national police chief of Vietnam, Brigadier General Nguygen Ngoc Loan, took a prisoner in February 1968, a suspected Vietcong soldier, and marched him down the streets of Saigon toward a waiting jeep. An Associated Press photographer, Eddie Adams, followed them. He saw Loan raise a gun to the suspect's head, and thinking that Loan was going to threaten the man, Adams raised his camera. As Adams moved to take his picture, Loan suddenly pulled the trigger and executed his prisoner. The resulting photo, which won a 1969 Pulitzer Prize, stunned Americans, who began to question who were the victims and who were the oppressors in this undeclared war.

THE KING FUNERAL
April 9, 1968

Four days after Martin Luther King, Jr., was assassinated, his widow, Coretta Scott King, comforts her daughter, Bernice, at King's funeral. King's actions and speeches continue to inspire, just as they did when King was alive. His followers remember a talk King gave not long before he was cut down on a motel balcony. "I've been to the mountaintop. . . . I've seen the promised land. I may not get there with you, but I want you to know tonight that we as a people will get to the promised land. . . . Mine eyes have seen the glory of the coming of the Lord."

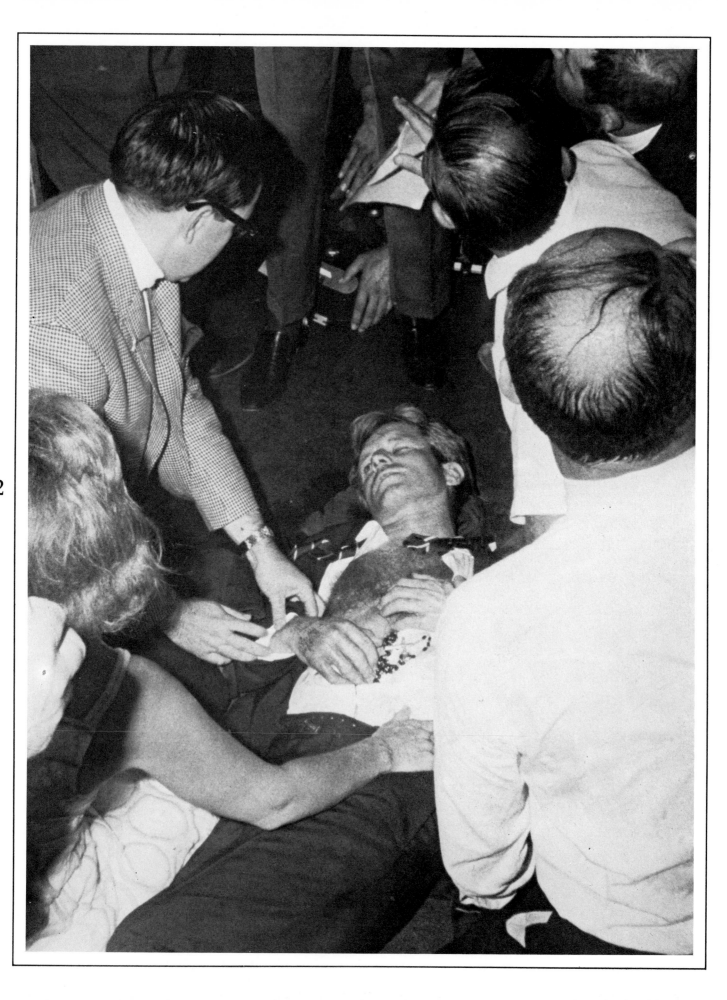

THE ASSASSINATION OF ROBERT KENNEDY

June 5, 1968

A second Kennedy wanted to be president. Robert, Attorney General under his brother John, was convinced that he could do a good job of running the country. He was convinced that someone had to speak for the powerless and the poor—groups that had always been his constituency. Kennedy was doing well in the presidential race, pulling ahead as the returns from the California primary were relayed to his vantage point at the Ambassador Hotel in Los Angeles on June 4, 1968. He addressed the excited crowd. "On to Chicago, and let's win there," he yelled, referring to the upcoming Democratic nominating convention. He turned and made his way through the kitchen hallway to leave the building. A disgruntled Jordanian Arab, Sirhan Sirhan, who hated Kennedy's stand on the question of Israel, was waiting for him. Sirhan fired a few shots into Kennedy just after midnight on June 5, 1968. Kennedy was rushed to a local hospital, and though he clung to life for several hours, he ultimately succumbed to his injuries. He had once said, "Some men see things as they are and ask, 'why?' I dream things and ask, 'why not?'"

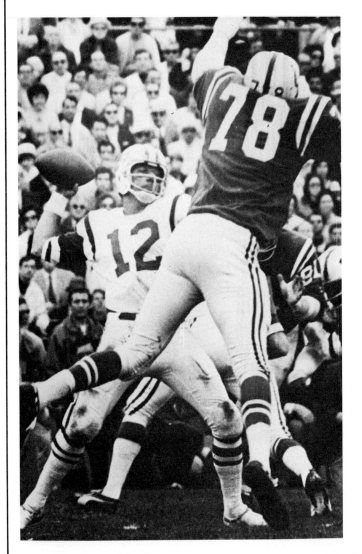

JOE NAMATH

January 12, 1969

The owner of the New York Jets football team, Sonny Werblin, signed a brash young man in 1965 for an unheard-of salary of $400,000. But Joe Namath, of the University of Alabama, proved to be worth every penny.

Namath (12) is shown here dodging an attempted block by Baltimore's Bubba Smith (78) during Super Bowl III in the Orange Bowl in Miami.

Part ownership of a nightclub and frequent late hours never seemed to affect Namath's performance on the field. After all, Namath's legendary coach at Alabama, Bear Bryant, said that Namath was the greatest player he had ever coached.

The 1969 Super Bowl was "Broadway Joe's" best year, and he played brilliantly—leading the Jets to a 16-7 victory over the Baltimore Colts. For the National Football League, it was their first Super Bowl win.

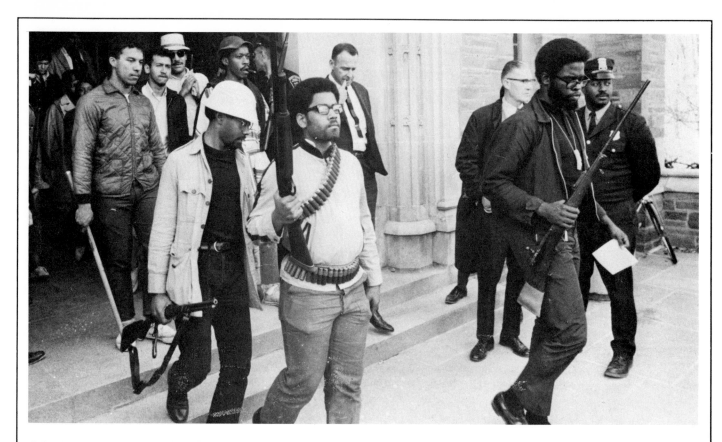

CORNELL CAMPUS TAKEOVER
April 20, 1969

The stormy years of student protest are summed up graphically in this photo, taken as the black students who had been holding the student union building at Cornell University come out, displaying a fearful arsenal. The students, who had barricaded themselves in the building during Parent's Weekend to protest a variety of grievances, held out for thirty-six hours before giving up.

MAN WALKS ON THE MOON
July 20, 1969

The voice was clouded by static, but the message and its impact were nonetheless clear.

"Houston, Tranquility Base here. The *Eagle* has landed."

"Roger, Tranquility, we copy you on the ground. You've got a bunch of guys about to turn blue. We're breathing again."

Houston was not the only place where people suddenly relaxed and started breathing again. The whole world was waiting, watching the historic Apollo 11 mission to the moon.

Neil Armstrong, Col. Edwin "Buzz" Aldrin, and Lt. Col. Michael Collins had blasted off four days earlier from Cape Kennedy on a trip that man had dreamed about since the beginning of time. On July 20, the command ship *Columbia* had begun to orbit the moon. Armstrong and Aldrin prepared to enter the lunar module, the *Eagle*, which would make the trip to the surface; Collins would stay aboard *Columbia* and continue to orbit the moon.

It was 4:18 P.M. when the *Eagle* landed. A few hours later, at 10:56, Armstrong opened the hatch of the ship, walked slowly down the ladder and, as his left boot touched the surface, said very simply some carefully chosen words: "That's one small step for [a] man, one giant leap for mankind."

Aldrin joined him twenty minutes later, and stood at attention while Armstrong snapped his picture. Armstrong is reflected in Aldrin's gold-tinted helmet visor.

"It [the moon] has a stark beauty all its own. It's much like the high desert of the United States . . . very pretty out here," commented Armstrong.

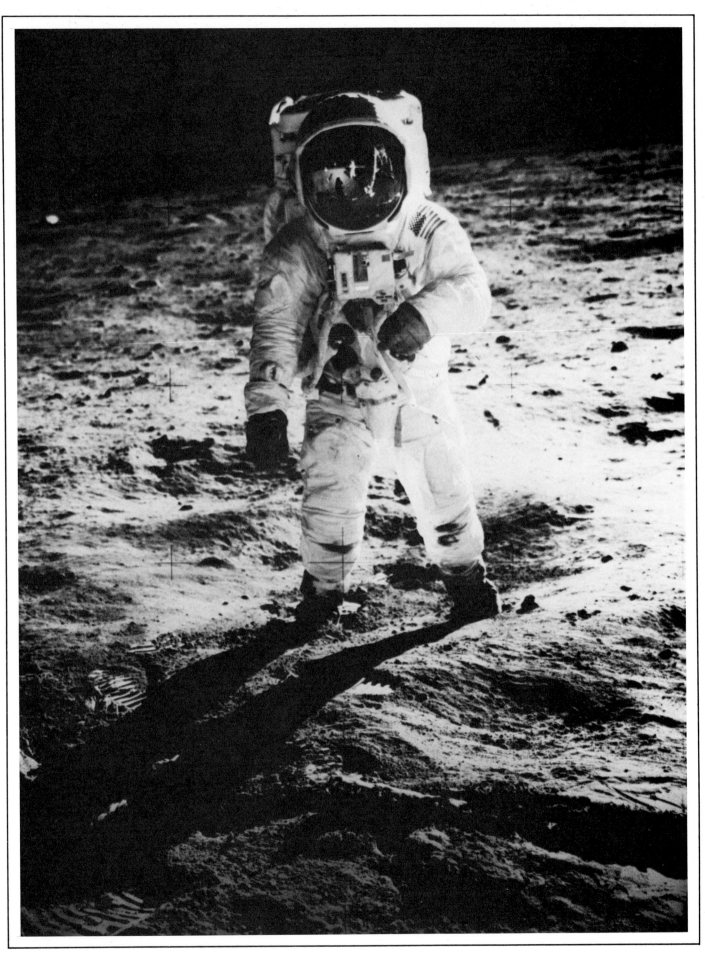

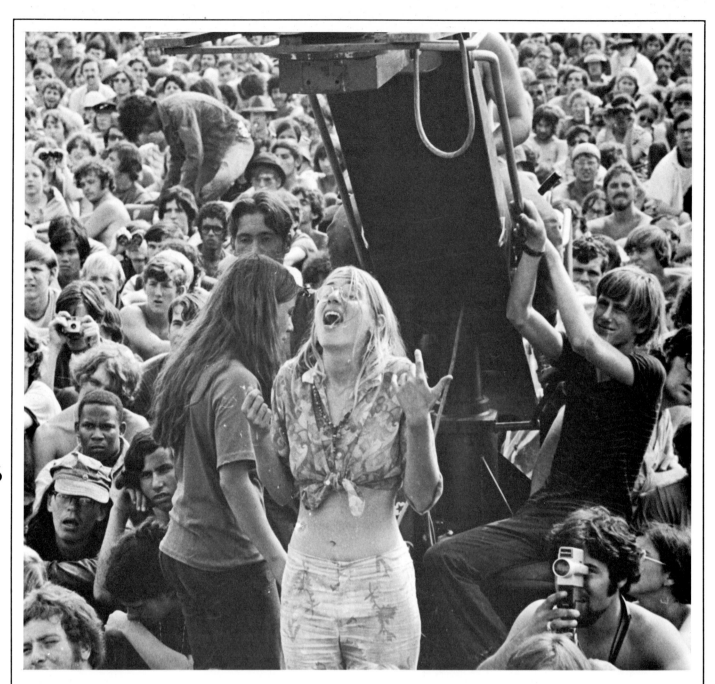

186

WOODSTOCK
August 15–17, 1969

"By the time we got to Woodstock, we were half a million strong," sang Joni Mitchell. Her estimate may have been off by a few hundred thousand, but it was the biggest thing that ever hit that remote farm in the Catskills. The promoters had brought in such rock stars as The Who, Joan Baez, The Grateful Dead, Crosby, Stills, and Nash, and Janis Joplin, and had expected about 100,000 people—but by the time the three-day festival was over, more than 300,000 had been there.

The rain and mud were relentless, fresh water and food were hard to find, and some were treated for drug overdoses, but the people who were there remember Woodstock as a peaceful, loving, happy time. They remember the music, the uninhibited and generous people, and the feeling of closeness that joined those present, many of whom felt alienated from the rest of society.

Times have changed. A tenth-reunion Woodstock concert was held in the summer of 1979—and only 1,000 people showed up.

ATTICA PRISON

September 11, 1971

Cellblock D was no longer under the control of prison authorities. Instead, over one thousand inmates, who took thirty-two guards as hostages, ruled the area and began to air their complaints with the prison. They made several demands on a makeshift megaphone, calling for coverage by state minimum wage laws, an end to censorship of their reading materials, better medical treatment, "true religious freedom," better food, and more recreational time. They also demanded that outside observers be allowed into the prison to look at conditions.

They released some of the hostages and let some observers in. After two days of talks, twenty-eight concessions were made to the prisoners, but they held out for two more: immunity from criminal prosecution, and the resignation of the Attica prison superintendent.

The next day, sheriff's deputies and prison guards stormed the prison in a bid to crush the rebellion. They succeeded but at a high price: nine hostages and twenty-eight prisoners were killed as lawmen took back the facility.

Here, several Attica inmates, stripped for searching, line up to be returned to their cell block.

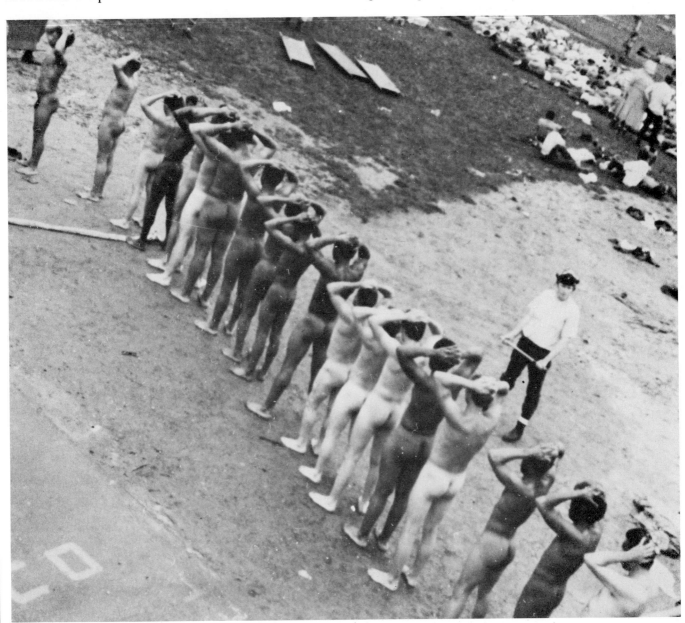

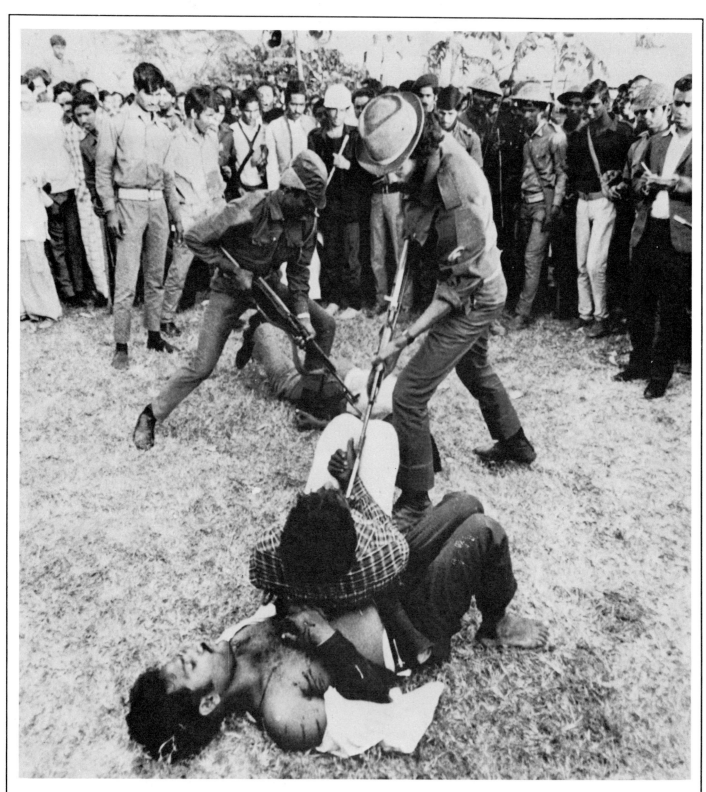

188

EAST PAKISTAN
December 18, 1971

Civil war was fought in the newly created Bangladesh, once known as East Pakistan. The Bangladeshan forces were successful in fending off an attack by West Pakistan, which tried to prevent them from seceding. The victory was in no small way attributable to the Indians who trained and equipped a force of guerrilla soldiers. Here the guerrillas torture and execute prisoners, in a controversial photograph that was sneaked out of the country by Pulitzer Prize-winning photographers Horst Faas and Michel Laurent.

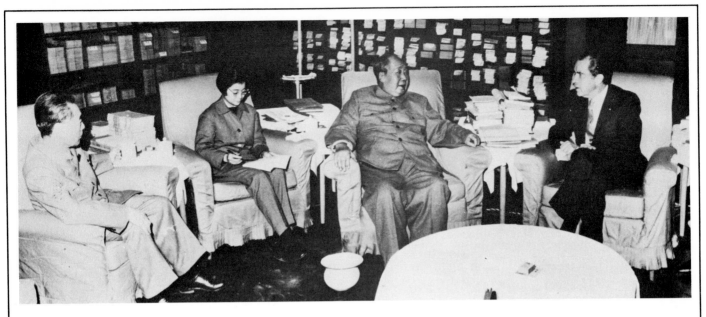

EAST MEETS WEST
February 1972

After a generation of virtually no diplomatic communication, the United States and the People's Republic of China came face to face in a dramatic meeting between Richard M. Nixon and Mao Tse-tung. President Nixon met with Chairman Mao only briefly during his eleven-day visit to China, spending most of his time with the Chinese premier, Chou En-lai. The visit produced an 1,800-word joint statement promising a gradual increase in Sino-American contacts but acknowledging major basic policy differences between the two nations.

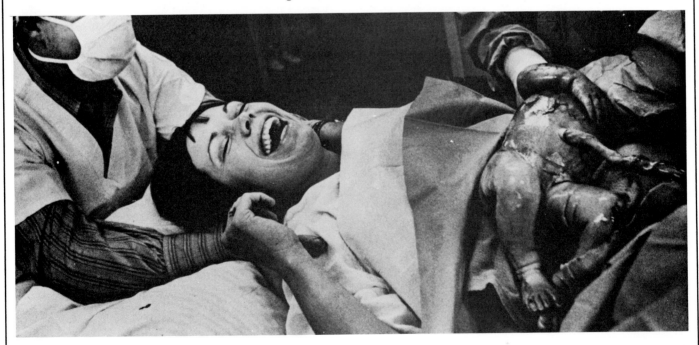

THE BIRTH OF JACKI LYNN COBURN
March 16, 1972

The climax of a series of Pulitzer Prize-winning photos of the birth of a child was this photograph of Lynda and Jerry Coburn's newborn daughter, Jacki Lynn. "One minute your stomach is so big and then in a second you have this hot, little, heavy, wet body on top of you, alive ... it's overwhelming," declared the new mother. The photos, taken by *Topeka Capital-Journal* photographer Brian Lanker, won the 1973 award for feature pictures.

VIETNAM BOMBING

June 8, 1972

Young Phan Thi Kim Phuc, a South Vietnamese girl, had probably never known peace in her life. But nothing could prepare her for the horror she experienced on June 8, 1972. The South Vietnamese Air Force, unaware that their own people were below, dropped napalm bombs upon them. Phuc tore off her burning clothes and ran screaming, as a South Vietnamese combat photographer took this picture. America's attention was riveted as never before.

190

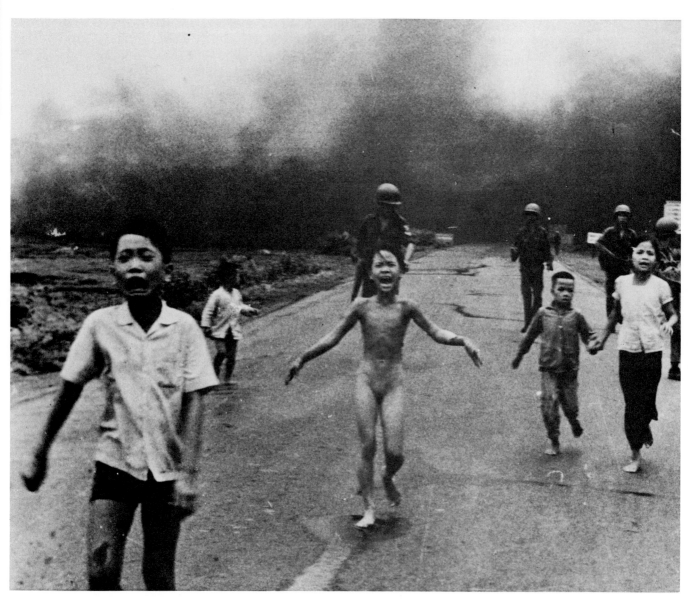

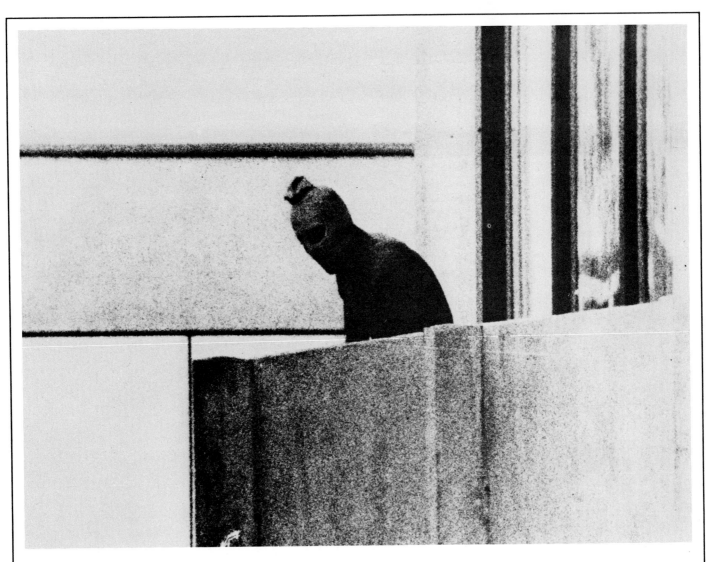

OLYMPIC GAMES, MUNICH
September 5, 1972

With few exceptions, the Olympic Games have been held every four years since 1896. To many, they are a haven of hope in a troubled world. The sight of athletes from across the world living and competing together in a spirit of healthy respect has bolstered many a faithless spirit.

There have been countless individual triumphs and tragedies, but the events that centered around September 5, 1972, were more devastating than anyone could have imagined.

In the early morning hours, eight Palestinian guerrillas, disguised as athletes in sweatsuits and wearing ski masks to hide their faces, sneaked into the Olympic Village and broke into the dormitory housing the Israeli teams. They killed two and took nine others hostage. Their goal: to force the release of two hundred Arab commandos being held in Israeli prisons. All we saw was this terrorist's silhouette on the balcony of the Olympic Village.

After sixteen hours of negotiations, the Arabs and their hostages prepared to board a Mid-East-bound plane when they were halted by a German police ambush designed to capture the terrorists.

Although the first reports of the ambush were hopeful, the eventual result was that five terrorists, one policeman, and all nine Israeli hostages were killed.

After a memorial service and a twenty-four-hour moratorium, the games continued.

RICHARD LEAKEY
November 9, 1972

British anthropologist Richard Leakey, son of the famed anthropologist Louis Leakey, displays in his right hand a cast of a 2.5-million-year-old skull he unearthed near a lake in Kenya. In his left hand Leakey holds the million-year-old version that, for fifty years, was thought to be the oldest ancestor of man as we know him. News of the older skull fascinated anthropologists and laymen alike.

COMING HOME
March 17, 1973

Lt. Col. Robert Stirm comes home after having spent five years as a POW in North Vietnam. His daughter Lori, age fifteen, leads the family as they rush toward him. Close behind are son Robert, fourteen; Cynthia, eleven; Stirm's wife, Loretta; and his younger son, Roger, twelve. The family reunion that must have seemed like an impossible hope has happened. Later, the couple were divorced, unable to breach the gap time and distance had carved. But, at this moment, that is all very far off. A family is just happy to be together.

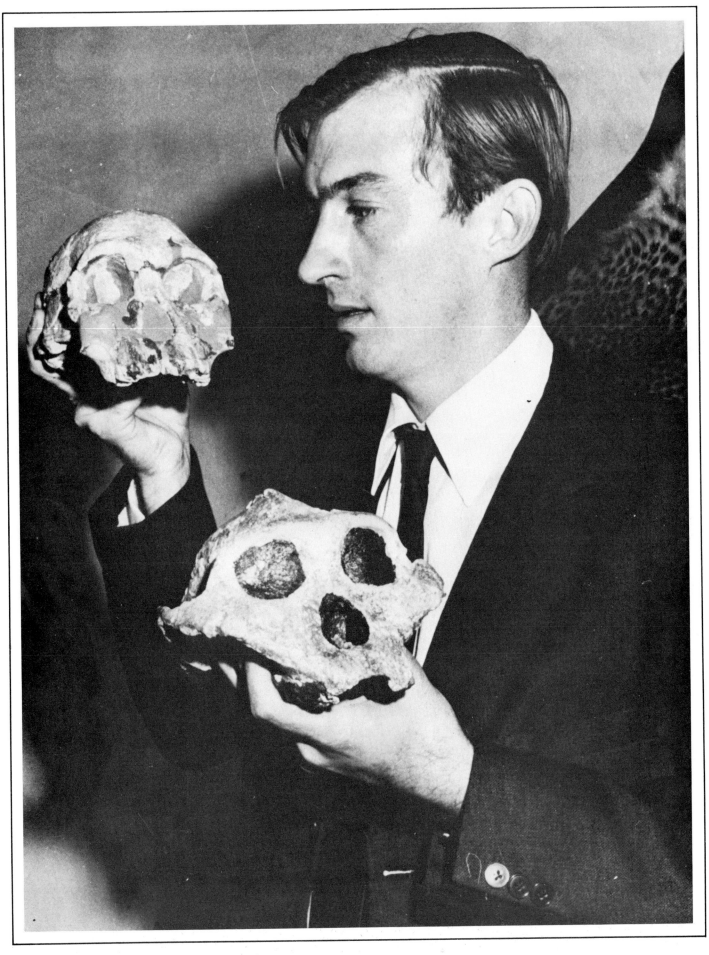

193

JOHN DEAN'S TESTIMONY
June 25, 1973

Slowly and deliberately, John Dean, former White House counsel, read his 245-page statement to the Senate Select Committee on Watergate. Dean implicated President Richard Nixon in the Watergate affair, charging that Nixon took part in the cover-up for as long as eight months. Although Dean stated his belief that Nixon did not realize or appreciate the implications of his involvement, his testimony against his former boss was damning.

194

SPIRO AGNEW'S RESIGNATION
October 10, 1973

After pleading *nolo contendere* to charges of income tax evasion, Spiro T. Agnew is seen here exiting from a Maryland courthouse. Just a little while earlier Agnew had submitted a formal resignation to Secretary of State Henry Kissinger: "I hereby resign the office of Vice-President of the United States, effective immediately." Agnew's resignation marked the first such in American history.

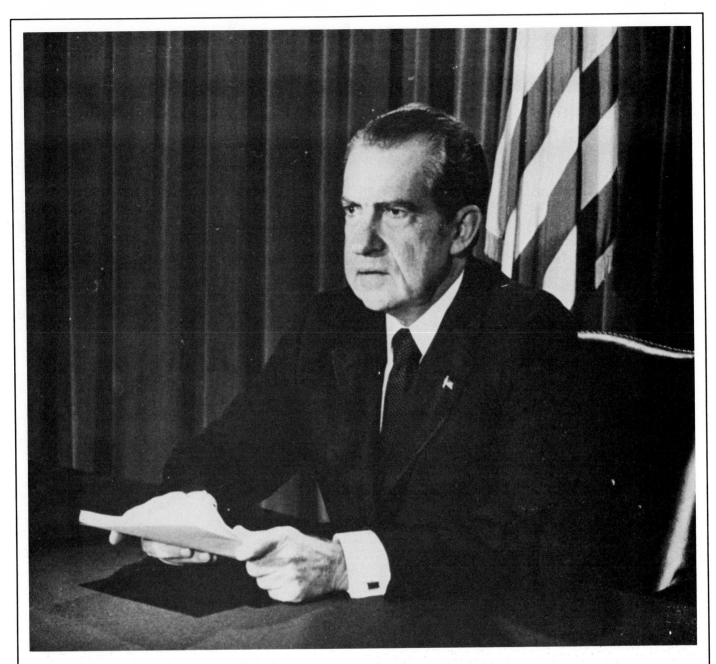

NIXON'S RESIGNATION
August 9, 1974

The break-in and bugging of the Democratic National Headquarters in the Watergate complex did not prevent Richard Nixon from being reelected by a landslide. It did, however, eventually prevent him from completing that second term.

On August 8, 1974, he appeared on prime-time television and announced that he would resign the next day, becoming the first president in history to do so.

"I have never been a quitter," he told viewers. "To leave office before my term is completed is op-posed to every instinct in my body. But as President, I must put the interests of America first. America needs a full-time president."

There was no question that Watergate was occupying most of his, as well as much of Congress's, time. After hours of hearings and testimony, it appeared certain that he would be impeached and probably found guilty by the Senate.

At 11:35 on the morning of August 9, 1974, President Nixon's letter of resignation was delivered to Secretary of State Henry Kissinger. It read simply: "Dear Mr. Secretary: I hereby resign the office of President of the United States. Sincerely, Richard Nixon."

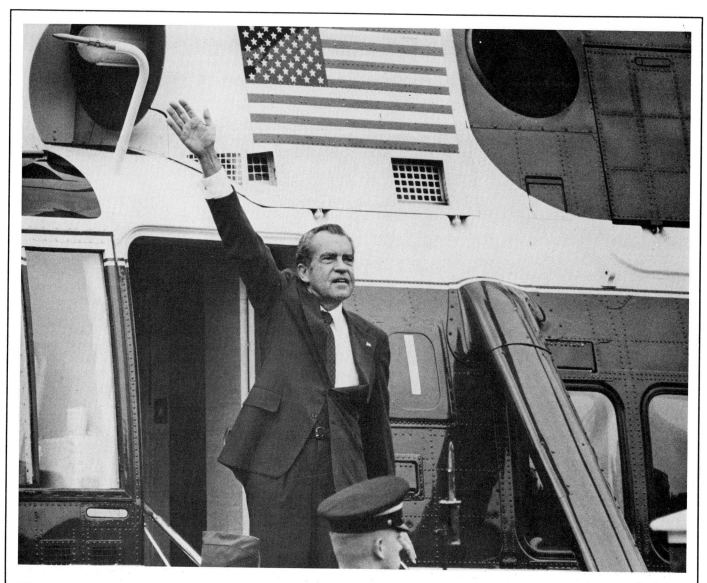

NIXON'S FAREWELL
August 9, 1974

Richard Nixon turns to wave goodbye before he steps into the helicopter that will take him to *Air Force One* for the last time as President. Earlier, bidding his staff and cabinet farewell, he told them,

"Always remember, others may hate you, but those who hate you don't win unless you hate them—and then you destroy yourself." A few hours later, while Nixon was aloft on his way back to his native California, Vice-President Gerald Ford was sworn in as President.

NUMBER 715
April 8, 1974

It was Hank Aaron's second time at bat on a balmy April evening in Atlanta, but he had yet to swing at anything that came his way that night. He was choosing them very carefully, since the next hard hit

he got was likely to break Babe Ruth's all-time record for career home runs. Just after nine o'clock the right ball was pitched and the forty-year-old outfielder swung mightily. Over 50,000 fans in the stadium and millions watching on television saw Aaron hit the 715th home run of his twenty-five-year career.

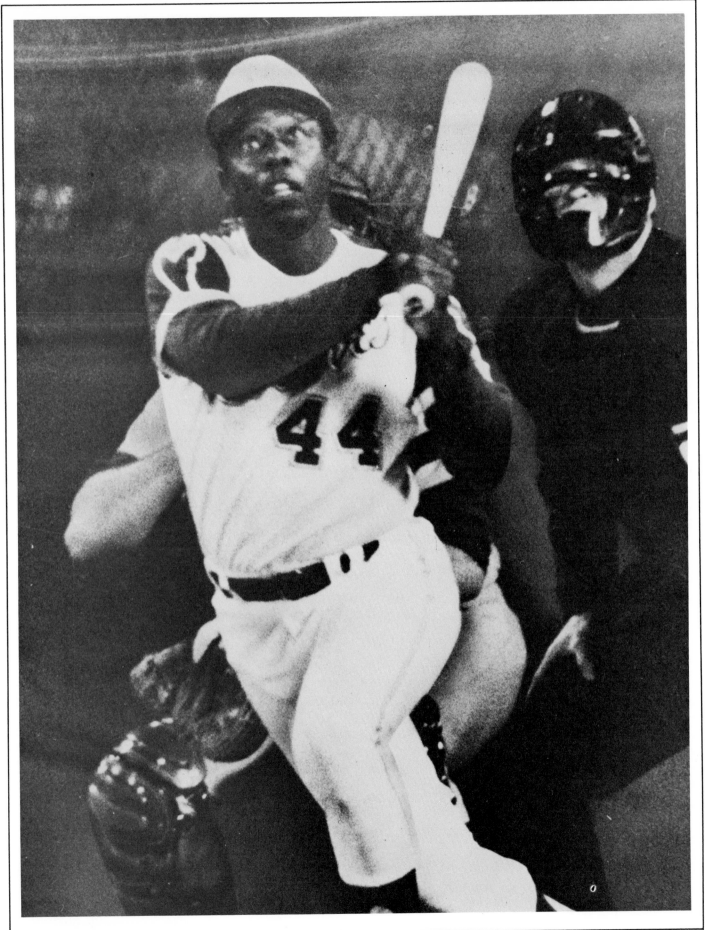

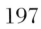

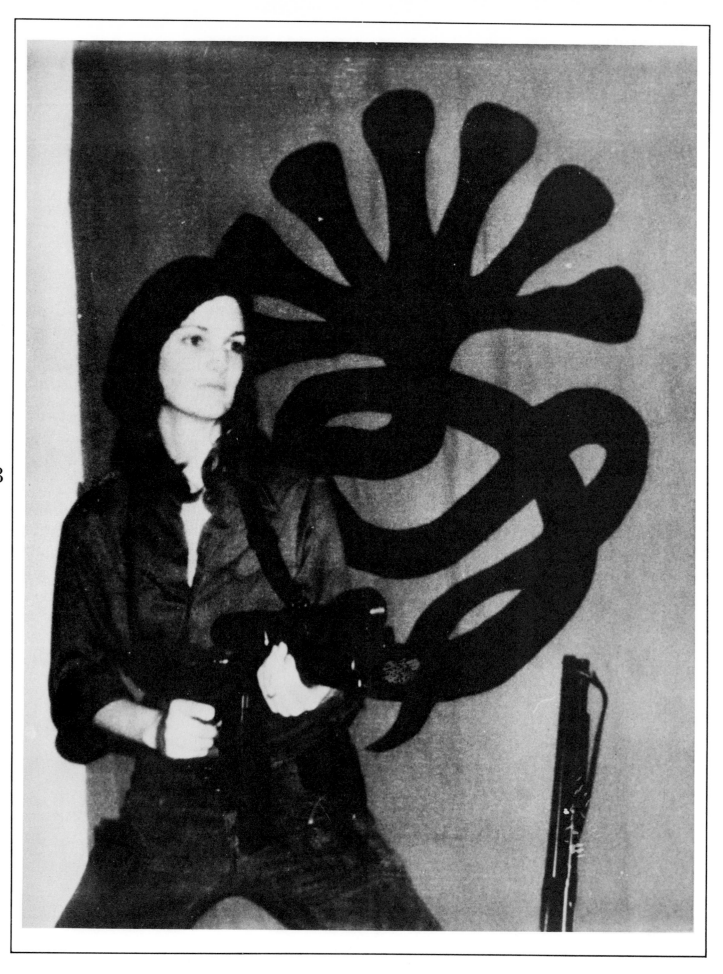

PATTY HEARST
April 1974

The California heiress, snatched from her Berkeley, California, apartment, had been missing for about two months when she appeared with members of the Symbionese Liberation Army in this bank robbery. She announced that she had taken the name "Tania" and willingly joined the group. Later, after being captured and arrested, she was convicted and served time in jail before being the recipient of a presidential pardon. Today, she lives a quiet life as the wife of Bernard Shaw, one of her former bodyguards.

APOLLO-SOYUZ FLIGHT
July 1975

Detente is space bound. A joint USA-USSR space mission paired American astronauts in space with Russian cosmonauts, practicing vital docking exercises. Here Donald K. "Deke" Slayton is shown with the Russian Aleksei Leonov. The two ships docked for two days before separating and returning safely to Earth.

199

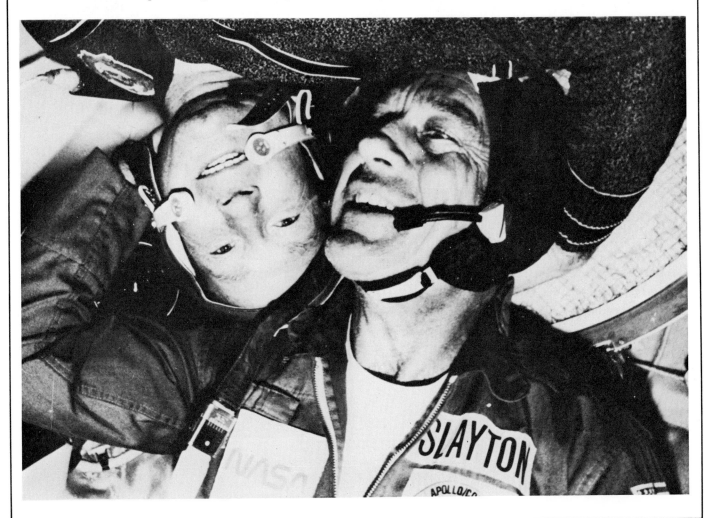

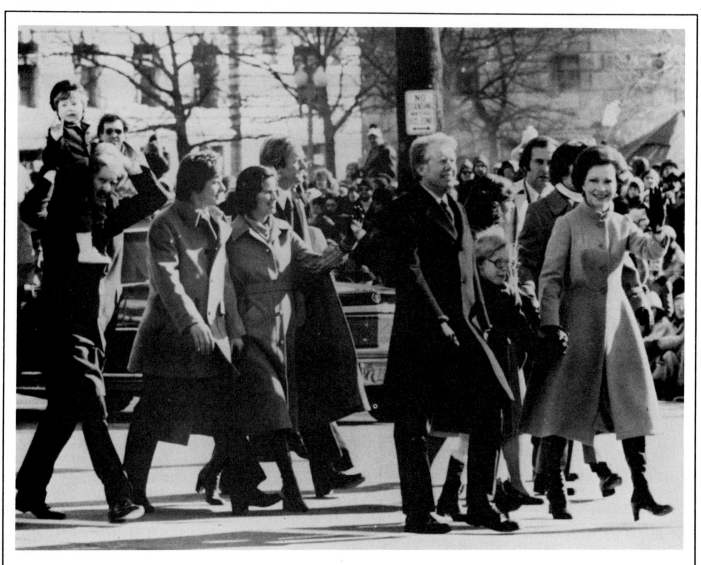

CARTER'S INAUGURAL WALK
January 20, 1977

The peanut farmer and ex-governor from Plains, Georgia, began planning and campaigning nearly four years before the 1976 presidential election. He built a grassroots organization in Georgia, Iowa, and all over the country, but it wasn't until he began winning presidential primaries that the nation took notice of Jimmy Carter. He swept the Democratic nominating convention with little opposition, and eked out a victory in November. But the moment the nation remembered most clearly was when the new President took his wife's hand and walked, rather than rode, down the avenue from the Capitol to his new home.

FIRST TEST-TUBE BABY

July 25, 1978

Baby Louise Joy Brown, a robust and healthy infant, lets out a yell, unaware of the stir her birth has created around the world.

Louise Brown was the first "test-tube" baby—conceived outside her mother's womb, in a laboratory. The fertilized egg was then implanted in her thir-ty-one-year-old mother, Lesley Brown. The baby was delivered on July 25, 1978, and the stunning achievement brought newfound hope to childless couples around the world. Some feared the implications of the child's birth, seeing her as a symbol of technology's inroads on nature. But to her parents and her doctor, Louise was, above all, a normal and healthy baby.

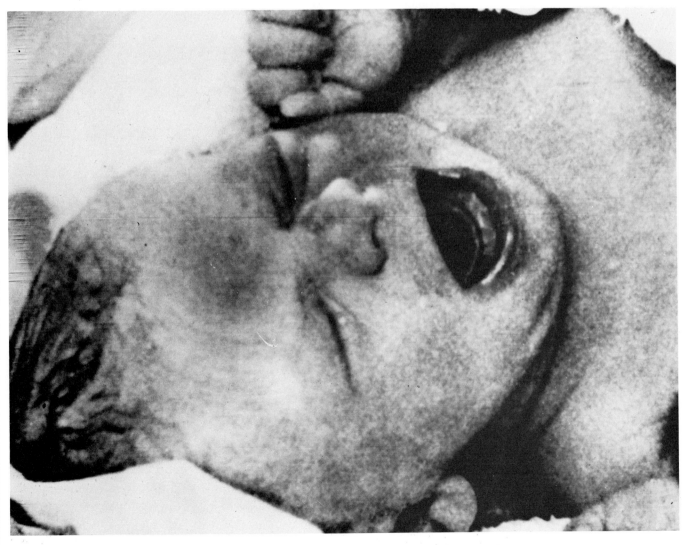

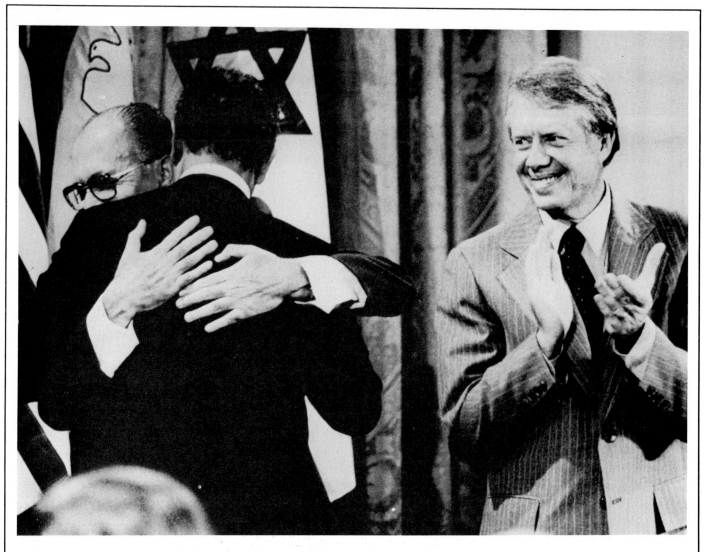

ISRAELI-EGYPTIAN PEACE TREATY

September 17, 1978

Israeli Prime Minister Menachem Begin and Egyptian President Anwar Sadat embrace in the East Room of the White House while a beaming Jimmy Carter looks on. The two had just signed a document, "A Framework for Peace," which was hammered out in a conference at Camp David. This document detailed the intention of each country to work toward a peace treaty. For the first time since Israel was formed in the late 1940s, peace in the Mid-East seemed possible.

POPE JOHN PAUL II

October 17, 1978

The former Cardinal Karol Wojtyla of Poland leaves the Sistine Chapel after celebrating his first mass as Pope John Paul II. The first non-Italian pope in 400 years captured the heart and the imagination of the world with his simple warmth and outgoing nature, as he traveled through Europe, North and Central America, and the Mid-East.

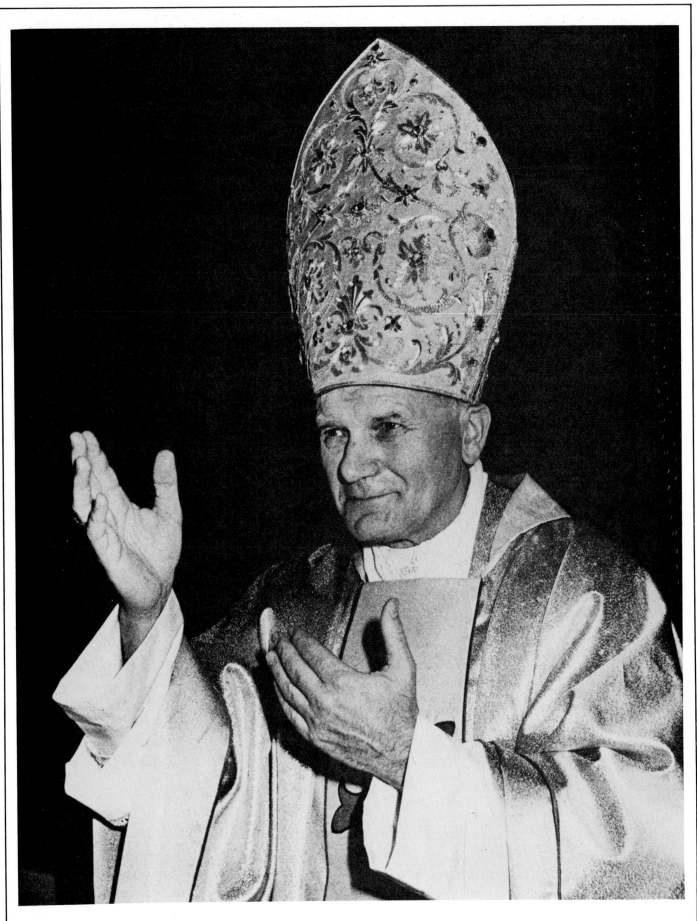

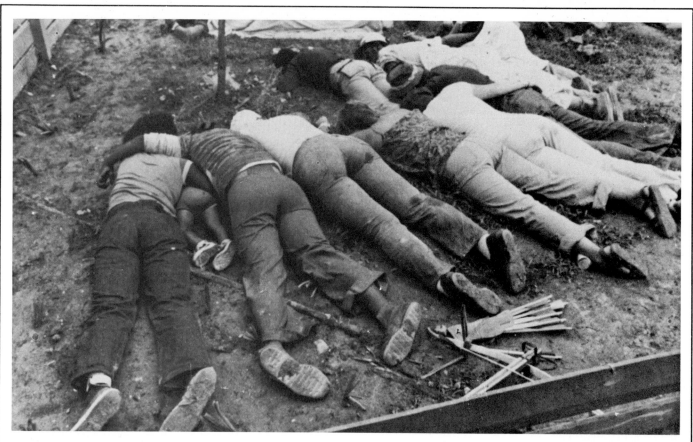

GUYANA—THE PEOPLE'S TEMPLE
November 1978

The news got worse every night. On November 19, 1978, California Congressman Leo J. Ryan, in Guyana to investigate rumors of a religious cult holding followers against their will, was murdered by members of the cult as he was leaving the Jonestown airport. Four journalists were also killed in the ambush.

Then the reports of mass suicide began to come in. The followers of the People's Temple of Disciples of Christ, led by a dark-haired, charismatic San Francisco man, Jim Jones, had drunk Kool-Aid laced with cyanide from a communal vat and had lain down together to die. Early reports put the dead at 300 or 400.

It became obvious that not all of the followers willingly drank the poison. Parents had forced the concoction down their children's throats or had given it to infants in their bottles. Many adults were murdered as they tried to escape. The death count rose substantially when a second layer of bodies was found under the first. By November 26, the count stood at double, almost triple, the original estimate—911 were dead.

Jones had reportedly feared outside intervention. Psychological experts all over the country tried to understand his behavior and explain why so many would follow so blindly. There still are no sure answers, only grief for the hundreds dead among the hundreds more loved ones they left behind.

AYATOLLAH KHOMEINI
February 1, 1979

On his triumphant return to Iran, the country from which he was exiled for fifteen years, religious leader Khomeini casts a solemn eye on his subjects. The previously obscure zealot stunned the world by leading the revolution that overthrew the Shah of Iran. Later, having set up an Islamic government, Khomeini gave tacit approval as fifty-three American hostages were taken in Iran.

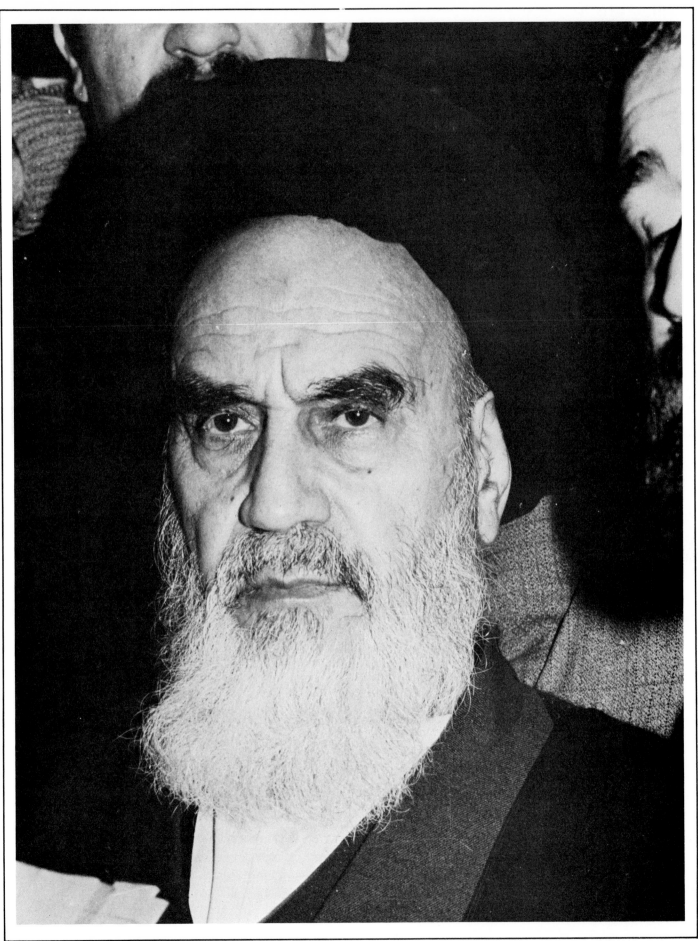

205

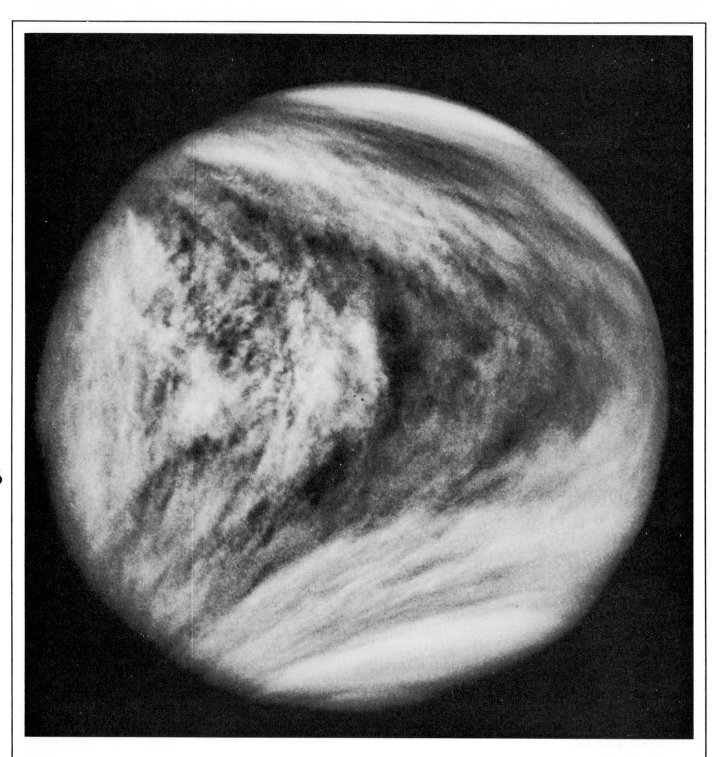

THE PLANET VENUS
February 19, 1979

The scientists at NASA's Ames Research Center in Mountain View, California, are still receiving data and analyzing it, but certain facts have been clear since the *Pioneer* explorer craft made its cruise by the planet Venus on its tour through the solar system. Temperatures on the planet reach 900 degrees Kelvin and winds blow at 400 miles an hour. There does not appear to be any water on the surface of the planet. This photograph was taken from about 40,000 miles above Venus and was transmitted back to Earth before the *Pioneer* continued on to Jupiter, Saturn, and points beyond.

THREE MILE ISLAND
March 1979

With the idyllic Pennsylvania countryside in the foreground, the cooling towers of the Three Mile Island nuclear plant loom ominously behind. The plant, damaged by a series of mishaps, spewed radioactive steam and gas for several days, prompting the governor of the state to call for the evacuation of young children and pregnant women from the area. Some said it was the beginning of the end for nuclear power—already a controversial topic. While that was probably an overstatement, the public's confidence was sorely shaken and doubt was cast on whether or not new plants would be licensed.

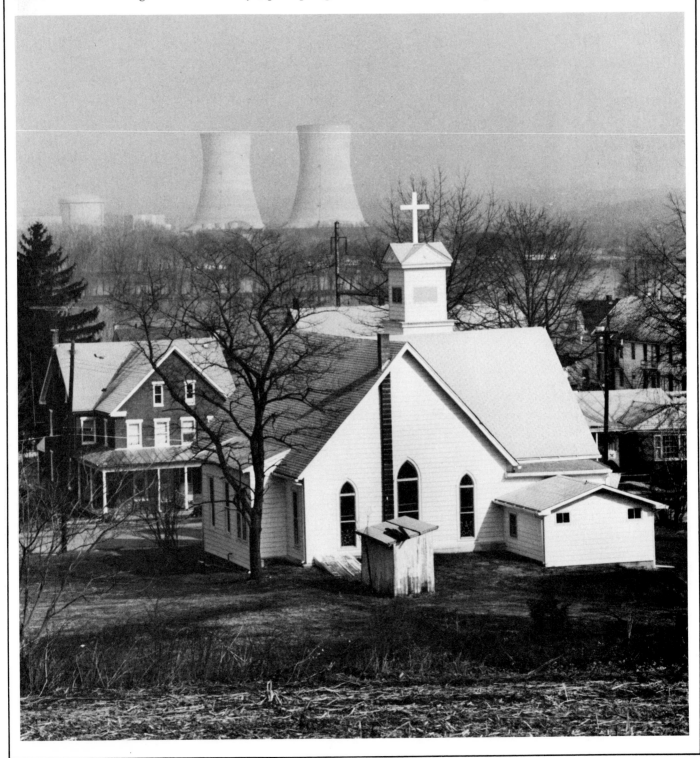

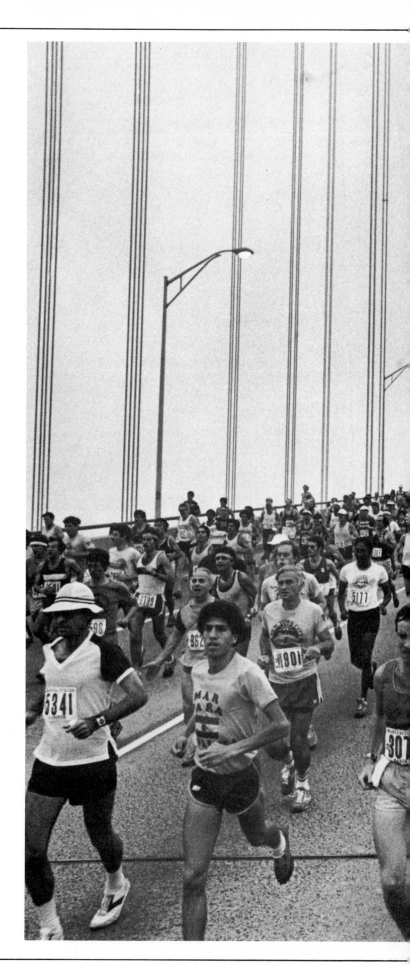

NEW YORK MARATHON
October 22, 1979

Well over 10,000 people entered the 26-mile, 384-yard race known as the New York Marathon—previously the domain of a few dedicated athletes. Here, the runners are shown streaming across the Verrazano-Narrows bridge. The winner was defending champion Bill Rodgers.

210

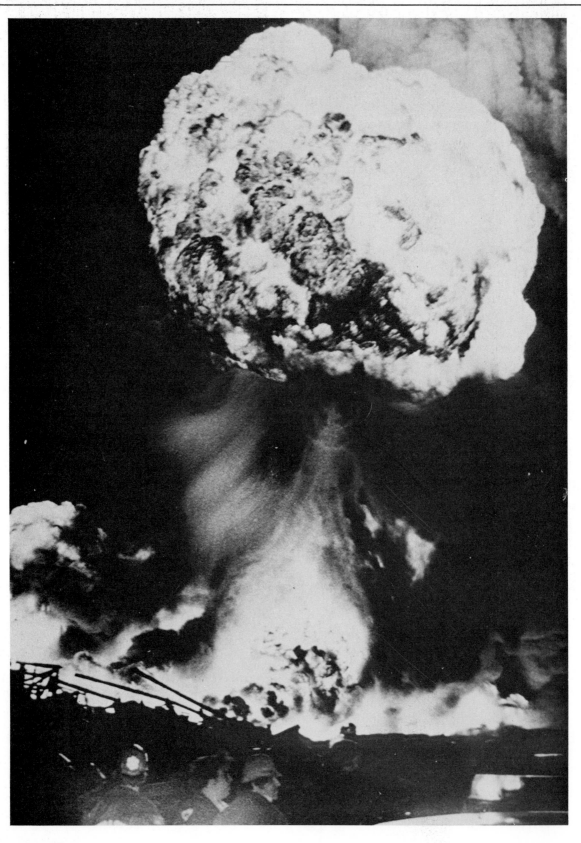

BALLS OF FIRE

April 22, 1980

Bystanders watch, early in the morning, as chemical storage drums at the Chemical Control Corporation in Elizabeth, New Jersey, explode, shooting balls of fire several hundred feet into the air.